T·H·E

Bourgeois and the Bibelot

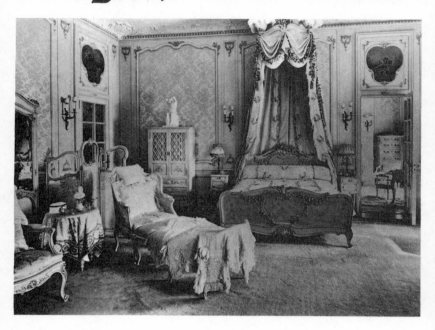

RÉMY G. SAISSELIN

RUTGERS UNIVERSITY PRESS

New Brunswick, New Jersey

Library of Congress Cataloging in Publication Data

Saisselin, Rémy G. (Rémy Gilbert), 1925–

The bourgeois and the bibelot.

Bibliography: p.
Includes index.

1. Art and society—History—19th century. 2. Civilization, Modern—19th
century. 3. Art—Collectors and collecting. 4. Art as investment. I. Title.

N72.S6S24 1984 701'.03'09034 84-4701

ISBN 0–8135–1062–7

Manufactured in the United States of America

*Bedroom, 1905. Photograph by Byron. The Byron Collection.
Museum of the City of New York.*

THE BOURGEOIS AND
THE BIBELOT

C · O · N · T · E · N · T · S

Contents

I·L·L·U·S·T·R·A·T·I·O·N·S

Illustrations

P·R·E·F·A·C·E

Objects of art from the Louvre, *by Blaise Alexandre Desgoffe.*
The Metropolitan Museum of Art. Bequest of Catharine Lorillard Wolfe, 1887.

The driver put the bus into third gear, then second, as we began our ascent and climbed and climbed to reach a parking area on the edge of a town dimly distinguishable in the evening light of this splendid Italian summer. The guide announced Tivoli.

It was the first time I had been here, as indeed it was the first time I had been to Rome from whence we had come to view the highly recommended illuminations of the Villa d'Este, also known for its myriad fountains and magnificent terraced gardens. But Tivoli had occupied a place in the landscape of my imagination for years. I had read Madame de Staël and Goethe and looked at Hubert Robert and Piranesi. Tivoli: the very word was charged with historical and cultural associations. Here milordi on the Grand Tour, great artists, great poets, the rich and the beautiful had come, and posed, and uttered the appropriate words about beauty, art, time, and eternity.

And so we got off the bus and followed the guide toward a little piazza that, from what I could see, seemed to be the center of the village. The piazza was one huge market of souvenirs, reproductions, and bibelots, all brand new. Never before had I seen such a concentration of world-renowned and universally admired masterpieces as in the shops of this piazza, and all reduced to convenient gift sizes. Michelangelo's *David*, in plastic, plaster, or alabaster; his Pietà, in the same materials, as well as luminous plastic; the Leaning Tower of Pisa; the famous Mona Lisa, Botticelli, Raphael—you name it they had it, some in beautifully crafted frames, some soft to the touch; and if somehow during your travels you had forgotten the Eiffel Tower or some other monument or picture, no matter, you found it here. For the serious tourist there were slides, in glorious Kodacolor, already mounted for use in any standard projector, for any kind of enthusiast: early Renaissance, High Renaissance, mannerist, baroque, rococo, neo-classic, romantic. The world of art was up for sale as reproductions and souvenirs on this world-famous hill where the great had once feasted and conversed and thought sublime thoughts.

Preface

Tivoli: I had come, I had seen, I had laughed. What delightful bibelots and what imagination mankind, industrial mankind, displayed in their production. And how modern ingenuity had outdone the old masters who could only produce one masterpiece at a time! Here they were by the thousands, in all sizes and materials, shiny, new, and for sale!

The villa, the gardens, the fountains, the illuminations, in comparison, were rather disappointing; after all, you couldn't buy those.

I had known about bibelots before my surrealistic experience at Tivoli. At my great aunt's Parisian apartment, as we sipped our coffee after dinner and carefully set our chinoiserie coffee cups on the not always steady Moroccan folding coffee table, my eyes would gaze at the heavy bronze ox and rider from Indo-China on the mantlepiece. And sometimes, turning slightly on the Louis XVI settee (nineteenth century but a good copy), the children and I would examine the bibelots on the Chinese-style étagère in the corner of this exemplary late nineteenth-century bourgeois salon: a rather flat-headed Buddha in crystal on a heavy bronze base; a cloisonné opium pipe with holder and tiny instruments with which to prepare the opium; several small Chinese figurines in ivory; five diminutive ivory elephants, each smaller than the next; a small Daum vase; silver boxes; photographs of family members in silver frames; and other little items, themselves put in little boxes, which, in turn, were placed in the little drawers of this cabinet of past dreams and tastes. Familiar objects all, familiar bibelots that had been the delight of children's imaginations for two or three generations. They had no value save as souvenirs of another world, another time, another French Republic; though with hindsight they seem souvenirs of the late bourgeois world.

On my return from Italy that summer, they were still there, in the same étagère. As I began to muse on them and the thousands of similar others I had seen at Tivoli and other places, like the abbé Laugier in the eighteenth century suddenly perceiving the origin of architecture

Preface

in the primitive hut, I, too, had an illumination. It was, however, not sudden, but a crystallization, as Stendhal used the term in regard to love: a variety of perceptions and impressions fell into place and I came to understand the significance of art in the nineteenth century: it had been bibelotized!

The pages that follow then, are not those of one more book in art history concerned with the description of the various movements of the nineteenth century. There are no chapters on romanticism, realism, naturalism, impressionism, postimpressionism, or symbolism. I am concerned, rather, with exploring that ambiguous moral and aesthetic space in which works of art or of beauty are no longer defined by philosophers of aesthetics writing of subjects perceiving objects defined as beautiful through the aesthetic experience, itself defined in terms of pure disinterestedness. Nor am I concerned with art critics writing about works of art they knew in advance to be great art. My concern is with the very human desire to possess objects of art and how this desire, accepted at the outset as a distinctive human trait, was magnified in the nineteenth century and how it affected the perception and status of art and works of art. Mine is a study in what might be called the democratization of collecting.

Some readers will immediately think of Veblen's theory of conspicuous consumption and assume that what I have to say merely points to a qualitative rather than a quantitative change in collecting, that conspicuous consumption has always been with us. The names of Renaissance princes are often coupled with those of American millionaires when collecting is discussed. Aline Saarinen has even written of noblesse oblige in connection with J. P. Morgan's great accumulation of treasure. But it ought to be remembered that the capitalists of the nineteenth century were not at all like the nobility of the old regime and that conspicuous consumption is not in the same order as noble spending, *dépenses nobiliaires*, made necessary by one's station in life, not possible merely because one had millions to spend.

Preface

The nature of collecting in the nineteenth century must not be confused, as Joseph Alsop pointed out in his recent book, *The Rare Art Traditions*, with patronage of the arts. As going broke magnificently was an inseparable risk from the obligations of the noble life, so desire and the accumulation of things was inseparable from the bourgeois life of the nineteenth century. That some qualitative change had occurred in the nature of the collecting did not escape the notice of social observers at the time. Edmond de Goncourt, along with his brother Jules, a great collector of eighteenth-century French art, pointed to a psychology of accumulation in the preface to the catalogue of their 1880 collection, *La Maison d'un artiste*. He noted the period's mania for bibelots and referred to it as *bricabracomania*, as if it were a kind of disease. He linked it with an uneasiness of the soul, the loneliness and emptiness of the human heart in the new industrial society and its modern cities. In the ennui and anxiety of the modern city with its fast pace, men and women, according to Goncourt, sought stability, durability, happiness, and spiritual value in the enjoyment and possession of works of art. Time passed, but works of art endured. These are of course Pascalian explanations: the enjoyment of art as the drive to accumulate art objects can be seen as a diversion, a divertissement from the human condition. The object, however, in those days of grand bourgeois accumulation, was not anxious but, rather, reassuring.

Yet this psychological phenomenon does not preclude a specific historical world that gives this new desire for objects its particular form and meaning. In this realm, the expansion of the limits that defined the fine arts transformed what Alsop calls the by-products of art, such as collecting, tastes, prices, expertise, and so on. In the ambiguous realm of desire for possessions of beauty, the objet d'art is no longer defined by some pure and disinterested aesthetic judgment satisfactory to Kantians, but by the social role of art, by prejudices, presuppositions, art history, money, and class. On this level the work of art functions less as a masterpiece within the web of art history than as a social sign denoting or conferring distinction and cachet upon its

Preface

possessor. In the old regime possession by nobility conferred cachet
upon the work; in the bourgeois world it is the other way around. Mo-
lière's Monsieur Jourdain, bourgeois gentilhomme, triumphs over the
common sense of his wife who has been invited to join the local mu-
seum's junior council.

My exploration of this ambiguous space where love of possession,
love of art, and social ambition meet is not to be read as a definitive,
scholarly study of art collecting in the nineteenth century. I have not
exhausted the libraries or museums or antique shops of the United
States or of Europe. Nor does the bibliography contain all that I have
read. The readers of the bibliography will notice that I have relied not
only on art historical sources and memoirs, but also on novels, some
of which are all but forgotten. These works are useful for their docu-
mentary value and for the ambiance or feeling for the times that they
can still impart.

This essay, and the stress is on "essay," may thus be likened to a
promenade in the course of which I have ambled and mused, like a
literary flaneur, in historical time on an itinerary that takes us from
Tivoli in about 1800, across the Atlantic to the United States, and back
to Europe to Berenson's villa I Tatti. Why Tivoli in 1800 and I Tatti? Be-
cause in her novel *Corinne*, Madame de Staël sums up a view of art
that is as good a starting point for understanding the assumptions
about art with which the nineteenth century began as any. Corinne
and Tivoli and all its ancient associations, marked one limit to my in-
quiry. I Tatti symbolizes the prestige of high art and of the established
art expert; it also represents the international scope of the current art
market.

And so it seems that the history of art in the nineteenth century
might conceivably be written as the transformation of the work of
art, first perceived as aesthetic object and historical sign, into a super-
bibelot calling for super prices.

A·B·B·R·E·V·I·A·T·I·O·N·S

A James, Henry. *The American*. Boston: Houghton Mifflin, 1907.

AH Berenson, Bernard. *Aesthetics and History*. New York: Pantheon, 1948.

AL Lee, Vernon. *Art and Life*. East Aurora, N.Y.: Roycroft Print Shop, 1896.

C Wharton, Edith. *The Custom of the Country*. New York: Scribner's, 1913.

D Nordau, Max. *Degeneration*. New York: Appleton, 1897.

LP Santayana, George. *The Last Puritan*. New York: Scribner's, 1936.

OM Bourget, Paul. *Outre-mer*. 2 vols. Paris: Lemerre and Meyer, 1894–1895.

PA Lee, Vernon. *The Beautiful, an Introduction to Psychological Aesthetics*. Cambridge: Cambridge University Press, 1913.

PL James, Henry. *The Portrait of a Lady*. New York: Penguin, 1978.

R Stein, Roger. *Ruskin and Aesthetic Thought in America, 1840–1900*. Cambridge, Mass.: Harvard University Press, 1967.

TG Taine, Hyppolite. *Notes sur Paris: Vie et opinions de M. Frédéric Thomas Graindorge*. Paris: Hachette, 1901.

V Bourget, Paul. *Voyageuses*. Paris: Nelson ed., Calmann-Lévy, n.d.

WP Fuller, Henry Blake. *With the Procession*. New York: Harper's, 1895.

Tivoli: Art and History

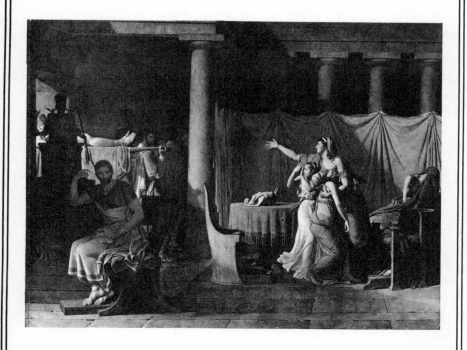

Brutus, *by Jacques Louis David. Archives Photographiques. The Louvre.*

Art is nothing to the people.
Submit the Beautiful to universal suffrage,
and what happens to the Beautiful?
The people rise to art only when art
descends to the people.

Edmond and Jules de Goncourt,
La Révolution dans les moeurs

There was a time when the tourists at Tivoli did not get out of buses to find a square filled with souvenirs and kitsch. There was a time when only ladies, gentlemen, cognoscenti, amateurs of the arts, scholars and artists, poets and writers came to Tivoli. They stepped out of coaches to sketch, and think, and seek inspiration, or just to have been there; for Tivoli was part of a gentleman's education in the eighteenth century. And in the romantic period of the nineteenth century, the literarily inclined wrote as they set on some stone bench in the gardens of the Villa d'Este, or in the shadows of the pines, by rippling waters, pages on beauty and human destiny. They knew that works of art and monuments were not bibelots, that art and time and history were very serious matters. And these travelers also knew—and found appropriate—that it was not given to all, and ought not to be given to all, to pose in the Roman countryside or climb the hill to Tivoli.

When Corinne, heroine of fiction created by anything but a fictitious Madame de Staël, née Germaine Necker, adoring daughter of a Genevan banker turned minister of finance under Louis XVI, took her lover Lord Oswald to her villa at Tivoli, there were no bibelots sold in the village square. She took Lord Oswald, romantic, melancholy, and profound man of the North, to show him her collection of paintings, which were not bibelots. They were in a literal way significant; they were signs; they had meaning, presumably universal. The collection

Tivoli: Art and History

was made of paintings that, since *Corinne* was published in 1807, have become famous and familiar to innumerable undergraduates taking low-numbered art history courses for easy credits at high prices. *Corinne* possessed histories, religious pictures, poetries, and landscapes. More important, Corinne, being as well-read, intellectual, and inspired as Madame de Staël, had arranged her collection in a sequence that made philosophical and historical sense; for the collection illustrated the literary-historical philosophy of Madame de Staël, who was none other than Corinne—as Madame Vigée Lebrun and the Baron Gérard both knew since they both painted her as Corinne.

The first of Corinne's history pictures was the famous *Brutus* by Jacques Louis David; its pendant, the *Marius at Minturne*, was by Jean Germain Drouais, one of David's best students; while the last of her histories was the now lost *Belisarius* of Baron Gerard, one of the masterpieces of Napoleonic painting. All these works, taken together, had a specific meaning: *Brutus* signified civic virtues that, in fact, resembled crime; *Marius*, who is shown exposing his breast to a Cimbrian warrior sent to kill him, while the latter is hiding his face in shame, exemplified glory as the cause of personal misfortune; while the *Belisarius*, a favorite of neoclassical art, was an obvious example of unjust persecution. The sacred pictures, a Christ asleep upon the cross by Albano, a Christ falling under the burden of the cross by Titian, also had their meaning, signifying, in contrast to the histories, the redemption and hope of the Christian faith as opposed to the hopelessness of the pagan world. Monsieur Necker had written a book on the consolations offered by Christianity, especially to the poor whose lot in this world would be lightened by thoughts of rewards in the next.

As for the poetries and landscapes, they too had a significance. One was a theme taken from Tasso; another was taken from the *Aenead*; a third from Racine; a fourth from Shakespeare. One landscape was a Salvator Rosa rustic scene; another, a heroic landscape showing Cincinnatus leaving his plow to take up the defense of his country. Finally,

Tivoli: Art and History

Corinne also had an Ossianic landscape that brought tears to Lord Oswald's eyes. In mood, subject matter, and in association, these poetries and landscapes corresponded to Madame de Staël's cultural differentiation between the literature of the North—Shakespeare and Ossian—and that of the South—Tasso and Racine—and, by extension, two different and often opposed temperaments and civilizations. Hers was a theme that would flourish in the course of the nineteenth century since the South would ever prove a fatal attraction to poets and painters of the North from Winckelmann to Goethe, Feuerbach, and Thomas Mann's Gustav von Aschenbach, who found his death in the decadent Venice of Bernard Berenson and Mrs. Isabella Stewart Gardner of Boston.

Obviously Corinne's pictures were not merely works to please the eye, like some rococo nudes or pastorals; together, they represented more than the collection of an amateur. The choice and arrangement of the pictures, Corinne's private guided tour, all signified what art after the French Revolution had come to mean in the new age of the arrived bourgeoisie: art works were the signs of history, and hence the collection presented a rather coherent set of historical and cultural values, values that distinguished the new ruling class from the old nobility which now had to share social preeminence with the bourgeoisie. The old nobility had had lineage, ancestors, breeding, military glory, and the right to bear arms to distinguish it from the commoners, as well as debts incurred in keeping up the necessary appearances. The bourgeoisie would have culture to distinguish itself from the former nobility and the threat of commoners who might legally aspire to its ranks and new ruling status. The principle that all men were equal under the law, taken seriously by some of the working lower orders, posed serious problems of authority and prestige for the bourgeoisie. Surely all men were created equal and were so under the law, but equally surely some were rather better than others. It was essential to keep the lower order low and maintain the better sort of people in the

right places. It was found that both education and art could do a great
deal in maintaining a social balance. There soon arose what one critic
of the French education system in the twentieth century was to call
the aesthetics of distinction. The entire educational system of the
French bourgeoisie in the nineteenth century was founded on the ne-
cessity of creating a level of distinction that would be an effective bar-
rier to the lower orders: hence the baccalaureate degree, the achieve-
ment of which required nonutilitarian Latin, the right table manners,
the right gloves, the right linguistic usage, the proper dress, quite dis-
tinct from the dress and manners of the working class, the knowledge
of how many glasses to put at a place setting and where to put the
right knives, forks, and spoons. There is no doubt that art could also
play a distinguishing role for a ruling class whose individual members
had often only recently arrived. As the educational system tended to
be increasingly democratized, the idea of distinction in the aesthetic-
artistic realm was bound to become more and more attractive since
the arts were rich in associations of nobility, beauty, leisure, heritage, a
beau monde, and the general phenomenon of snobbism that marked
the world in the time of James and Proust. Aestheticism of the fin de
siècle was implicit in the bourgeois avid for distinction and in the very
foundation of his society.

True daughter of the Enlightenment and of a successful banker,
Madame de Staël was an optimist who believed in progress, liberal-
ism, and the elite to which she belonged. Her contemporary, Jean
Chrysostome Quatremère de Quincy belonged to the same elite of
bourgeois notables, but he was no banker's son and so tended to be
somewhat less optimistic than Madame de Staël. Originally a sculptor,
he turned antiquarian and made the acquaintance of the painter Da-
vid in Italy, became a political exile during the Revolution, returned to
serve Napoleon and then the Bourbons, was appointed perpetual sec-
retary of the reformed and revived Academy of Painting, transformed

under various regimes into the Classe des Beaux-Arts of the Institut. Having been to Italy, he too had come to think of the arts in noble and exalted terms. Friend of Canova, he had come to represent the upholder and the defender of the Greek ideal in art. But as he lived on during the reign of the Citizen-King Louis Philippe, who used to appear in public with an umbrella like any bourgeois, Quatremère came to have fewer and fewer illusions about the status of art in an age of steam, speed, manufactures, money, art collections, public art exhibitions, and museums.

For Quatremère had come to understand and explain in prose only slightly more lucid than Hegel's, who had understood the same thing, what no one dared say out loud: art was dead. By this he did not mean that paintings and sculpture or public monuments were no longer produced. The contrary was perhaps only too true: too much was being produced. But he sensed that the nineteenth century—the modern world—was in a profound disharmony with the forces that in the past had been the conditions or the "causes" productive of art. The Greek world had known harmony between its beliefs and the causes productive of art and for this reason had produced the only valid canon for art and beauty, and in the mind of Quatremère and his followers both terms were written with capitals and were seen as inseparable: Art is Beauty. The individual work of art was an intimation of universal ideal beauty. The theory was Platonic. The models of universal beauty were the Greek works that had survived. And the harmony between Greek life, religion, and art was such that beauty, incarnate in works of art as well as healthy and handsome Greek youths and maidens, seemed the product of an ideal nature. But this was far from the situation of the nineteenth century in which art could only be an evocation of a lost harmony, an aspiration to regain or reestablish harmony, in short, the ideal. Education in the arts came to be seen as one way to establish this lost harmony within the modern world. Witness

Tivoli: Art and History

the efforts of academies to maintain high art, or the efforts of men like Ruskin and William Morris to counter the effects of industry and the machine by preaching for a return to art as craft.

The result of this general malaise about the state of art and beauty in the new industrial world and its great cities in Europe and North America was an idealization of art in general and a reverential attitude toward works of art in particular. The state became concerned with art as it formerly had with religion. Indeed, in Anglo-Saxon countries religion was sometimes confused with art, or vice versa.

It is possible to separate idealism in the arts into various strains, but those who used the word *ideal* often failed to draw sharp distinctions unless they happened to be professional philosophers who lectured on beauty. The word thus remains a vague but useful term characteristic of an age. One thing was clear: the ideal was always spiritual; it was never sensationist and certainly not sensational. And it was never vulgar. In the early nineteenth century the ideal was the opposite of the subversive, sensationist, materialistic philosophy of the Enlightenment, which, as all the well-to-do knew, had been responsible for the Revolution. Materialism was dangerous to social values and to the stability of society. The bourgeois, who had finally arrived after centuries of climbing, was an idealist, at least in his salon if not on the marketplace. The bourgeoisie had even found its ideal professor to expound this doctrine of the new trinity of the true, the good, and the beautiful. Victor Cousin, eminent eclectic philosopher, pillar of the establishment, was quite clear on the distinction between the truly aesthetic from the snares of sensation: the "judgment of beauty is absolute, and as such, entirely different from sensation."[1] Just as the neoclassical painters and sculptors jumped right over the art of the baroque and rococo to find inspiration with the Greeks, so Victor Cousin dismissed eighteenth-century philosophy to find inspiration in Plato. Plato in-

1. Victor Cousin, *Du Vrai, du beau et du bien* (Paris: Didier, 1878), 141.

sisted on the Idea of Beauty rather than a thing of beauty. The thing was material, but the Idea was spiritual, intangible, eternal, transcendent. Given these premises an artist who produced a thing of beauty would always be at a disadvantage since beauty was spiritual. He could only approximate the ideal; but, if successful, his work would provide an intimation of that ideal.

Sensation, titillation, and strong emotion were thus effectively separated from the admiration of an object of art. Love of beauty and love of art remained spiritual and therefore pure. The sentiment for beauty, according to Cousin, the aesthetic judgment, according to Kant, was so defined as to exclude desire. For the essence of beauty according to these philosophers was not to prompt desire but, rather, to purify and ennoble it. "The more a form is beautiful," wrote Cousin, "not of that common and gross beauty by which Rubens vainly animates his ardent colors, but that ideal beauty known to Antiquity, Raphael and Lesueur, the more is desire tempered by an exquisite and delicate sentiment and sometimes even replaced by a disinterested cult of beauty before such noble creations."[2] Art and religion were thus not far apart. The ideal led to thoughts of eternity and the true and absolute ideal was none other than God. A romantic view of the artist as somehow close to God and the infinite was thereby joined to a classical aesthetic theory and its concomitant taste for the works of the Greeks. It was conveniently forgotten that the Greeks had been pagans and far less "spiritual" than Winckelmann.

This philosophical-aesthetic idealism was formulated in a variety of ways and forms. Theophile Gautier, poet, journalist, critic, novelist, wrote an entire novel about it, namely his famous—or, rather, infamous—*Mademoiselle de Maupin* of 1835. He also thought that "the verses of Homer, the statues of Phidias, the painting of Raphael have raised the human soul more than all the treatises of the moralists.

2. Ibid., p. 145.

Tivoli: Art and History

They have given a conception of the ideal to people who otherwise would never have suspected its existence."[3] The idea that art could raise the human soul would not be lost on the bourgeois. As for Homer, Phidias, and Raphael, they constituted the very canon of the Ecole des Beaux-Arts.

Jean Auguste Dominique Ingres—painter, member of the Institut, onetime director of the Ecole de Rome, decorated with the Legion of Honor—though defined as a classicist would here have agreed with the romantic Gautier. Ingres held the same views about art as Quatremère de Quincy. He was equally as pessimistic as the perpetual secretary of the Académie des Beaux-Arts. For him, in his despair at the lack of beauty in the modern world, the end of art meant that the great moments of its history were over; nothing greater than Raphael had been or could be produced. All an artist could do in the modern world was to maintain the purity of line and the harmony of form which to Raphael had come naturally. At best, with the proper training, one could perhaps repeat or emulate Raphael, find inspiration in his work, but one could never surpass him. As for the rest, the current production of color, movement, romanticism, Delacroix: heresy. Color and positivism, that is, finicky, minute finishing and attention to detail, Horace Vernet: heresy. Low subject matter, vulgarity, surface play and materiality of texture, realism, Courbet: heresy. And it followed that all other *isms* to be produced by the age would be merely deviation, degradation, decadence. As Baudelaire was to tell Manet, you are but the first in the decrepitude of your art. And so Monsieur Ingres with his rosette of the Legion of Honor, maintained, against a mounting tide of vulgarity and materialism, the beauty of Raphael, the ideal, the eternally beautiful.

As for Quatremère de Quincy, he lived so long in a world he did not

3. Quoted in H. A. Needham, *Le Développement de l'esthétique sociologique en France et en Angleterre au XIX*[e] *siècle* (Paris: Champion, 1926), 100.

like that he came to wish for death. For it was a world of money valua-
tions and what he called materialist considerations in the arts. By this
he meant museums, exhibitions, private and public collections, all of
which he despised. The enemy of art was not only romanticism in its
myriad manifestations, but also, perhaps more so, the ignorant lover of
the arts and that figure from the seventeenth century, the tulip specu-
lator, who, in the eyes of Quatremère, came to represent the acquisitive
and speculative spirit that seemed, like democracy, to be conquering
the world. Quatremère looked at the tulip speculator as Tocqueville
looked at rising democracy. And the tulip speculator had, in the mod-
ern world, become the art speculator, the collector, the curator, the ac-
cumulator, the dealer. One might say he came to symbolize all those
byproducts of art that Joseph Alsop so knowledgably outlined as in-
separable from the rare art traditions. Yet even at the Institut, where he
presided and where his authority was undisputed, there were fools
and optimists who saw in the greater and greater production of works
of art, in the exhibitions, collections, and museums, a sign of progress.
As if, Quatremère called out in a speech to the members of the acad-
emy, the increasing number of boutiques in Paris were proof of greater
civilization!

The allusion to the boutiques was, as we shall see, more significant
than Quatremère himself may have realized. For it was unwittingly
pointing the finger at art's greatest enemy in modern capitalist society:
the tulip speculator was opening shop and would soon own a depart-
ment store, becoming a collector in the name of the ideal. Meanwhile,
Tivoli, symbol of the ideal, of art understood as historical sign, with its
association with the antique and Renaissance villas, was turning into a
museum and tourist pilgrimage. Art is dead, long live museums! There
was reason to be pessimistic for those who had believed in the har-
mony of Greek life and Greek art and had failed to make that telling
distinction between patrons of art and mere collectors. Quatremère's

Tivoli: Art and History

suspicion of amateurs, collectors and museums were justified even though he did not, in his time, formulate his suspicions in terms comprehensible to us. For he lived at the beginning of the Museum Age while we live in the time of museum show biz. The disharmony between art and the nineteenth century that Quatremère sensed was the product of a period in which patronage of the arts was increasingly being replaced by collection of the art of the past—when, in other words, history as the accumulation of past works housed in collections would threaten the supposed absolute of taste founded on Greek antiquity. What Quatremère did not see, however, was an even greater danger to art, namely, the very nature of modern life as manifested in the new, modern, industrial city.

Friend of David and Canova, lover of Italy and antiquity, Quatremère saw art endangered by color, movement, romanticism, positivism, and materialism, by which he meant, among other things, what we tend to regard as romantic and realist art. But the true danger to art, art as he understood it, was entirely different and would include Ingres *and* Delacroix, Girodet *and* Horace Vernet, classicists *and* romantics, idealists *and* materialists.

The man who understood the new danger to art, perhaps because he was at odds with his society and had not been brought up in the eighteenth century, was Charles Baudelaire. Poet and Parisian, a failure by every middle-class standard of success then and now, Baudelaire wasted his inheritance, wrote verses that brought him to court, and contracted an unspeakable disease from the type of woman respectable people do not mention in public; yet he was a lucid poet and critic. He understood quite early on the role of the new *rapports de force*, the power structure that would rule the new society; he also saw what it would mean for the arts, artists, and poets. When Quatremère thought and wrote about the arts he addressed himself to persons of his own class, the notables of the nation, the aesthetic elite, and the officialdom of the arts. Baudelaire, on the other hand, discov-

Tivoli: Art and History

ered the bourgeois, and in the preface to the *Salon of 1846* he stressed what the power of this new public meant: "You are the majority, number and intelligence; you are therefore power, which is justice."[4] He saw and understood that this new public would have to be educated in matters aesthetic, whereas Quatremère simply viewed the uneducated public as dangerous.

Baudelaire the poet saw what Quatremère had missed in the new social and political situation in which the arts had to live, namely, the fascination of the modern city. London and Paris in the eighteenth century had been relatively large, but until the nineteenth century, the arts had flourished by and large in slow-paced and modest-sized cities. Industrialization under Victoria and Napoleon III increased the size and population of cities, which effected a qualitative change in life in such cities as Paris, London, Berlin. What Baudelaire understood about the city and its effects on life and the arts may be gleaned from two sonnets that stand as pendants to each other. The first is entitled *Beauty*:

> I am beautiful, O Mortals, like a dream of stone,
> And my breast where all in turn were bruised
> Is made to inspire in poets a love
> Eternal and mute as the stone.
>
> I rule the Heavens as inscrutable sphinx,
> My heart is snow and white as the Swan,
> I hate the motion displacing line,
> And I never weep and I never smile.
>
> Poets before my grand poses,
> Borrowed of the proudest monuments,
> Consume their days in austere study:

4. Charles Baudelaire, *Oeuvres complètes de Charles Baudelaire*, 2 vols. (Paris: Le Club du meilleur livre, 1955), 213.

Tivoli: Art and History

> For I possess, to fascinate these docile lovers,
> Pure mirrors, which everything do beautify:
> My eyes, my great eyes of eternal clarity. (1:689)

The aesthetic summed up in this sonnet inspired by a statue corresponds to the aesthetics of Ingres and his cult of Raphael or that of Flaubert and the endless pain he took over a page of prose. It is the religion of art, implying discipline and sacrifice though not salvation. But consider this other sonnet to a passing woman:

> The noisy street about me shrieked
> When slender and in grand mourning,
> Hand ostentatious, balancing garland
> And hem, a woman passed . . .
>
> Agile and noble with the legs of a statue,
> I, like a madman, from her livid eyes,
> Whence issued storms, drank in the sweetness
> Fascinating, and the pleasure which kills.
>
> A flash, then night, a fleeting beauty,
> Whose look for me a rebirth was,
> Shall I then see you only in Eternity?
>
> Elsewhere, so far from here, too late,
> Or never: for I know not your way and you not mine:
> O thou I would have loved, O thou that knew it. (1:802)

The allusion to fleeting beauty in the second sonnet might easily be worked into a "classic" opposition of universal, ideal beauty, as in the first sonnet, and merely passing beauties. It was an opposition frequently found in the aesthetics of the Renaissance, the baroque, and the Enlightenment. But Baudelaire is no longer working within the

tenets of classical aesthetics. His aesthetics is beyond that of the Renaissance or the Enlightenment: the two sonnets point to a far more telling opposition. The opposition is not one between ancient and modern manners within an aesthetic system, such as the baroque, or the Enlightenment period, which can accommodate both. The opposition is no longer between rococo fancies and supposedly classic universal values founded on the premise that ancient art is the only true model for art and aesthetics. At issue rather is idealism, as expressed in the first sonnet, confused with art, and the experience of beauty in the world of the modern city. The aesthetic experience of the modern is set in opposition to the traditional canon of art and beauty. It is not two styles or two beauties that are at issue but rival aesthetic systems and values.

The two sonnets mark what we may playfully call a moment of the Hegelian dialectic: the opposition of thesis and antithesis. Art as conceptualized by Quatremère, Kant, and Victor Cousin is the thesis; the experience of the modern city and what it offers the imagination is the antithesis. At issue is the possibility of art's survival in a modern world that is itself rich, exciting, dynamic, tempting, indeed so stimulating to the aesthetic sense as to make art and its concomitant disinterested aesthetic experience as defined by philosophers, superannuated.

Idealist art and theory had but one solution to this challenge: ignore the modern world. The tradition of high art was maintained against the temptations of the modern world. But both systems—the classical ideal in art, and the modern city and its products—appealed to the same human faculty: the imagination.

The modern in the age of Baudelaire was thus no longer what it had been in the eighteenth century. The modern now was that of the modern city, which had itself become a powerful aesthetic stimulant. The city could be more powerfully stimulating and even aesthetically attractive than a masterpiece housed in some museum and prompting responses only among cognoscenti. Quatremère had understood only

too well that by 1800 what had been the space of the arts was becoming a museum. Art was being severed from the source of life. In retrospect even Corinne's villa looked a trifle educational. Tivoli signified the end of the classical aesthetic; Paris, that of the modern to come.

Tivoli, as interpreted by Madame de Staël, prefigures the early nineteenth century's experience of art. Corinne gives Lord Oswald a guided tour of her collection. Although this collection is didactic, it supports the idea that works of art are more than luxury items. They are, in addition, historical signs, as well as objects of beauty. At the same time, the very site of the visit was an aesthetic and moral experience associated with a glorious past, literary, historical, artistic. Lord Oswald's visit was also a privilege. Not all were invited to visit the collection, and not all sought to do so. Corinne's villa was not a public museum. Neither she nor her class assumed that art was for everyone, or that it could or need be understood and appreciated by all. Finally, Corinne's collection was not for sale. Thus, insofar as the aesthetic experience was concerned with art at the beginning of the nineteenth century, it was connected with beauty, history, and privilege. The world created by the bourgeois in the course of the nineteenth century would considerably change this view and status of art.

T · W · O

Paris and the Aesthetics
of the Flaneur

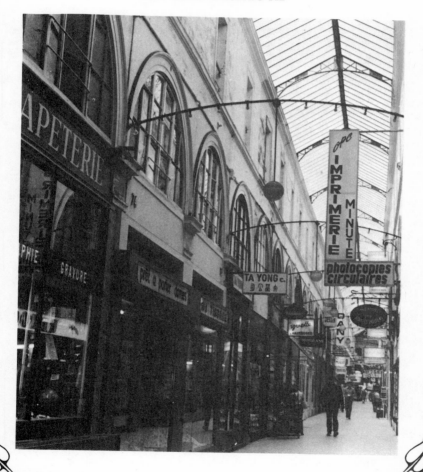

The Passage des Panoramas. Photograph by Anne F. Saisselin.

It often seemed to Mallet that he wholly lacked
the prime requisite of an expert flaneur—
the simple, sensuous, confident relish of pleasure.

Henry James, *Roderick Hudson*

To make the opposition of art in the classic sense and the modern city clear, let us have recourse to symbolic spaces: the museum and the experiences it furnishes may be opposed to the modern city and its stimulants. The classic aesthetic experience was in the past associated not only with pictures and sculpture, but also with gardens, parks, views, and the trappings of the noble life; these, in turn, implied certain spaces: palace, town house, château, and galleries within. The nineteenth century turned some of these spaces into museums and created new spaces of aesthetic experience. But these were quite different and associated with different forms of life and activities. The new spaces to rival those of art were the *passages*, or arcades, and the department stores. There is no doubt that these had predecessors on the architectural level: the *passage* can conceivably be regarded as a gallery adapted not to hang pictures but for some other commercial purpose, while the department store, with its interior galleries, grand staircase, majestic grand entrance, great halls, and even cabinets, was a species of new palace. It was in these new spaces that the nineteenth-century aesthetic observer discovered the most powerful aesthetic activity and experience of the modern man and, even more important, the modern woman: the attraction of commodity and luxury items and the pleasure of purchasing same; in short, the aesthetics of buying and selling.

I was led to rediscover these new aesthetic spaces of Paris by reading Walter Benjamin on Baudelaire and Paris. In his study of this poet he poses the existence of a new aesthetic observer, the flaneur, the walker

Paris and the Aesthetics of the Flaneur

in the city. And what happened in the city as one walked about with the only purpose of seeking out what it had to offer, is that it affected the imagination. One was stimulated as never before. Quatremère had not neglected the necessity of the imagination in the appreciation of works of art; but he had not seen the city would prove a much more powerful stimulant to it than a masterpiece. And so during lunch breaks when I worked at the Bibliothèque Nationale, I, too, wandered in the footsteps of Baudelaire, Benjamin, and Zola's Nana to discover these first modern spaces that were to rival the classic spaces of art, the *passages*.

The first *passage* I discovered was the Passage Choiseul, opened in 1825. Soon I discovered others, both in the area and farther away, such as the famous Passage des Panoramas, one of the early ones—built in 1800—and made famous not only by Nana but the panorama, stage for perfectly illusory painting on the grand scale of Paris, London, Rome, Naples, Athens, Jerusalem, as well as the battles of Tilsitt and Wagram. These vast panoramas had been patented by Robert Barker of Edinburgh, but two years later, in 1789, the American Robert Fulton and Pierre Prevost, a landscape painter, joined forces to create one in Paris. Their panorama is now gone, but the *passage* is still lined with a variety of boutiques. Later I stumbled on the Galerie Vivienne, 1823; the Passage Verdeau, built about the same time as that of the Panorama; the delightful Galerie Véro-Dodat, excellently preserved; and later, the last to be built, the Passage des Princes, 1860. These galleries or *passages* date from the late eighteenth century, such as the Galeries du Palais Royal, 1786, and the Passage du Caire, very much in neo-Egyptian style, of 1799. There are, of course, others: the famous and nearly colossal Galleria in Milan, the Burlington Arcades in London, and a fine example in Cleveland, Ohio. These *passages* are interesting not only sociologically but also architecturally. The Parisian ones date from the late neoclassicism of the Restoration and the reign of Louis Philippe. Their motifs are thus neoclassical, but the modernity of the

arcades lies in the glass roofs that allow daylight to illuminate their long galleries and the often elegant mosaic and tile floors. These spaces rivaled those reserved for art and were those of commodity capitalism. They were also the privileged haunts of that product of the new city, the flaneur.

The nineteenth-century city produced a revolution in aesthetic perception and attitudes toward works of art that is still with us. The city expanded the range of the seeable. The art object was redefined, as was the status and definition of the artist. The eye began to take in far more than it had in the preindustrial city; some critics have referred to this widened range of attention as a new eye. This so-called new eye is sometimes linked to the camera as well as to impressionism. But this new eye of man in the modern city does not so much presuppose photography as photography presupposes a new eye. In other words, the stimulation of the modern city—its multitudes, its variety of objects, its thriving life—transformed the gaze and the observer; and the photographer went hand in hand with the new aesthetic observer of the modern city, the flaneur.

This new eye was the result of the novel conditions of the bourgeois regime. Writers, poets, and artists found themselves in a world of economic values, imperatives, and products rather than the religious, mythic, or traditional values founded on landed wealth. The new regime incorporated new forms of capital, banking, commerce, and manufacturing; and the city that resulted was complex, dynamic, and expanding.

The city as aesthetic or literary experience was not new at all. Louis Sebastien Mercier's *Tableau de Paris* of the late eighteenth century is a case in point, as are the innumerable pictures from that time of Rome, Venice, London, Dresden, Paris, and Amsterdam. And it is well known how Dr. Johnson appreciated and thrived in his beloved London. But these were still relatively small cities by later standards. The Paris of Louis Philippe and Napoleon III was on a grander scale, and the new

Paris and the Aesthetics of the Flaneur

aesthetic observer, poet, writer, painter, architect, student, bohemian, found himself not only in a new city, but also, as Benjamin remarks, in a new market. And he surveyed the new market for the arts and letters as he might have surveyed the Panorama. The image is that of Rastignac surveying the city he would conquer.

The panoramas were not the only art forms prompted by the new city and its greater scale and population. Literature was also affected, as was journalism. The *feuilletons* or *physionomies*—newspaper articles—were turned into volumes that were in effect literary panoramas of the new city and its population, habits, foibles: *Les Français peints par eux-mêmes, Le Diable à Paris, La Grande Ville* were only a few of the titles in which prose was supplemented by lithography to make known the discoveries of the new eye to all those who never left their corner of the city. The new artists were Gavarni, Daumier, among other illustrators. The photo or camera eye is implicit in this new perspective on the city and its teeming crowds, types, professions, manners, morals, works, amusements, places, streets, alleys. The representation of this new world also implied a new reader whose interests and curiosity went beyond the limits of accepted taste to cover all types of men and women, from rag pickers and cocottes to the elegants at Tortoni's and the professional beauties of the opera and the theaters. Henri Monnier was a master of this new genre of city observation and reporting that, beginning with various Parisian city types, turned to the physiognomy of the city itself to produce images of Paris dining, taking the waters, riding, attending funerals and weddings, going to work, out in the country taking the air, in court, at the exhibition, in the music hall, and even at home. There was no theoretical limit to this physiognomic approach, which may well be the origin of the omnipresence of photography in our own day.

This physiognomic genre supposed, as I said, a new aesthetic observer. This observer was no longer the man of taste in contemplation

Paris and the Aesthetics of the Flaneur

before a picture or a landscape. Nor was he Dr. Johnson's London idler, or the spectator of Addison and Steele, or Rousseau's solitary walker herborizing in the country. He was the flaneur in the modern city. The above-named types had been his predecessors with the idler closest to the flaneur. Today the flaneur is all but gone for the automobile has made his idling all but impossible. It was the new environment of the modern city and the historical moment that distinguished him from his prototypes as well as from Marcel Proust's promeneur out for a walk in the country, along Swann's way, or toward Guermantes. For those who made up Proust's world hardly strolled in the city but rode to where they met. The flaneur was not of their class.

As a type he was soon recognized, and his name even had an English equivalent coined by the anonymous translator of Jules Janin's guide to Paris, *The American in Paris, or Heath's Picturesque Annual for 1843*, in which the flaneur is spotted, followed, and called a "lounger."

> Paris is the principal city of loungers; it is laid out, built, arranged expressly for lounging. The broad quays, the monuments, the boulevards, the public places, the flowing water, the domes, the pointed spires, the noise, the movement, the dust, the carriages which pass like lightning, the active, restless, foolish crowd, the schools, the temples, the great men who elbow you at every corner of the street, the beautiful gardens, the statues, the emperor Napoleon whom you meet everywhere, the soldiers who march to the sound of all kinds of music,—the Palais Royal, the most immense shop in the world, where everything is to be bought, from the diamond of the finest water, to the pearl at twenty-five centimes; the mob, the motion, the engravings, the old books, the caricatures, living histories of absurdities of everything; and the permission to do everything, to see everything, with your hands in your pockets, and a cigar in your mouth, . . .

Paris and the Aesthetics of the Flaneur

> the libraries are open to every comer, and the museums, where
> centuries of fine arts have heaped up all their splendours. . . . I
> hope this is a sufficiently extensive theatre for lounging.[1]

The lounger, Janin went on, did not perceive himself as such; he was
no idler but a very busy person who set out to his business every
morning and was distracted by the spectacle of the city. The street
transformed him into a lounger who was seen everywhere, and no-
where: "He is in the gardens of the Palais Royal, to regulate his watch
by the cannon which fires off, discharged by the rays of the midday
sun. He is on the quai Voltaire, occupied in contemplating the antiq-
uities of the curiosity vendors, or looking at the celebrated men of
Madame Delpech" (165). He can be seen in the rue de Richelieu, the
rue Vivienne, the Place de la Bourse, but above all, "we shall find our
man, in the Passage de l'Opera, at the hour when the rehearsal com-
mences, and there, he sees passing, in every kind of dress, in satin
shoes, in slippers down at the heel, and even without any shoes at all,
the pretty little danseuses, to whom glory has not yet held out her
hand, filled with laces and cashmeres. Lounger! That word implies
everything" (*AP*, 166). But there was another arcade the lounger found
particularly to his taste and loved to frequent because of its congenial
atmosphere: "The Passage des Panoramas is his abode. There he is un-
der shelter, there he is at home, there he receives friends, and makes
his appointments, and there you are sure to meet him. And what finer
saloon can he have, than this Passage des Panoramas? where will you
find more numerous visitors, and more liberty? find prettier faces in
the morning, and more brilliant gas in the evening? Never was a saloon
more fitted with masterpieces, music, refreshment of every kind" (166).
Jules Janin was not the only writer to have spotted the flaneur as a

1. Jules Janin, *The American in Paris, or Heath's Picturesque Annual for 1843* (London:
Heath's, 1843), 164–165.

new city type. Victor Fournel, in *Ce qu'on voit dans les rues de Paris* (1858), also devoted a few pages to him and compared him to a passionate and mobile daguerrotype, sensitive not only to every trace, changing reflection, event, and movement of the city, but also to the spirit, antipathies, and admirations of the ever-present crowd. The flaneur was seen as a free spirit and the phenomenon of lounging, of being a flaneur, as so novel as not yet to have entered a dictionary. Fournel distinguished between the flaneur and the idler, thereby raising the flaneur to philosophical type: for the simple flaneur observes and reflects and is in possession of his own individuality. The idler, or *badaud* in French, on the contrary, tends to disappear into and allows himself to be absorbed by the world around him, the crowd, the city and its life which ravishes his personality, affecting him to the point of inebriation and ecstasy. "Under the influence of the spectacle the *badaud* becomes an impersonal being; he is no longer an individual, he is public, he is crowd."[2] The flaneur remained a conscious observer for whom the word *boredom* had become meaningless: he animated all he saw, admired all he perceived. He strolled, observed, watched, espied, and generally amused himself within these newly created spaces that would eventually transform art and letters: the *passages* and arcades of the age of Louis Philippe with their glass roofs and their shops filled with what were called *articles de Paris* or *articles de nouveauté* but that, today, are more likely to contain anything from antiques to kitsch, toys, gloves, canes, stamps, curios, books, old photos, post cards, visiting cards, cameras old and new, lead soldiers, lingerie, pipes and tobacco, masks, bonnets, oriental goods, and even pizza.

However, his observation of the phenomena of the city life was a double-edged sword, for he lost his innocence, alienated himself from the observed, turned into the outsider looking in. In a sense the flaneur might be seen as a prototype of Steppenwolf. He had turned

2. Victor Fournel, *Ce qu'on voit dans les rues de Paris* (Paris: Delahays, 1858), 263.

into the aesthetic observer, somewhat apart from the modern, industrial city in which the lines of demarcation between life and art, art and industry, beauty and mere fashion were becoming increasingly blurred.

In earlier days these had been the new shops of commodity and luxury capitalism, places of predilection for the flaneur as well as for the shopper; for shopping had at that time recently become a novel pleasure. Passing from one street to another, piercing entire blocks of buildings, they sheltered from inclement weather and the mud of still unpaved streets. Within the great city they were little cities, microcosms of human activity, taste, desires, temptations. Here the flaneur might come to get away from a meager garret and stroll at ease, entertained by the spectacle about him, which was free; here, too, he could play the chronicler and philosopher of the life of the city and its various and seemingly inexhaustible products, made known by the colorful advertisements called *affiches*. Here in the *passages* and the city the flaneur might escape boredom. For as Baudelaire, Constantin Guys, and also Gavarni pointed out, only a fool could find himself bored by the crowd: for it had become a continuous spectacle. Gavarni, returning from Paris to his room in Montmartre, wrote in his diary in 1828: "Each time I return from Paris I am convinced it yet remains to be discovered and I am tormented by the desire to try it. Every time I go there, at every step, I find so much; and as for the feelings I experience there in a day, I should need a year to express them."[3] This emphasis on the city's spectacle as a therapy for boredom is suggestive of a shift from Pascalian divertissement to modernity.

Pascal in the seventeenth century, the abbé Du Bos in the eighteenth, and later the architect Jacques François Blondel, had all argued that the arts were a noble way of avoiding and overcoming the all too human condition of ennui. Now if Benjamin is right in following

3. Edmond and Jules de Goncourt, *Gavarni* (Paris: Fasquelle, 1926), 37–38.

Paris and the Aesthetics of the Flaneur

Baudelaire and Guys in their opinion about the relation of the city and ennui, then it becomes possible to see in the city and its products, its commodities and luxuries, its articles de nouveautés and its shop windows, a way to construct a new aesthetics, closely linked to capitalism, built on the need to dissipate ennui. In this sense the flaneur is no longer the successor of the eighteenth-century spectator but, rather, of that age's *curieux* and collector. Only he is a new type of collector, interested not only in small works of art but also in the products of modern capitalism. His attention has shifted from the consecrated object of the collector and curieux to the products of the city, its spaces, types, sensations. Fashion and advertising became a redoubtable rival of art as more and more art was used to promote the products of luxury. Hairdressers and tailors used fashion plates in their windows; hairdressers and milliners used wax figures to show off their wares. "As for the wax busts I've contemplated so often through the windows of milliners and hairdressers," writes Fournel, "Pradier or Canova never turned more voluptuous contours, more rounded forms, or more irreproachable outlines."[4]

The flaneur could also note the ingenuity of the merchants' efforts to attract passing crowds. The *affiches*, printed advertisements usually on colored paper, were a new type of literature raised to an art by the eloquent use of typography and seductive vignettes, and appealing to the new fascination with color. As the seventeenth-century critic Roger de Piles had argued, a good picture really ought to stop a spectator in his tracks, so the new advertisements stopped the idler, the flaneur, the shopper in the street, attracting him or her to new products, awakening new desires, creating new necessities. Zola, in his novel *His Excellency Eugène Rougon*, describes in a long chapter the pomp and circumstance of an imperial procession advancing in magnificent costumes to Notre-Dame for an imperial baptism. But when it is all over

4. Fournel, *Ce qu'on voit*, 292.

Paris and the Aesthetics of the Flaneur

and the evening settles down upon the city, the last glimpse given of what is a magnificent Parisian impressionist tableau is that of a huge frock coat, a titanic advertisement floating in the misty evening near the tip of the Ile Saint-Louis. Zola's was a vision in which the new aesthetics put the old pomp and circumstance, the aesthetics of monarchy, revived by Napoleon, in true perspective.

Not all advertising was flamboyant; it could be discreet. The new luxuries, the articles de nouveauté (like works of art in museums today) could be expertly staged and exhibited in such a way as to attract the eye of the consumer. The attraction exercised by the shop as a scene appropriately decorated for and with certain products is brought out by Flaubert in his *Education sentimentale.* I allude to the shop of Alexandre Arnoux in the rue Montmartre, in an area still rich today with *passages* such as we discussed. His shop was precisely one of nouveautés, called, significantly, *A l'Art industriel*: "The high transparent glass offered the eye a clever display of statuettes, drawings, engravings, catalogues of *l'Art industriel*; the subscription rates were repeated on the door which was decorated, in its center, by the initials of the editor. Against the wall could be seen big pictures, brilliant with varnish, and in the back, two chests loaded with porcelains, bronzes, attractive curios; the chests were separated by a small staircase closed by a curtain at the top; an old Meissen hanging lamp, a green rug on the floor, and a marquetry table made of this interior more a salon than a boutique."[5]

The significance of Arnoux's boutique is revealed in part by its name, which suggests the union of art and industry (opposites to a Quatremère de Quincy); but its attraction lay in its resemblance to a private, bourgeois interior. Art and industry were united only in the title; the shop itself separated the two by looking like a living room. For the separation of art and industry lay at the heart of bourgeois aesthetics and would have important consequences. The arcades, like Ar-

5. Gustave Flaubert, *L'Education sentimentale* (Paris: Collection GF, 1969), 58.

Paris and the Aesthetics of the Flaneur

noux's boutique, were a mean between the street and the interior, public and private space, commerce and art. Arnoux's shop offered the bourgeois a look at his own interior, one that would most likely be strictly separated from his work place. It was at this time that the private interior came to be separated from the work place; in the course of the century the two would come to represent increasingly distinct, almost antagonistic spheres. It was a separation great with consequences for art and attitudes toward the arts. For much as religion in a highly secular society came to be reserved for Sunday, so the arts in bourgeois society came to be the pretext of special occasions, special spaces, a special experience, and a life divorced from work. Art came to be reserved for the private domain, the intimate interior, the private world of the bourgeois, so that it came to be associated with an imaginary universe at variance and sometimes in conflict with the public world, values, and activities of the bourgeois. Hardheaded in business, the bourgeois might be softheaded in art. The bourgeois interior, in contrast to the spaces in which others worked for him, became the space of private fantasies. Here, as Benjamin put it, he gathered objects from remote places and the past to create the space of his dreams and secret longings; here, too, his psyche betrayed itself through the objects he gathered.

As Arnoux's shop was the model of a potential interior, so real salons, interiors, and houses were later described, photographed, and published as models for those who wished to create a "house beautiful,"—which, as Lewis Mumford found in *The Brown Decades* (1931), was often confused with a house filled with bric-a-brac. Earl Shinn, alias Edward Strahan, published the art objects that made up the "nineteenth-century clutter" of the Vanderbilt mansion in a ten-volume limited luxury edition.[6] Despite its colossal size and expense, the house of Mr. Vanderbilt was still referred to as a "home," implying

6. See Jan Cohn, *The Palace and the Poor House: The American House as Cultural Symbol* (Lansing, Mich.: Michigan State University Press, 1979), 119.

Paris and the Aesthetics of the Flaneur

privacy, intimacy, rather than a palace, which was always somewhat public. The house expressed Mr. Vanderbilt's personal needs, in contrast to the public need for display of the old nobility. The public Mr. Vanderbilt represented industry, power, wealth, ruthlessness; but the private Mr. Vanderbilt needed art as only a nineteenth-century bourgeois could need it—as only a glutton can require food—quantitatively.

The bourgeois dreaming within his private interior cluttered with objects from distant places and distant pasts may be likened to a part-time flaneur come to rest following innumerable occasions on which he could not resist the desires offered by the new world of the city, commodity capitalism, and boutiques. As a city type, an aesthetic observer, the flaneur did not die out until the predominance of the automobile on city streets. His connection with the arcades of the city and his fascination with luxury commodities ended once the space of the arcades was superseded. The flaneur disappeared into the labyrinth of the new department stores and was soon lost in a crowd of new aesthetic consumers—women.

Enter Woman: The Department Store as Cultural Space

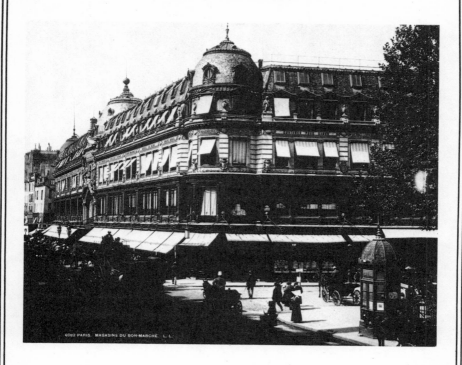

The Bon Marché. Photograph by L. L. Roger-Viollet.

Give the Lady What She Wants.
Marshall Field

When the flaneur wandered into the new department stores he did not have to enter as a consumer. He went through the doors as freely as he had entered the *passages* from the streets. He was free to look, free to touch, free to allow himself to be seduced, open to desire for . . . things. The commodities and luxuries existed to be gazed at, were exhibited to attract, stimulated and induced a state of desire that transcended need. What distinguished the new department stores from the old shops and boutiques was precisely their invitation to desire. Whereas Arnoux's shop in the Rue Montmartre was attractive, the department stores were veritable magnets, for you could enter without having to buy.

The first department store, the Bon Marché, was founded in 1852 by Aristide Boucicaut; however, it was not until 1869 that Boucicaut expanded it by building the grand building that still stands on the Rue Babylone and that Michael Miller, in his study of the store from 1869 to 1920, sees as an embodiment or central institution of what he calls bourgeois culture. The Bon Marché's originality as a business venture lay in its small mark-up of price, compensated for by a high volume of sales and a rapid stock run. The merchandise was sold at fixed prices, whereas the old shops and boutiques, which you entered only as a consumer, never as a flaneur, charged what the buyer could bear or what he or she was willing to haggle over. Fixed prices were a democratic feature, as was free entry into the store. Anyone could enter, look about, and leave without having to purchase anything. And another innovation: Boucicaut allowed returns and exchanges for items bought in his store. Something simple and common today, but genial at the time; that, too, gave desire free rein, for it was no longer limited

The Department Store as Cultural Space

by the article bought and unreturnable. If you could return the article you could also indulge another desire if the initial item no longer satisfied. There was no longer any regret following the satisfied desire.

The Bon Marché inspired others to follow suit and the second half of the nineteenth century became an age of great department stores: Chauchard and Heriot founded the Magasin du Louvre in 1855; Jalazet the Printemps in 1865; Cognacq the Samaritaine in 1869, the same year Boucicaut and his wife were expanding theirs. There were parallel developments in the United States: Stewart's of New York, later absorbed by Wanamaker's of Philadelphia; Marshall Field in Chicago; Lord and Taylor's and Macy's in New York. The efficiency of department stores was soon increased in the United States: the first lift was introduced by Strawbridge and Clothier's of Philadelphia in 1865; Macy's and Wanamaker's were using electric lighting by 1878 and the first electric lifts in the 1880s. Jordan Marsh introduced the telephone into his store in 1876, Marshall Field the pneumatic tube system in 1893, and the cash register came into use in the course of the 1880s. But these stores also necessitated a new architecture: new construction materials such as iron and steel, reinforced concrete, and the vast use of glass all made for grander spaces and more light, while lifts allowed the construction of higher and higher buildings. Capitalism had found its palace.

The crowd and passages that had lured the flaneur out of his garret now drew him into the department stores, which, as Benjamin put it, put him to use for commodity circulation. But Benjamin, following his flaneur into the department stores that marked the end of the *passages*, had thought of these stores as a vast marketplace, which they surely were; yet he seemingly missed the true intent or direction of these new institutions, namely, their appeal to women.

As Zola saw it, they aimed to victimize women, or, as we might say, to exploit them. But there is another way of looking at this novel phenomenon of women and department stores. Instead of exploitation, one might speak of a certain education of women, if not, indeed, the

The Department Store as Cultural Space

creation of what came to be called "the new woman." In an essay on *Les Grands Magasins* of 1927, J. Valmy-Baisse insisted that the stores had been created for woman, first to embellish her through toilette and adornment, and then to ornament her home. In this way the stores evolved from mere merchandising novelties into centers where one might learn interior decoration; later, they turned into restaurants, even art galleries, educating the palate as well as the eye.

This claim is less exaggerated than might appear at first. One need only follow Dreiser's Sister Carrie to see how this education worked: Sister Carrie rises from one experience of luxury to another as she moves from Chicago to New York, and Dreiser as well as Zola understood how the stores affected the feminine soul. Looking for work in Chicago Sister Carrie enters a department store called the Fair:

> Carrie passed along the busy aisles, much affected by the re-
> markable displays of trinkets, dress goods, shoes, stationery,
> jewelry. Each separate counter was a show place of dazzling in-
> terest and attraction. She could not help feeling the claim of
> each trinket and valuable upon her personality and yet she did
> not stop. There was nothing there which she could not have
> used—nothing which she did not long to own. The dainty slip-
> pers and stockings, the delicately frilled shirts and petticoats,
> the laces, ribbons, hair-combs, purses, all touched her with indi-
> vidual desire.[1]

Having no money to spend, poor Carrie hurried through the store. But later she visited it again, this time with twenty dollars to spend, and Dreiser in effect describes a type of aesthetic experience hardly touched upon or imagined by the classical philosophers of the aesthetic experience:

1. Theodore Dreiser, *Sister Carrie* (Baltimore, Md.: Penguin Books, 1981), 22.

There is nothing in this world more delightful than that middle state in which we mentally balance at times, possessed of the means, lured by desire and deterred by conscience or want of decision. When Carrie began wandering around the store amid the fine displays, she was in this mood. Her original experience in this same place had given her a high opinion of its merits. Now she paused at each individual bit of finery, where she before had hurried on. Her woman's heart was warm with desire of them. How would she look in this, how charming that would make her. (67)

Carrie, indeed, in Zola's terms, is a perfect victim of the department stores. She instinctively understands their language, which is that of clothes:

Fine clothes were to her a vast persuasion; they spoke tenderly and Jesuitically for themselves. When she came within earshot of their pleading, desire in her bent a willing ear. . . . "My dear," said the lace collar she secured from Partridge's, "I fit you beautifully; don't give me up." "Ah, such little feet," said the leather of the soft new shoes, "how effectively I cover them; what a pity they should ever want my aid." (98)

Unwittingly Carrie was taking lessons from the new stores and their creation, the new woman. And in her relation to the department store, Carrie, as any other woman, was the same in Chicago, New York, or Paris. Yet it was in Chicago that social conditions, economics, and Marshall Field had created what came to be known as the new woman, member of the social set, later of the Junior Council, and part of the new elite that in the United States would set the fashions and moral values for other women. The new woman's husband was in business, usually doing well, and she, accompanied or not, would make a pil-

grimage to Europe, coming back loaded with new dresses and other luxuries as well as with talk of the splendors of Paris and the aesthetic movement in London. On Chicago's Michigan Avenue, or New York's Fifth, or in her Newport summer residence the new woman might have lived in an interior that we would probably find rather cluttered and garish. But she knew that she aspired to taste, art, refinement, and what was generally referred to as art's elevating influence. In Europe this elevating influence was usually called the ideal and was associated with art and noble sentiments, but not department stores. Yet it is undeniable that in the aesthetic education of women, in the formation of her interior, in the creation of the new woman, and even in this aspiration for the ideal, the department stores played a very important role. Historically speaking, they preceded the museums that the new woman would eventually join as a member of the Junior Council, as a patron, or even as a member of the education department.

Yet supporter of the arts was not the new woman's only role. For if we are to believe Schopenhauer, who thought women looked on men as the earners of the money they would spend, within the new woman was the old Eve, cause of man's fall. In the nineteenth century this meant women devoured luxuries, ruined man as a demimondaine, and drove him sick in his money making, only to fall victim herself to the shiny capitalist apples seen in shops and department stores. Sister Carrie quite innocently ruined Hurstwood—innocently because she was unaware of the evil involved in her rise to a life of luxury and success. But Hurstwood himself was a victim of the same belief in material success since he assumed man had to heap trinkets upon women.

In *Au Bonheur des Dames*, Zola likens the department store to a cathedral of modern commerce dedicated to woman. To use Henry Adams's famous historical metaphor, the Virgin of Chartres had turned into the new woman and the dynamo into a department store. In Adams's view the power of the dynamo had displaced that of the Virgin over men's imagination. In Zola's world, the dynamic department

The Department Store as Cultural Space

store devours woman. The Bonheur des Dames, Mouret's store, is not only a cathedral but a machine into which woman is attracted and seduced. It is worth noting that this view has an eighteenth-century precedent in the doctrine of *architecture parlante*. A tale by Bastide, called *La Petite Maison*, tells of the seduction of a woman by the architecture of the house, its decor, its sensuous effects, its very luxury. Zola's brilliant interpretation of the department store improves upon this phenomenon by altering the scale of the seduction: the intimate seduction of the rococo is turned into the mass seduction of a crowd of women rendered frantic by a new type of artist, neither the architect of *architecture parlante* nor the *grand couturier*, but the genius of advertising and display.

The Bonheur des Dames, like its prototype the Bon Marché—and, as we shall see, Wanamaker's in Philadelphia—was an architectural marvel: stone for the base, brick and iron for the rest of the structure, thus creating an effect of light and spaciousness. Mouret's expanded store included two lifts, a buffet, a reading room, and an art gallery. Owner and manager of the store, Mouret was an advertising genius who offered the women free drinks and free balloons for the children. There were also catalogues, posters, and advertisements in the papers. The Bon Marché issued some 200,000 catalogues of which 50,000 were sent abroad. Mouret was a brilliant psychologist who claimed that woman could not resist a sale or publicity and that she tended naturally to be attracted by noise. To overcome whatever resistance she still possessed, he invented returns and lowered prices. He also exploited the aesthetic effect of displays on his customers, much as the eighteenth-century architects of expressive architecture had argued that forms, masses, the play of light and dark affected the soul. Thus for one special sale he created a fairylandlike effect, an atmosphere of spring by the profuse use of colored umbrellas, and light, colored fabrics floating in the air. Obviously these special effects had their origin in the the-

The Department Store as Cultural Space

ater: the stage was no longer fixed to the theater and its special space; theater was made to enter the department store and daily life. The aesthetic experience was generalized and democratized.

As advertising was a species of new literature, so the display of consumer goods and commodities was a new type of staging. But the entire machine of the store—the architecture, special displays, special sales and events—was directed to one end: the seduction of woman. It was the modern devil tempting the modern Eve. As in the original fall, in this modern version, it was man again who would be made to pay for the apple. *Mon Dieu que les hommes sont bêtes* went one of Offenbach's songs, sung by a woman. In Zola's words:

> It was woman the department stores fought over for their business, woman they continually entrapped by their bargains, after having made them dizzy by their displays. They had awakened in her flesh new desires and had become an immense temptation to which they fatally succumbed, yielding first to the purchases of a good and careful housewife, then won over by coquetry, finally devoured. By increasing sales, by democratizing luxury, the stores became a terrible agency of spending, creating havoc in homes, working up women to the madness of fashion which was ever dearer and dearer.[2]

There is no mystery to this seduction. Shopping was integral to the identity of the new woman. Shopping was liberation. As Elizabeth Cady Stanton had told women, "go out and buy." But it was also an effect of woman's new situation in society. For the first time in history the women of the bourgeoisie found themselves free and with leisure time, whereas formerly they had tended to stay at home and partici-

2. Emile Zola, *Au Bonheur des dames* (Paris: Charpentier, 1883), 83.

The Department Store as Cultural Space

pate in the economic life of the household. The capital accumulation of the nineteenth century made it possible for women of this class to enjoy a certain leisure, leave their interiors, and lead a form of aristocratic life modeled on that of the old nobility. The men worked to assure the women the possibility of conspicuous consumption. This contrast of occupations between men and women was manifest even in their dress: the masculine fashions remained sober, economic, puritan even, while the feminine costume or dress was allowed to be courtly, that is, colorful, luxurious, flowing, impractical, expensive, decorative. Women set the fashion rather than the men as had been the case in the old courtly society.

This empire over fashion extended beyond dress to include interior decorating. Here, too, woman displaced the former creators of fashion and style, namely, the architects. As the sociologist René König has pointed out, this had important consequences: it meant the appearance of the first truly bourgeois style in interior decoration.

> On the one hand this style remained tributary to the feudal period, as witness the cheap horrors spread by industry and called Louis XV, Louis XVI, or Empire (stiff little chairs with fragile legs, and heavy chimney pieces). But on the other hand one must recognize that woman created the conditions of an "intimate" style of interior decor, precisely a typical modern bourgeois idea which neither the petite bourgeoisie of the seventeenth or the eighteenth century knew, while the great bourgeois of the time, when they imagined a characteristic style, only bothered with ceremonial rooms and not with the intimate interior, intimacy being a nineteenth century discovery.[3]

It was in the intimacy of her interior that woman put all those things

3. René König, *Sociologie de la mode* (Paris: Payot, 1969), 136.

The Department Store as Cultural Space

she bought, the accumulation of which Edith Wharton, according to her biographer R. W. B. Lewis, defined as the result of the "voluptuousness of acquiring things one might do without."[4]

Although engaged in commodity circulation and the exploitation or education of women, the department stores also saw themselves as cultural agencies responsible for educating taste. Successful, on the whole, in this role, they became the rivals of a complementary nineteenth-century cultural space, the art museum. And their cultural role was such that it eventually blurred the distinction between an attractive consumer object sold in a department store or in a boutique, and the objet d'art, which might or might not be in a museum. The department store also turned the male flaneur into a consumer by attracting him with their gentlemen's line of goods; though women were undeniably their most important and most numerous customers. But both the flaneur and the woman shopper were moved by the same desire for and attraction to things and pleasure. The modern aesthetic experience arose out of desire as the classic aesthetic experience had supposedly been founded on its lack, defined as disinterestedness. The flaneur might escape the lure of consumer goods merely by stepping from the Magasin du Louvre into the Musée du Louvre, to stroll, gaze, and lounge. Yet even there he might be attracted by objects— objects beyond his desire only because they could not be purchased. Outside the museum, or before entering it, these objects of art were, like objects in the department store, also objects of desire, even though philosophers might have defined them as beyond desire. But they were a special—because unique—type of consumer item. What differentiated them is that their value was always said to be beyond price. It was a subtle distinction but quite false, and it would hardly save art from commerce in a world in which department stores were as palatial as museums.

4. R. W. B. Lewis, *Edith Wharton: A Biography* (New York: Harper and Row, 1975), 374.

The Department Store as Cultural Space

The parallel between museums and department stores ought not be overlooked. Like museums, department stores were spacious and often palatial, and, like museums, they were divided into departments. Both institutions exhibited their wares, though in the case of the stores, the wares were for sale and were not unique but mass produced. There were other contrasts of course. The wares in the museum had reached the end point of an itinerary through space and historical time; the wares in the department stores were arranged as if on a line of departure. In a sense the department store was an anti-museum of modern, productive, dynamic capitalist production in which objets d'art were but one possible line of goods; an almost infinite possibility of commodity circulation existed since this was based on desire, which by definition of human nature knew no bounds. In the museum art was the only line of goods exhibited. It was singled out, distinguished from other items, and thus lent a special aura that was increased by its inaccessibility and its historical pedigree. But in the realm of commerce the label would soon rival this pedigree of time in the battle between the moderns and the ancients. Although the differences between art and commerce, objet d'art and consumer objects, were stressed on the social, aesthetic, and theoretical level, the similarities, among the structures, space, and methods of exhibiting objects in museum and department store remained striking. And as the nineteenth century gave way to the twentieth, the similarities increased: more and more items were declared works of art and entered museums so that an entire department store could easily have been turned into a museum by simply freezing its operations and letting it exist as a monument of a particular moment of our civilization. (That moment seems almost to have passed as we move closer to electronic or computerized long-distance purchasing.) In fact, the true museum of the nineteenth century might well be a department store rather than a specialized exhibition space reserved for nineteenth-century painting and sculpture.

The Department Store as Cultural Space

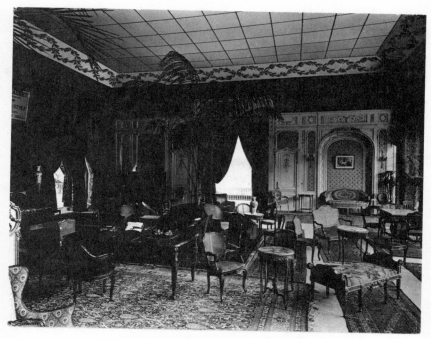

Furniture department at the Bon Marché.
Photograph by N. D. Roger-Viollet.

The department stores were very much aware of their cultural importance and mission. They pioneered methods of art education that would later be undertaken by museums in the United States, though whereas the stores sold works of art, the museums exhibited them and taught art appreciation. But stores did form taste. Marshall Field in Chicago "set diligently to educate western taste—his conception of a merchant's task. . . . If the American woman yearned to imitate the wealthy classes of Europe and the society leaders of the Eastern cities,

The Department Store as Cultural Space

she would be indulged with important originals or, where necessary, with factory 'modifications' of European styles."[5]

Wanamaker's, in its Philadelphia and New York stores, was even more intent upon its cultural mission. Indeed, Wanamaker's and other such stores probably did more to give the public a sense of "art," however it may have been understood or misunderstood, than art schools, academies, or museums if only because they reached a greater public. Wanamaker's had a clearly defined "philosophy of art":

> It is not only the person whose soul sings through his lips, or who puts his thought on canvas with a brush, who is an artist. The vehicle of expression does not matter. It is the spirit that counts. The woman who arranges a room charmingly, who dresses to express her personality, or serves dinner with grace; the man who binds a book in good taste, or turns out a chair that is a pleasure, or lays out a garden to give delight—all are artists in their way. So too is the store that lives up to its highest ideals.[6]

This philosophy was also exemplified in the very building of the store. As Wanamaker told his architect:

> What you must do for me . . . is to strive to say in stone what this business has said to the world in deed. You must make a building that is solid and true. It shall be of granite and of steel throughout. It shall stand four-square to the city—simple, unpretentious, noble, classic—a work of art, and, humanly speaking, a monument for all time. . . . And who shall say that just to

5. Lloyd Wendt and Herman Kogan, *Give the Lady What She Wants: The Story of Marshall Field and Company* (New York: Rand McNally, 1952), 155.

6. John Wanamaker Firm, *The Golden Book of the Wanamaker Stores* (Jubilee Year, 1861–1911), 245–246.

The Department Store as Cultural Space

live in its shadow and to pass daily through its great Corinthian pillars is not turning the minds of thousands of men and women toward a larger appreciation of the fitness and nobleness and sincerity of art? (246–247)

Mr. Wanamaker spoke a language no different from that of a Ledoux and the architecture parlante of the Enlightenment period: the building must express the meaning of its purpose and it must educate mankind. Wanamaker's, like a museum, was a palace of art—not that of the past so much as that of the progressive, democratic nineteenth century, an age that was very conscious of the history of art. The interior was also reminiscent of nineteenth-century museums. There was a large auditorium capable of seating 1,400 people that was designed in the Egyptian style, complete with sphinxes, frescoes, and reliefs. Around this auditorium there were various smaller halls of various styles: a Greek room, a Byzantine chamber, a Moorish room, an empire salon, as well as Louis XIII and Louis XIV suites, plus art nouveau rooms, all "perfect types of their respective styles" (243). In addition to these period rooms, the store had what any palace had, a grand court of honor flanked with fine marble columns and panels; it also had what few if any palaces had, an organ. It stood to reason that such a fine store sold the best merchandise: "The results of this (artistic endeavor) are felt in the artistic assemblage and display of the fine kind of merchandise brought from foreign parts, and its distribution into thousands of American homes, to the betterment of taste, and refinement in appreciation of the beautiful" (248).

But Wanamaker's art education was not limited to the expressive architecture of the building and quality of the merchandise sold. It also purchased and sold works of art. Paintings from the Paris salons were bought and exhibited in their Philadelphia and New York galleries:

There is probably no other store in the world that has gone into the Paris salons and purchased the pictures best worth having

to decorate its walls. It is largely these paintings and this kind of artistic exhibition, open to all for the coming, that have helped to convert the Wanamaker stores into vast public museums, quickening the interest of thousands of visitors, and reaching a larger number than many museums owned and controlled by the city and the state. (249)

From 1892 through 1903 Wanamaker's bought 250 paintings from the salons, "so comprehensive in subject and characteristic of contemporary French painting as to be of unquestionably great educational value to American art students, as well as a source of true pleasure to the thousands who came to see them" (250). And in 1903 the store bought 300 paintings, practically the entire stock of the studio of one Vacslav Brozik who died in Paris in 1901, a historical painter described as the equal of the greatest. Old masters at these exhibitions were represented by copies: there was a bronze cast of the Venus de Milo, a copy of Atalanta and Hippomenes at the north and south ends of the grand court, colossal Roman eagles, and a statue of Joan of Arc. The mural decorations for the New York store auditorium had been done by Frederick X. Frieseke of the Société Nationale des Beaux-Arts, while H. O. Tanner produced biblical pictures, and Anna Estelle Rice did "a large group of mural decorations, reminiscent of the days of Louis XVI, which are destined when completed, for the wall panels above the elevators in the new Philadelphia Wanamaker Stores" (254). But art was not only used to decorate the stores and educate the public, it was also applied to advertisement pages. The store also organized painting and drawing exhibitions for children and art students.

This ambitious program for educating and forming public taste was also carried on in the New York stores once Stewart's had been absorbed by Wanamaker's. A new store was built next to the old Stewart's and the two buildings were joined by a Venetian-style bridge called, appropriately, the bridge of progress. There were in fact three stores in

this complex of buildings: women's wear; men's and boys' wear; and furnishings and decoration. The new building was composed of a series of galleries that acted as a teaching museum since it included the House Palatial of twenty-two rooms and a summer garden. Wanamaker's galleries of furnishings and decoration thus comprised forty-four furnished period rooms "representing various periods, to enable architects and homemakers to study and select proper furniture and home adornments, and to enable them to individualize their homes from the mere commercial furnishing way" (295). When the new galleries and the House Palatial opened there were more than seventy thousand visitors on the first day alone. The House Palatial was meant to be a model "representing the home of a family of taste and wealth; the best of its type that can be seen in Fifth Avenue, of Hyde Park, London." Its cost, including the furnishings, amounted to $250,000, which may seem extravagant, but it was considered "as an educational feature that will enable houseowners and architects to judge decorative schemes and furnishings, . . . without parallel in the world" (296).

If one may claim that in the course of European history up to the nineteenth century the church, the palace, and the villa or town house determined the nature of art, then in the bourgeois era, the department store and the museum played similar roles, defining the nature and status of art. Their rivalry is superficial. The difference is that in the first, art is part of commerce and in the other, not for sale. The two spaces in fact correspond to the internal contradictions of bourgeois aesthetics which are founded on idealism in a world that in its daily business is anything but ideal. The opposition is that of idealism, associated with high art, spiritual art, intellectual and moral art, to the power, dynamism, and materialism of capitalism and its products. The solution to this internal contradiction was not that advocated by a Quatremère de Quincy who would ensure the survival of high art by placing it in the hothouse; neither did the moralism of Ruskin or the

The Department Store as Cultural Space

idealism of James Jackson Jarves and others who made a cult of art offer any answers. More likely the truth lay with Wanamaker's. In France the opposition between the ideal and the materialism of contemporary civilization took the form of an institutional opposition between art as represented by the Beaux-Arts tradition, doctrine, and methods of teaching, and the works of art produced for the market, the salons, the various deviations from the ideal. It was an opposition much like that between religion and secular snares. The world was represented by money, luxury, Parisian articles, the attractions of the market, a modern art for modern times, and the salons des refusés, officialdom's concession to artists working outside the canons of the Ecole des Beaux-Arts. The power of the modern thus made for an ever wider gap between official doctrine and practical realities.

In the United States the opposition between the museum and the department store took a different form since, as we have seen, the department store—like museums and like theorists of the arts—believed in art and insisted on educating the public. The museum, the department stores, the publicists, the moralists, and the reverends were agreed on the value of art. Indeed, there was no opposition; for Americans, after the Civil War, had come to be convinced that art and culture—"Kulcher" as Ezra Pound would later put it—were a good thing. The only debatable question was which art and which culture was best for Americans. The symbolic opposition of department store and museum that I have used metaphorically to explain the internal contradictions of bourgeois aesthetics took an entirely different form in the United States, one between aestheticism and vulgarity. The ideal was associated with a definite type of art, much as in Europe, but it was opposed not so much to luxury as to the world of commerce, money, materialism, and progress, even democracy. In France the opposition between the conservatives of the Institut and the Ecole des Beaux-Arts, and the promoters of the art of the modern world, called materialists or positivists (the realists and impressionists, for example),

The Department Store as Cultural Space

was ultimately an opposition within the world of art, the issue being the relation of art to the modern world. But in the United States the champions of art were aesthetes at odds with their own country and who fled to Europe on the erroneous assumption that true art, true culture, and true taste could only be found there. If in Europe the idealists were conservative intellectuals, in the United States they were sentimental aesthetes.

But the museum and the department store, used here metaphorically to explore the nature of bourgeois aesthetics, are also typical of the bourgeois's way of apprehending and understanding art. Not only is he an idealist in his views of high art, but he is also a materialist at the same time. The idealist in the bourgeois would deny his materialism, but this is not a difficult task since the bourgeois world depends on the strict separation of the moral and the business world. As an idealist the bourgeois loves art, speaks of it in the loftiest terms, writes long treatises on aesthetics, develops the history of art, introduces the study of art in universities, endows museums and collections, and, finally, even if he owns a department store, thinks of educating the public in the realm of art and interior decoration. But as a materialist the bourgeois, through his spouse, produces a cluttered private interior and ultimately thinks of art objects as so many items to be collected and exhibited, even bought and sold if need be. And so the bourgeois as idealist flaneur and the woman on a shopping spree, converges to alter radically the nature and status of the art object. What the nineteenth century succeeded in doing through the museum, the boutiques, and the department stores, was to bibelotize art. In this generalized bibelotization woman played a role as significant as that potential consumer, the flaneur; for in an age in which art was a species of new religion, woman, as in the old religion, was also the temptress, and the bibelot her apple.

F · O · U · R

Woman, Desire, and
the Bibelot

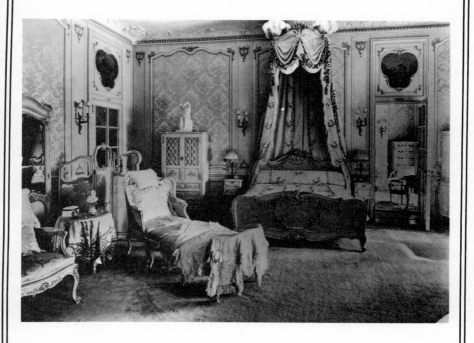

Bedroom, 1905. Photograph by Byron. The Byron Collection.
Museum of the City of New York.

Everyone wants to have a mistress,
as everyone wants to go hunting,
frequent watering places and go to the beaches,
and be seen at theatre premieres.

Maxime du Camp,
Paris, ses organes, ses fonctions et sa vie dans
la seconde moitié du XIXe Siècle.

The role of woman in the subtle transformation of the status of and attitudes toward the work of art in the nineteenth century may be followed on several levels: the work of art, which the academy in the eighteenth and nineteenth century strictly separated from the luxury item, becomes a luxury item. It also becomes a "collectible," an apt if inelegant term sometimes used by antique dealers. Finally, the work of art functions as an object within an intimate interior space inseparable from woman herself. These aspects converge to form that phenomenon of the age, the ubiquity of the bibelot, attribute of the feminine, so much so that women and luxury are part of the same general phenomenon of bibelotization. Woman herself turns into a most expensive bibelot and yet is, at the same time, a voracious consumer of luxury and accumulator of bibelots. It is this interrelatedness of woman and luxury that further explains her link not only to the bibelot itself, but also to the department store and, even before these enterprises were created, to that fascinating and ambiguous zone of the bourgeois style of life and psyche, the demimonde.

Alexandre Dumas the younger's novel, *La Dame aux camélias*, begins with the narrator, a veritable flaneur, out strolling in Paris; he notices the announcement of an estate sale, *vente après décès*, for March 16, 1847, to be held at 9 rue d'Antin. The address, let us note in passing, is

Woman, Desire, and the Bibelot

not insignificant, nor for that matter is the date. It is the time of Louis Philippe, of the *passages* that fascinated the flaneurs, and the address is located in a quarter not far from such arcades or from the new apartments designed as the bourgeois equivalents of the old noble apartments that were formerly the attributes of the *hôtels particuliers*. The narrator, being not only a man of leisure but also an *amateur de curiosité*, did not fail to go to the sale at the appointed time. Once there, he immediately noticed that the apartment was already filled both with men and with women who, though dressed in velvet and cashmere, looked with astonishment but also admiration, at the luxury spread out before them. He later understood the women's reactions when he realized the apartment in question was that of a demimondaine, a kept woman. The rosewood furniture of the apartment was superb; there were pieces by Boulle, Sèvres and Saxe porcelains and statuettes, as well as fine Chinese porcelain, velvets, and laces; nothing was missing from what constituted the luxury and bibelots of the time.

In the preface of his novel, which is based on a real character, Dumas, by way of an object (an eighteenth-century ormolu clock), established a link between Marie Duplessis, *la dame aux camélias*, and the Pompadour as well as Madame Du Barry. Thus both the bibelot and woman as luxury items had their precedents in the Paris of Louis XV and Louis XVI, what with the production of fine furniture, Sèvres figurines, terra-cottas by Clodion, magnificent jewelry, snuff boxes, and other such small but finely executed and expensive luxury items. The demimonde in the eighteenth century did not exist in the manner of the nineteenth, but it was there on a restricted scale, in the form of an imitation court of women recruited from the theater and the opera, a class of professionals not only of music and acting, but of what Stendhal might have described as *amour-goût*. In the nineteenth century the possession and flouting of mistresses and courtesans was one way the successful bourgeois sought to appear noble, aristocratic, worldly,

Woman, Desire, and the Bibelot

dashing even, and at the same time show off his success. Thus, woman as well as what she wore and purchased or received as gifts, was an item of conspicuous consumption supposing a lavish scale. Marguerite, Dumas's "heroine" tells young Armand, who has foolishly fallen in love with her, that if she were his mistress, she would cost him 100,000 francs a year, which, for 1840, was a very considerable sum indeed. Luxury was thus linked to sexuality, as was buying, as we shall see; and hence haute prostitution was not only a grand luxury but also a commercial enterprise. The men were considered as possible investments for the women: they were carefully looked over and their incomes were investigated before being accepted.

The demimonde, like the real world, and like the financial world centered about the stock exchange, had a specific setting and a specific ritual. The rue d'Antin was one indication as to setting, but there were other ritual practices: the daily appearance, in a carriage, on the Champs Elysées, the ride in the Bois de Boulogne, and of course the loge in the theater or the opera. It was in these places that the demimondaine made her appearance: object of desire, object of luxury, actress in the ritual of the demimonde, but also actress in the market place; for all these places in which she appeared, exhibiting herself to advantages just as articles de Paris were shown to advantage in the boutiques, were in a sense her bourse.

The link between royal mistresses such as the Pompadour, the Du Barry, and the Marguerite of Dumas, not to mention the real high courtesans of the time, implies that a certain type of noble life was continued by the demimonde. Indeed this demimonde of luxury, women, gambling, theater, riding, dining and wining, represented for the bourgeois the noble life of the aristocracy he tried to imitate. It represented, also, considerable expense. As Prudence, Marguerite's friend, explains to Armand: "How do you expect the kept women of Paris to maintain their style of life (*le train qu'elles mènent*), without having three or four lovers at the same time? No single fortune, no

Woman, Desire, and the Bibelot

matter how considerable, could alone meet the expenses of a woman like Marguerite. All in all, with 500,000 francs a year, a man can give a woman no more than forty or fifty thousand, and that is a lot. And so other loves make up the sums necessary for the other expenses of the woman. All these young people with twenty or thirty thousand a year, hardly enough to live in the milieux they frequent, know very well that when they are the lovers of a woman like Marguerite, she couldn't even pay her apartment and servants with what they give her." [1]

But whatever was given, it hardly ever sufficed, for the women of the demimonde were like a torrent of cash flow. Only the wise put aside for a rainy day by investing or purchasing property. Marguerite herself not only died young but also in debt, even though she knew how to choose her lovers. Doctor Lucien-Graux, in his book on those bills of hers that she kept and that turned up at her sale and survived to become collectors' items, examined her spending in some detail for the years 1840–1847. They covered a variety of items: bibelots, antique furniture, restaurants, stable fees and bills, flowers, medicine, sheets and draperies, dresses, boots, gloves, hairdresser fees, jewelry, wood, coal, food, picture frames, books, music, glassware for the table, porcelain, wages, and miscellany. The use of horses and carriages proved particularly expensive, as did the apartment she occupied, which cost 3,200 francs a year. And while some items, such as gloves, were inexpensive in those days of cheap labor, she would buy them by the dozen or the half-dozen so that she would have a new pair each day. And hats, too, in the end amounted to quite a sum when a new one was purchased every five days over a period of seventy-five days, fifteen hats in all at 486 francs. Marguerite admitted to spending about 500 francs a day and was consequently haunted by her creditors, ever on the point of having her property seized. She prepared for that eventuality by hid-

1. Alexandre Dumas, *fils, La Dame aux camélias* (Paris: Nelson ed., Calmann-Lévy, n.d.), 141–142.

ing jewels, bibelots, and precious items in two other apartments. At times she would spend 1,000 francs a day and wear a 100,000-franc gown to a ball.

When it was suggested to her she ought to invest her money for a future income, she explained why she could not: "An income with the product of my luxury? In this case [i.e., selling her jewelry and buying bonds], an income is ruin, unless you enjoy it in solitude. You sell your horses and your carriage. You occupy a modest apartment, you reduce personal expenses to a minimum, and, next day, all your adorers have disappeared. They do not, alas, seek out our qualities. On the contrary, it is our faults, our extravagance. They are attracted by our luxury, as the light draws the moth. To renounce luxury would be to surrender and give ourselves for nothing. But by the sumptuous toilettes, jewels and horses, we are assured to conquer all those who seek adventure, all the categories of the debauched, and principally those blasé old men who need a refined luxury." It is an excellent description of a baroque spending mentality that is based on the coincidence of appearance and reality. But Maxime du Camp in his book on Paris saw these demimondaines and their function in a somewhat different light, as the distributors of capital, a drainage system for capital that would otherwise remain fixed and unused, unfructifying. Essentially the demimondaines, with their vulgar display of riches, were active agents of the general vulgarization of luxury in the nineteenth century.

Marguerite and her colleagues knew very well that all the money spent on them and others of the demimonde was not spent for them but for the men: "egotistical lovers who spend their fortunes not for us, as they claim, but for their vanity. . . . We do not belong to ourselves, we are no longer beings, but things" (166–167). Hyppolite Taine's character, Thomas Graindorge, a retired businessman who, having made his fortune, has turned into an observer of the Paris scene and a literary flaneur, makes the same remark regarding the women of the Paris he sees in the drawing rooms he frequents: "The men watch, leaning

Woman, Desire, and the Bibelot

against the door jambs; gaping, as at a bazaar. Indeed it is an exhibition of ruffles, diamonds, and shoulders."[2]

To Graindorge woman also appears as a luxury item manifesting itself, or herself, through her dress and jewelry. Dress was perhaps even more important than jewelry; for just as a diamond had to be cut and mounted to advantage, so woman as a luxury item had to be dressed advantageously. Dress acted in a sense as the setting to the diamond, the frame to the picture. Both gown and woman were turned into an object of beauty by the new artist of the nineteenth century, the *grand couturier*: "That little dry creature, dark, nervous, looking like some roasted abortion, received them (the women) in a velvet morning coat, proudly spread out on a divan, a cigar in his mouth, ordering them to 'Walk, turn 'round; good, come back in a week, I'll compose the toilette befitting you'" (*TG*, 144).

Ludovic Halévy's delightful short story, "La Plus Belle," published in 1892, provides an accurate illustration of Graindorge's views of women in the society of the nineteenth-century's real monde. Prince Agénor de Nérins, man about town, constantly mentioned in the gossip columns of the papers, and taste maker in the world of fashion, discovers a woman at the opera he has never seen before and pronounces her to be the most beautiful woman in Paris. The prince is overheard by a gossip columnist, and thus the bourgeoise Madame Derline, virtuous wife of a Left Bank notary, finds herself famous overnight. She suddenly realizes too that as the most beautiful woman of Paris she can hardly go to next Thursday's ball in a dress designed by her mother's unknown, Left Bank couturière. Consequently, she immediately sets off to one of the Right Bank's most famous dress designers for a dress befitting the most beautiful woman of Paris. She enters an overly

2. Hyppolite Taine, *Notes sur Paris: Vie et opinions de Monsieur Frédéric Thomas Graindorge* (Paris: Hachette, 1901), 7.

Woman, Desire, and the Bibelot

sumptuous salon artfully littered with the house's latest creations and presided over by Monsieur Arthur, who is dressed like a diplomat. Not being a regular customer, Madame Derline has to see Monsieur Arthur in his cabinet, which is decorated by photographs of the Princess Eugénie. Upon learning that the stranger before him is the beautiful Madame Derline (he had just read the morning paper), Monsieur Arthur decides he will find the time to create something for her even on such short notice and begins to study her: "He walked slowly about Madame Derline, examining her with a profound attention; then took a few steps back, looked at her from a little farther off. . . . His face was serious, worried, anxious. A great man of science seeking to solve a great problem. He wiped his brow with his hand, raised his eyes to heaven, looking for inspiration in his birthpangs; but suddenly his brow brightened; the spirit above had answered his call."[3] Madame Derline is redesigned in Monsieur Arthur's mind—the most beautiful woman of Paris would have a beautiful dress indeed.

But, realizing that her other dresses were no longer fit for her, Madame Derline leaves only after having bought several other trifles at 800 francs each. Once outside in the rue de la Paix, seeing all the splendid carriages lined up, she also realizes that her old carriage, faithful servant of seventeen years, will no longer do, so a new carriage is bought, upon which it becomes obvious that the old horse will no longer do either and that the old coachman will not fit in with either the new carriage or the new horse. Art, fashion, beauty, publicity, and cost are inextricably mixed. No wonder the philosophical Thomas Graindorge concludes that women share a subtle but certain kinship with the nature of works of art: "Women and works of art are related creatures: both may be overtaken by the same kind of fall; they share

3. See Ludovic Halévy, *Karikari* (Paris: Calmann-Lévy, 1892), 179; "La Plus Belle" is one story in this volume.

the same incapacity to adore and produce. They are no longer the dreams which imagination or illusion may embody. What is really wanted of them is possession or exhibition" (*TG*, 307).

Woman was the most expensive jewel men wore in society. Saccard, Emile Zola's financial genius and adventurer of *L'Argent*, bought one night with Madame de Jeumont for 200,000 francs, a price that entitled him to exhibit her at a ball. The emperor had made the prestige of that particular lady by paying 100,000 francs. It is obvious that Marguerite was right: such women were not only objects to be possessed and exhibited, but they also shared another characteristic of works of art, they had a pedigree, a provenance. And as some pictures were valued in part because of their preceding possessors, so these women were esteemed, desired, and priced for the same reasons. Graindorge might have added to his comparison of women and works of art the relatively low price of works of art compared to the cost of keeping a mistress.

The purchase of the favors of such women had nothing to do with *amour-passion*, save in novels, but, as Prudence knew, everything to do with male vanity. Madame de Jeumont on Saccard's arm was as certain a sign of his financial success as a diamond pinned to his cravat. She advertised his success. Paul Bourget, writing novels and stories about a later generation, said much the same thing. In *Un Homme d'affaires*, he writes: "One does not keep one of the glories of the *Comédie* to amuse oneself,—but to have the air of a man of taste, almost a patron of the arts and of artists; but also to advertise one's talents as a financier and to hear whispers of He must be making a great deal of money, the rascal, to spend a hundred thousand a year on Favier." [4]

It must not be thought that this confusion between woman and object was confined to those who frequented the Parisian monde or

4. Paul Bourget, *Un Homme d'affaires* (Paris: Plon-Nourrit, 1900), 57.

Woman, Desire, and the Bibelot

demimonde or the later Edwardian era. Henry James's Christopher Newman, the American, also thought of a wife as "a beautiful woman perched on the pile" of his financial success, "like a statue on a monument." What he sought, even in looking for a wife, was "the best article on the market," and while he valued the woman he had fixed on for herself, he also valued the world's admiration for what it would add to the "prospective glory of possession."⁵ And surely Gilbert Osmond in *Portrait of a Lady* looked upon his wife, Isabel Archer, as but another acquisition befitting his exquisite and exclusive taste. As James wrote: "We know he was fond of originals, or rarities; and now that he had seen Lord Warburton, whom he thought a very fine example of his race and order, he perceived a new attraction of the idea of taking to himself a young lady who had qualified herself to figure in his collection of choice objects by declining so noble a hand."⁶ Osmond is, of course, far more corrupt than the frequenters of the demimonde who did not extend their collector's instinct to include their wives. They were more likely to marry for their fortunes than for their affinity to a rare object. Love, business, luxury, mistresses, and marriage all had their separate places. Women might be bought as objects—one might enjoy possessing them for a time—but one hardly married such playthings except in novels or plays, or if one were really foolish enough to fall in love.

These reservations, or limits, did not mean the husband did not also sometimes view his wife as an object he was proud to show to the world. Only she was out of the market, so to speak; just as the objet d'art in a museum was beyond it, so the wife. If she committed what was called a *faute*, she risked falling into the demimonde. In either case, woman as object of beauty, luxury, and collection fascinated the

5. See Viola Hopkins Winner, *Henry James and the Visual Arts* (Charlottesville: University of Virginia Press, 1970), 132.
6. Henry James, *Portrait of a Lady* (New York: Penguin, 1978), 304.

male imagination. The poet who perceived this assimilation of woman to an objet d'art was Baudelaire. For him everything that went toward the ornamentation of woman was part of her: she became a general, artistic harmony, not only in movement and allure, but also in her dress, the shimmering clouds of materials in which she enveloped herself. In addition, according to Baudelaire, the metals and minerals serpenting about her arms and neck, adding sparkle to that of her eyes, were part of the same general harmony; she was a work of art, a new type of divinity presiding over the conceptions of the male mind and imagination.

The world of luxury into which woman was assimilated was not only the demimonde but also Paris and modernity. Woman became the rival of the work of art. She turned into a bibelot herself, surrounded by bibelots, an expensive object of desire, to be possessed and cherished, but also exhibited. "Woman" encompassed everything from an object of beauty and art for the aesthete, of pride of possession for the successful speculator, financier, and banker, to an intimation of transcendent spirituality for poets still enamored of the ideal. But in the capitalist sublunar world, woman was also a consumer and as such she represented an extraordinary market for the creators of department stores, the grand couturier, as well as the antique dealer and sellers of bric-a-brac.

The department stores had fostered an extravagant taste not only for clothes but also for "things one might do without." This desire for "things" was, as noted in the preface, already remarked upon by the Goncourt brothers, and by the end of the century it had become a commonplace observation and object of psychological investigation. When Laura Jadwin, in Frank Norris's novel *The Pit* (1903), realized that her husband Curtis was lost to her because he was entirely taken up with bold speculations and making an immense fortune, "she began to

Woman, Desire, and the Bibelot

indulge in a mania for old books and first editions. She haunted the stationers and secondhand bookstores, studied the authorities, followed the auctions, and bought right and left, with reckless extravagance."[7] According to this Pascalian logic, shopping had become one vast escape into divertissement, literally, a diversion from an inner emptiness. The philosophical essayist Max Nordau saw this desire for things as a symptom of decadence or, to use his more medical term, "degenerescence": "The present rage for collecting, he wrote, the piling up in dwellings, of aimless bric-a-brac, which does not become any more useful or beautiful by being called *bibelots*, appear to us in a completely new light when we know that Magnan [a French doctor concerned with degenerates] has established an irresistible desire among degenerates to accumulate useless trifles."[8]

Whatever the explanations given for this generally observed accumulation of bric-a-brac, the result according to sociologist René König, was the bourgeois style of interior decoration, which expressed the general if at times unconscious or at least unstated values of bourgeois society, but also, the true status or situation of the art object in that society. Art joined with fashion, only to be in turn bibelotized. The bibelot thus became the general characteristic of this bourgeois style and could be anything, from any time, and any place. In the American home of the later nineteenth century, the bibelot had been displaced from a piece of furniture called a whatnot to the more artistic, supposedly more appropriate, and certainly more up-to-date "Empire cabinet" designed for bibelots. "Empire" here obviously referred not to the first empire of the great Napoleon, but to the second empire of Napoleon III. How else can we explain Harry Leon Wilson's description of such a cabinet "with its rounding front of glass, its painted

7. Frank Norris, *The Pit* (New York: Doubleday Page, 1904), 353.

8. Max Nordau, *Degeneration* (New York: Appleton, 1897), 27.

Woman, Desire, and the Bibelot

Watteau scenes, and its mirrored back" in his novel, *The Spenders*, of 1902? The difference between the old whatnot and the new Empire cabinet marked not only a movement from the new West to the older East but also an advancement of culture:

> The Nines' what-not in the sitting room was grimly orthodox in its equipment. Here was an ancient box covered with shell-work, with a wavy little mirror in its back; a tender motto worked with the hair of the dead; a "Rock of Ages" in a glass case, with a garland of pink chenille around the base; two dried pine cones brightly varnished; an old daguerrotype in an ornamental case of hard rubber; a small old album; two small china vases of the kind that came always in pairs, standing on mats of crocheted worsted; three sea shells; and the cup and saucer that belonged to grandma, which no one must touch because they'd been broken and were held together but weakly, owing to the imperfection of home-made cement.
>
> The new cabinet, haughty in its varnished elegance, with its Watteau dames and courtiers, and perhaps the knowledge that it enjoys widespread approval among the elect,—that is a different matter. In every American home that is a home, today, it demands attention. The visitor, after eyeing it with cautious side-glances, goes jauntily up to it, affecting to have been stirred by the mere impulse of elegant idleness. Under the affectedly careless scrutiny of the hostess he falls dramatically into an attitude of awed entrancement. Reverently he gazes upon the priceless bibelots within: the mother-of-pearl fan, half open; the tiny cup and saucer of Sèvres on their brass easel; the miniature Cupid and Psyche in marble; the Japanese wrestlers carved in ivory; the ballet dancer in bisque; the coral necklace; the souvenir spoon from the Paris Exposition; the jade bracelet; and the silver snuff box that grandfather carried the day of his death. If the gazing

Woman, Desire, and the Bibelot

visitor be a person of abandoned character he makes humour-
ous pretense that the householder has done wisely to turn a key
upon these treasures, against the ravishings of the overwhelmed
and frenzied connoisseur. He wears the look of one gnawed by
envy, and he heaves a sigh of despair. The what-not is obsolete.
The Empire cabinet is regnant. Yet though one is the lineal de-
scendant of the other—its sophisticated grandchild—they are
hostile and irreconcilable.[9]

For the latter showed the superior taste of its owner, the superiority
of taste and culture over mere sentimentalism. The bourgeois interior
thus also came to resemble a museum, smaller in scale than the na-
tional or local institutions, but private, intimate; and yet, the richer it
was, the more capable it was of one day being turned into a public
museum by donation. As such the bourgeois collection was not neces-
sarily a gallery or collection geared to some historical view of the de-
velopment of art or the visual expression of some guiding aesthetic or
historical principle. It might be thus among some amateurs or histo-
rians; but as expressive of the general tendency of the times, it tended
to bric-a-brac, clutter, accumulation.

Santayana, in a once famous novel, *The Last Puritan*, an astute study of
the New England conscience and mind, described Mrs. Van de Weyer's
Newport drawing room and the impression it made on Nathaniel
Alden, a Boston Puritan: "The room was littered with little sofas, little
armchairs, little tables, with plants flowering in porcelain jars, and
flowers flaunting in cut-glass bowls, photographs in silver frames,
work baskets, cushions, footstools, books and magazines, while the
walls were a mosaic of trivial decorations (not the work of deserving
artists like those in his own house), but étagères with knick-knacks and

9. Harry Leon Wilson, *The Spenders. A Tale of the Third Generation* (Boston: Lathrop,
1902), 36–37.

Woman, Desire, and the Bibelot

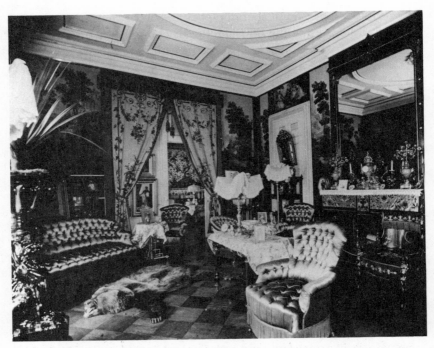

Drawing room, 1894. Photograph by Byron. The Byron Collection.
Museum of the City of New York.

bric-a-brac, feeble watercolours, sentimental engravings, and slanting mirrors in showy frames."[10] European interiors of the well-to-do, or of the "artistic," were much the same, and on both continents this bibe-lotization of the interior came to be regarded as a particularly femi-nine trait to be distinguished from the more manly enterprise of col-lecting works of art.

10. George Santayana, *The Last Puritan* (New York: Scribner's, 1936), 45.

Woman, Desire, and the Bibelot

As we have seen, Max Nordau's interpretation of the accumulation of bibelots as a sign of decadence implies, by extension, the assimilation of women to Magnan's degenerates. The accumulation of bibelots by women was perceived as an aspect not only of their dominion over the home in the United States but also as a feminine weakness. And in the United States as in Europe, women tended to accept this view. In *The Pit* the world of art is distinctly contrasted with the world of business, the "real world" in which real men fight with other real men and are, in effect, at war with each other, hard, "always cruel, always selfish, always pitiless" (*TP*, 64). Those men in the street are quite different from husbands at the breakfast table. They are also quite different from the artist. "To contrast these men with such as Corthell was inevitable. She remembered him, to whom the business district was an unexplored country, who kept himself far from the fighting, his hands unstained, his feet unsullied. He passed life gently, in the calm, still atmosphere of art, in the cult of the beautiful, unperturbed, tranquil; painting, reading, or, piece by piece, developing his beautiful stained glass. Him women could know, with him they could sympathize" (*TP*, 64). The realm of art was the realm of women; it answers to the feminine principle while the battle of the street exemplifies the male principle. Significantly, even Laura Jadwin prefers the man who does battle.

In Europe a similar distinction was drawn, though to exclude women rather than men from the world of art. Similarly, watchful husbands tended to keep their wives from reading the more advanced and daring literature of the day. Educated women, cultivated women, well-read women, all were often suspect as late as 1900. As Anne Martin-Fugier has shown in her excellent study of *La Bourgeoise* (1983), the culture of the woman of the bourgeoisie could only be that of an amateur since it did not include the opportunity for professionalism. In view of this, the accumulation of bibelots might be interpreted as a compensation for this exclusion from true culture. It may also explain the ugliness of bourgeois interiors cluttered with bibelots,

Woman, Desire, and the Bibelot

needlework, tapestries, watercolors painted by the lady of the house, decorated panels, flower arrangements, and all other minor arts that were considered les arts de la femme.

By 1880 in France women were perceived as mere buyers of bibelots, which they bought as they did clothing, in their daily bargain hunting. Men of course collected too, but their collecting was perceived as serious and creative. Women were consumers of objects; men were collectors. Women bought to decorate and for sheer joy of buying, but men had a vision for their collections, a view of the collection as an ensemble, with a philosophy behind it. Or so the argument went. But by the 1890s the distinction between feminine accumulation and real collecting tended, in the bourgeois interior and even the American millionaire "home," to be blurred, and the bibelot seemed to have triumphed, along with a certain view of what constituted "Art."

The bibelotization of art implies too much of anything from anywhere in the same space, and hence it is a bourgeois style, rather than a true style, namely, the creation of artists and architects, of mind disciplining imagination, such as Louis XV, Louis XVI, or Directoire, the styles which suppose a harmony and unity. The bourgeois style, in contrast, is an economic and psychological style that at worst might be called the accumulative, or museum style, or, at best, the eclectic. As the narrator, a painter with a trained eye, of Paul Bourget's *Blue Duchess* remarks of one such Parisian interior: "How not detest the impressions made by these furnishings and furniture which taste of pillaging and the junk shop; for nothing is in its place: tapestries of the eighteenth century alternate with paintings of the sixteenth, furniture of the Louis XV period with a bishop's seat, modern draw curtain with antique material on a chaise longue, the back of an armchair or some cushion or divan!"[11] As the room, so the edifice, the modern successful businessman's hôtel particulier, manor, or Fifth Avenue "home." It, too, was eclectic and flaunted its luxury. The same narrator of the *Blue*

11. Paul Bourget, *La Duchesse bleue* (Paris: Plon-Nourrit, 1898), 168.

Woman, Desire, and the Bibelot

Duchess referred to one of these Parisian hotels—which had its coun-
terparts in other major cities—as "an architecture of parody, in which
one found a way of mixing twenty-five styles, and of placing a wooden
staircase in the English late medieval manner in a Renaissance stair-
well" (165). This luxury was completed by footmen in livery, all of
which added to the factitiousness of this insolent luxury. In the same
novel, dated 1898, an aspiring poet and playwright is introduced into
the drawing room of the worldly writer Jacques Molan who, being suc-
cessful, also surrounds himself with the signs of success: "The groom
showed one into a vast smoking room next to a small work cabinet
which displayed a glass case filled with bibelots, all authentic: old Chi-
nese lacquer, bronzes of the sixteenth century, old boxes, Saxe figu-
rines, old bonbonnières. The disparate nature of the objects betrayed
quite well the eternal utilitarianism of Molan. He was ready for pos-
sible sale, just in case" (110). Descriptions such as this may be found in
most of the novels of the period, European as well as American,
though in the work of Henry James the collection of such bibelots is
perhaps even more important than in the work of Bourget and his Eu-
ropean confreres, if only because Americans took art so much more
seriously than the more materialistic and corrupt Europeans.

Bourget was among the most perceptive of writers with regard to
the significance of the bibelot. He did not, like Max Nordau, whom he
had read, consider the collection of knickknacks a symptom of racial
or congenital degeneracy. But he did see in it something connected
with the nervous sensibility, the "refined mania of an unquiet period
in which the fatigues of boredom and the diseases of the nervous sen-
sibility led man to invent the factitious passion for collecting because
his interior complexities made him incapable of appreciating the
grand and simple sanity of things in the world around him."[12]

This mania for collecting, linked to the nervous sensibility of the

12. Paul Bourget, *Nouveaux essais de psychologie contemporaine* (Paris: Lemerre, 1888),
149.

Woman, Desire, and the Bibelot

modern world and its boredom, spread even to those who had no artistic sensibility at all. It is here the department stores and boutiques, with the help of modern industry, intervened to produce the inexpensive, industrialized bibelot that could be afforded by those who could not purchase the authentic one. The bibelot was thus to be found everywhere and it was this ubiquity and clutter that turned into bric-a-brac. Bourget thought the bibelot mentality so pervasive that he perceived its influence in the literary style, phrase, and vocabulary of the Goncourt brothers, who were inveterate collectors. Their collection took no less than three volumes of description and cataloguing for their catalogue, *Maison d'un artiste.* "By indefinitely looking at works of art," wrote Bourget, "they developed in themselves the impression of the contour and projection which every object projects against a background of atmosphere, so that a sentence describing such an object seems to them exact only if it also necessarily reproduced this contour and sally. That is why they proceed by inversion, hoping thereby to give a species of swelling to their prose, as a line delineates a model" (186). It was a style, thought Bourget, ultimately derived from Chateaubriand, based on love of color and the description of sensations, and this explained why it lent itself so well to the description of the neurotic sensibility. But one wonders whether Bourget's observations on the Goncourt style do not also illuminate some of the characteristics of Henry James, for example his preoccupation with the defining of exact psychological nuances, the use of the precise term, word, nuance, or weight of a sentence. Indeed, may we not say that the bourgeois psychology of the novelist, the ever-finer analysis of character, is also that of observers of objects, of clinicians as of experts of art objects? The novelist's reactions, as well as those of his characters, his descriptions and analyses, all betray a similar preoccupation with detail, akin to the almost manic connoisseur of precious objects. But then this aesthetics of the bibelot, central to the bourgeois interior, may also be gleaned in the dense universe of Marcel Proust so rich in

Woman, Desire, and the Bibelot

objects, smells, associations, tastes, all contriving to prompt the involuntary memory. The world of the bibelot thus turns into the dream world of the bourgeois, his sentimental world of recall, souvenirs, associations, intimate escape from the world of material cares.

But by the time Proust was writing his great work, this search for times past through memory, prompted by objects and smells and touch, the ubiquity and clutter of bibelots had become such as to strike the consciousness as a problem. Art nouveau may be seen as one solution to the eclectic nature of the bourgeois interior. For though art nouveau resulted in new bibelots, those bibelots were integrated into a general style, a unity. But another solution to bourgeois clutter and eclecticism was to re-think the whole problem of interior decoration.

Edith Wharton's first book, *The Decoration of Houses*, was not only a historical survey of interior decoration, it was also a book written against the clutter caused by the taste for bibelots that had also been manifest in her mother's home. It is in fact coextensive with the whole bourgeois era of civilization, which extends roughly from about 1830 to 1914.

Edith Wharton began her considerations on the bibelot by making distinctions. French, she wrote, had three words to designate the English "knickknack" or "objects of small value," to wit, *bibelots, bric-à-brac,* and *objets d'art.* The connotations were not the same: any object might be a bibelot for some individual; bric-a-brac referred to an ensemble of objects, good, bad, indifferent, and amounted to clutter; the objet d'art implied a quality above the others. The use of these objects was related not to accumulation but to interior decor and ornamentation and to those minor touches that might give a room the charm of completeness. Objects embellished a room. But only two kinds of objects could embellish a room: objects of art proper, such as busts, pictures, and vases; and useful objects such as lamps, clocks, firescreens, candelabra, bookbindings. Edith Wharton realized that bibelotization

Woman, Desire, and the Bibelot

and clutter had blurred the distinction between a mere bibelot and an objet d'art. Anyone could acquire bibelots—all you needed was money. But not anyone could collect or acquire objets d'art: "Good objects of art give to a room its crowning touch of distinction. Their intrinsic beauty is hardly more valuable than their suggestion of a mellower civilization—of days when rich men were patrons of the 'arts of elegance' and when collecting beautiful objects was one of the obligations of noble leisure. The qualities implied in the ownership of such bibelots [i.e., works of art] are the mark of their unattainableness. The man who wishes to possess objects of art must not only have the means to acquire them, but the skill to choose them—a skill made up of cultivation and judgment, combined with the feeling for beauty that no amount of study can give, but that study alone can quicken and render profitable."[13]

Taste could save one from the general debasement of the passion for bibelots caused by the industrial production of knickknacks by re-establishing the distinction between mere bric-a-brac and art. Taste also established but two conditions for the use of bibelots in a room: that they be in scale with the room and that it not be crowded.

Wharton's critique of bourgeois clutter aimed to preserve the distinction of possessing the ultimate bibelots, works of art, by drawing aristocratic lines between the passionate, democratic, acquisitive spirit and the commercial bibelotization of fashion. The principle of aristocratic taste, based on judgment and knowledge of art, was used to counter the effects of industry and department stores. But at the same time, as we shall see, it sublimated the work of art by distinguishing the mere bibelot, associated with commerce and industry, from the objet d'art, associated with nobility and noble leisure. But this distinction did not restore the work of art to its function in prebourgeois

13. Edith Wharton and Ogden Codman, Jr., *The Decoration of Houses* (New York: Scribner's, 1901), 187.

Woman, Desire, and the Bibelot

and preindustrial society. The work of art was simply raised to the rank of sublime bibelot, distinct from the one anybody could buy in a novelty shop or a department store, or some antique dealer's shop. But given the nature of capitalist society, the bibelot, sublime or not, remained a marketable item.

Historically speaking, the bibelotization of art is worth pondering. There had always been collectors of works of art, but nineteenth-century collecting was perhaps unusual not only in scale but also in kind; for the bourgeois era, in fact, collected anything because it collected the past, history as well as art. Anything could enter a collection. The Gardners of Boston, in 1897, started amassing more than paintings as they brought home a French Gothic double door, a round wooden screen for a circular staircase, a beamed paneled ceiling, stone lions, a Spanish wheel window, a Roman mosaic pavement with the head of a gorgon, and so forth. Parts of buildings—indeed, entire buildings—were removed and transplanted to foreign shores. The past itself was turned into a gigantic quarry of bibelots.

Bibelotization then may well be the bourgeois way of apprehending and understanding art. It is related to possession, acquisition, and production. It implies the bourgeois love of the inheritance and passion for selling and buying and finding a bargain. Bibelotization even makes it possible to put the past up for auction. With art nouveau the link to the past is untied as the bibelot finds its general style as furniture, statuettes, vases, lamps, perfume bottles, jewelry, all disciplined into a flowing line that lent a space and the objects within it a unity. Yet the objects of that style, intended to be objects of art, remained reproducible on an industrial scale as some vases or lamps were produced unsigned while others were distinguished by a signature. Art nouveau thus made Alexandre Arnoux's dream of uniting art and industry come true. Like the photograph in its silver frame among the other bibelots on the table or the étagère, the art nouveau object remains as an instance of the reproducibility of the bibelot and testifies

Woman, Desire, and the Bibelot

to its ubiquity and its femininity. It could be bought in the magasins de nouveauté or in the department stores. It was made to be fitted into the intimate, private interior presided over by woman, herself a desirable, living, expensive bibelot presiding over other bibelots she had gathered about her in her nest.

But the bibelot, no matter how sublime, had at some time been up for sale; it was a bought object. The old nobility had possessed works of art and galleries because it was expected of them in order to maintain their rank in society. To the nobleman these were necessities. The possession of art was, in part, noblesse oblige. It was part of a life-style, the stage set of his life, inseparable from his rank and its function in the society of his time. But the bourgeois and his wife, or mistress, needed bibelots as signs of success, social and financial. Hence, the importance of possessions. Objects that had come from a past, or some market or foreign place, which were not originally intrinsic to the bourgeois world, conferred a distinction that bourgeois activity as such did not. They also hinted at another distinguishing trait, culture. The noble had not been defined by culture so much as by feats of arms, lineage, landed wealth, or, in the case of the *noblesse de robe*, learning. But the bibelot as objet d'art could confer distinction upon the bourgeois, a lesson soon learned by those who had neither education nor letters nor lineage nor taste—only money. By transforming the bibelot, or objet d'art, into a sign of more than mere possession, namely, distinction and culture, the Americans abroad played a decisive role in the history of taste and aesthetics and determined to a large extent the assumptions and values on which art history would be written.

F·I·V·E

The American Impact, or
Shopping for the Ideal

*Any valuable object in order to appeal to our
sense of beauty must conform to the
requirements of beauty and expensiveness both.*

Thorstein Veblen
Theory of the Leisure Class

Edith Wharton's critique of cluttered interiors appeared at a time when Americans had been acquiring bibelots and works of art for about a generation and had made an impact on the European imagination precisely as a result of their avidity for culture, which they often seemed to translate into accumulation. Americans were obviously destined to play an all-important role in the formation of a specifically bourgeois apprehension of art. Europe, to be sure, had its collectors and its collections, such as that of the Duc d'Aumale at Chantilly or du Sommerard in the Cluny in Paris, the Wallace collection in London or that of Price Demidoff in Florence, Poldi-Pezzoli in Milan, Jacquemart-André in Paris, Don Jose Lazaro in Madrid. Americans, in their collecting, knew of these and, in some sense, emulated them.

The American concern with culture was a veritable national trait, so that any inquiry into the specifically bourgeois nature of the appreciation and accumulation of art and its role in capitalist society must surely take account of the most dynamic capitalist society of the nineteenth century. Americans, drawn to Europe and the East, became great travelers and collectors and instituted tours far grander than their English predecessors of the eighteenth century, with much the same results, namely, the migration of works of art from one country to another.

Yet it is also true that Americans did not look at art in quite the same way that most Europeans did, if only because so many Americans were concerned with culture and were also rich. Art thus came to play

American Impact, or Shopping for the Ideal

a somewhat different role in American society than in Europe with its officialdom, its old aristocracies, and its past. The United States provided a near-perfect milieu for the development of the purely bourgeois view and use of art. For American society was relatively unburdened by Europe's feudal past, which had formed artistic tastes and attitudes. At the same time, as a result of this new cross-Atlantic grand tourism, European and American attitudes combined to form that ultimate bourgeois aesthetic, social, and artistic phenomenon, the cosmopolis, complement of the international art market and aesthetic phenomenon of the beautiful rich people in the beautiful places looking at beautiful works of art available for the right price.

European observers of Americans abroad were particularly struck by two related phenomena: the American woman and the American interest in culture. To be sure, there was a great variety of Americans, from the "western barbarian," to use Henry James's term, the millionaire on an art raid, the social climber, to the college graduate traveling as an unescorted young lady avid for culture. Henry James took note of this American invasion of Europe in the November 3, 1878 issue of the *Nation* and outlined the alleged reasons for traveling abroad: culture, music, art, languages, economy, and the education of children. He also stressed that whereas the English, French, and Germans all found their intellectual and aesthetic ideals in their own countries, only the Americans felt obliged to go abroad for them. He made note of a particular type, "the unattached young American lady" traveling for culture, relaxation, or economy (life in Europe being then far less expensive than in the United States), who might appear to Europeans as a touching or startling phenomenon. In the novels of the period they appeared rather more the latter than the former. Startling indeed, those Bryn Mawr or Vassar graduates who seemed to know so much more about art or literature than their European counterparts, though these might live in châteaux, villas, or town houses filled with art.

American Impact, or Shopping for the Ideal

Pierre de Coulevain, a turn-of-the-century French novelist who was particularly interested in American women abroad and at home distinguished three types of such women in the Paris of that period: the type who sought to enter European nobility, thought she had, but never really knew she had not; the type who lived abroad but kept within American circles and belonged to what was known at home as "the best people"; and finally, that other phenomenon, already noted by James, the artistic type. But Coulevain noted something else that James did not stress, namely, that on the whole the American woman was really far more cultivated than her European counterpart. Unlike most European women, she was a free woman, disposing as she willed of her fortune.

There were other American types less well known to European novelists or members of society receiving rich Americans in Paris, London, or Florence. These "not so innocents abroad," in a sense, defined a new type and were different from earlier Americans who had not been to Europe or were suspicious of her vices. And in addition to the American fanatics of culture there were those who could not understand why anyone would take art seriously. They were content to leave the arts to women and let the women go on their tour alone. Thus to H. B. Fuller's character David Marshall of Chicago art was wholly inexplicable. He could not understand why "any man could be so feeble as to yield himself to such trivial matters in a town where money and general success still stood ready to meet any live, practical fellow half-way—a fellow . . . who knew an opportunity when he saw one. The desire of beauty was not an integral part of the great frame of things; it was mere surface decoration, and the artist was but for the adornment of the rich man's triumph—in case the rich man were, on his side, so feeble as to need his triumph adorned."[1] But Mr. Marshall was willing to let his wife and daughter improve themselves and was even proud

1. Henry Blake Fuller, *With the Procession* (New York: Harper's, 1895), 141.

that Jane, his daughter, kept up with the general advance of culture. But this was hardly acceptable in a man, and his son, unfortunately, had decided, upon his return from Europe, to be interested in art!

Mr. Marshall, who died from exhaustion just as he and his wife moved into their new home in a more fashionable part of Chicago, was an honest man. He summed up one way the bourgeois thought about art: as adornment. It was for women not men, for a man's life was supposed to be dedicated to making money. Mr. Marshall's views were similar to those of his European bourgeois counterpart in that equally aggressive and philistine society of Napoleon III's second empire or Bismarck's dynamic new reich or Mr. Gladstone's prosperous and moral England.

But, unlike the European bourgeois, Mr. Marshall had not lived in a world in which the arts had survived from former societies and were part of the social ambiance, indeed, sometimes even part of the furniture, and accorded some sort of official status and recognition through public patronage. Thus Mr. Marshall, though a member of the nouveau riche, did not, like his European counterpart, think of hiding his lowly origins and his new money beneath a veneer of culture and art. His wife and daughters, however, did. They had been to Europe and they saw other Chicagoans doing that. Mr. Marshall was not ashamed of being a bourgeois. It had probably never occurred to him he was one; he had probably never even heard the word. Nor had it even occurred to him art might be an investment.

But Mr. Marshall was behind the times. He died feeling vaguely that the world was getting harder and harder and wondering whether it had been wise to want a new home; he had been content in the old one. He had not had the social ambitions of his wife and daughter, dazzled not only by Europe but also by the new houses and the luxury of a Chicago bent on surpassing the East Coast. But Mr. Marshall was also out of tune with the new type of capitalist, one who wanted the

American Impact, or Shopping for the Ideal

arts to adorn his triumph and not be thought weak for it. Mr. Marshall was not Frank Algernon Cowperwood, Dreiser's "Titan." Mr. Marshall belonged to the old Chicago society and "those who, having grown suddenly rich from dull poverty, could not so easily forget the village church and the village social standards."[2] His was the "dullest and most bovine" of Chicago social classes; for him money was the sole standard of success and society consisted in weekday receptions and Sunday afternoon calls in which one saw the others and was seen in turn.

Cowperwood was an entirely different sort of capitalist and entrepreneur. He belonged to the newer element of Chicago, having moved west from Philadelphia; for him the arts were not only useful adornments but a subject of fascination. Cowperwood loved art, though he was not an aesthete.

Insofar as he is representative of American attitudes toward the arts, Cowperwood occupies a middle position between the incomprehension of Mr. Marshall and the aestheticism of certain Henry James characters. Cowperwood is intrigued by art though he is not sure why. But he desires works of art as he does power and women. He thus invests in it and sees it playing a role in his future. But when he begins collecting in Chicago, he has a curiously quantitative approach to it, thinking first of the sum to spend rather than the works to get:

> He decided to invest as much as thirty thousand dollars in pictures, if he could find the right ones, and to have Aileen's portrait painted while she was still so beautiful. Addison had four or five good pictures—a Rousseau, a Greuze, a Wouverman, and one Lawrence—picked up heaven knows where. A Hotel-man by the name of Collard, a dry-goods and real-estate merchant, was said to have a very striking collection. Addison told him of one

2. Theodore Dreiser, *The Titan* (New York: John Lane, 1914), 60.

American Impact, or Shopping for the Ideal

Davis Trask, a hardware prince, who was now collecting. There were many homes he knew, where art was beginning to be assembled. He must begin too. (56)

He goes on the American Grand Tour with his wife Aileen, first to London, where he meets Lord Leighton, Dante Gabriel Rossetti, and Whistler, thanks to an art dealer who sees in Cowperwood a future client. But Cowperwood is not attracted to artists as such: "These men saw only a strong, polite, remote, conservative man. He realized the emotional, egotistic, and artistic soul. He felt on the instant there could be little in common between such men and himself in so far as personal contact was concerned, yet there was a mutual ground on which they could meet. He could not be a slavish admirer of anything, only a princely patron" (59). Already the capitalist would be a Renaissance prince. He buys a Raeburn in London, then goes on to Paris where he purchases a plowing scene by Millet, a small Jan Steen, a battle piece by Meissonier, and a romantic courtyard scene by Isabey. Later we learn that at his first reception in their new house on Michigan Avenue, his guests were shown not only Aileen's somewhat showy yet refreshingly apt portrait but also a brilliant Gérôme, then highly popular. Cowperwood's taste at this stage of his life reflected rather faithfully the taste of the 1870s in the United States, and his collection corresponded to those considered the best in the country, namely, those of the Astors and the Vanderbilts, collections essentially of modern works from the French and Belgian schools but also containing pictures from the Düsseldorf school as well as a few old Dutch pictures.

Later Cowperwood's taste refines itself and he begins collecting old masters. On a second trip to Europe he becomes aware not only that Aileen is not the ideal wife but that there are other places to see and know besides London and Paris. His collection accordingly becomes more ample and rises to a higher aesthetic level. He brings back a Perugino, a Luini, a Previtali, and a Pinturricchio portrait of Caesar Borgia,

picked up in Italy. This Borgia portrait is as significant in throwing light upon Cowperwood's character and power as the Gérôme had been: a conqueror à la Borgia in business affairs, he also had enough women to fill a harem.

On this second tour he expands his collection in other ways, picking up two African vases in Cairo, Venetian candelabra, Italian *torcheros*, found in Naples, for his library, and a Louis XV standard of carved wood found in Rome. Later he adds jade, ancient glass, and illuminated manuscripts to his collection, which had also been augmented by a Paul Potter, a Goya, a Rembrandt portrait of a rabbi, a Hals and an Ingres, not to mention rugs, draperies, mirror frames, and rare sculptures.

Cowperwood is representative of the many American millionaires of the late Gilded Age who built museums for their collections or gave these to already existing museums. Cowperwood's taste, the evolution of his collection, generally parallels the evolution of taste as perceived in American collections. This is quite evident from René Brimo's *L'Evolution du Goût aux Etats Unis d'après les collections* (1938). The first American collections in New York of the period before and during the Civil War—those of John Jacob Aster, William Astor, August Belmont, and W. T. Blodgett, Henry Probasco in Cincinatti, or Henry C. Gikon in Philadelphia—were filled with the works of eminent academicians: Meissonier, Gérôme, Vibert, Bonnat, Fromentin, Troyon, Knaus, Rosa Bonheur, Bouguereau, Scheier, Madrazo, Zamacois, Diaz, and Fortuny. The W. T. Blodgett sale of 1870 in New York, which netted $887,145, had a few American painters such as William Morris Hunt, Church, and Dana, among the overwhelmingly more familiar European names. Henry Probasco had Innes and Thomas Cole in his collection, along with Jules Breton, Kaulbach, Fromentin, Gérôme, and Achenbach, and KoekKoek.

Yet the most considerable and considered collection was that of William H. Vanderbilt housed in his French Renaissance palace on Fifth

American Impact, or Shopping for the Ideal

Avenue and Fifty-first Street, designed by Richard Morris Hunt. The château itself was a fine example of the eclectic taste of the times and was compared to a Roman villa and a Flemish or Venetian merchant's palace for its splendor. The doors were reproductions of those of Ghiberti for the Florence Baptistry while the atrium was in the manner of Germain Pilon with cloisonné furniture, gilded, and faience derived from the Persian. The gallery was hung with 208 pictures in three superimposed rows, as was the fashion in those days. Among the artists named by Brimo were Alma Tadema, Knaus, Boldini, Rosa Bonheur, Bouguereau, Jules Breton, Cabanel, Bonnat, Clays, de Neuville, Detaille, Detti, Fortuny, Gérôme, Lefébure, Leloir, Leighton, Roybet, Bracquemond; also, Corot, Daubigny, Diaz, Decamps, Millet, Troyon, Turner, and Delacroix's *Sultan of Morocco and His Guard*. Vanderbilt liked pictures that told a story and paid up to 850,000 francs for a Meissonier war picture. He would not admit nudes and looked for exactitude of execution and rendition. While he liked looking at pictures he also, like a true bourgeois, considered them an investment, explaining that their price would increase after the death of the artist. This taste and approach to art collecting was no different from what then obtained in Europe. It was, from the second empire on through the 1880s, the *esprit de salon*, and the great painters in vogue were those who were stars at the salons and also winners of the Prix de Rome. How could one go wrong purchasing a picture from a Prix de Rome, or even better, a member of the Legion of Honor?

In the United States this salon taste would be questioned with the introduction of the painters of the Barbizon school by the American painter William Morris Hunt. Between 1870 and 1900 salon paintings would gradually be replaced by other works. The department store magnate A. T. Stewart also had a splendid gallery for his pictures, one wall for American paintings, the other for European—including Meissonier's *1807*—for which Stewart paid $85,000. But, in a sign of things to come, Stewart also began to buy old masters, Murillo, Rem-

American Impact, or Shopping for the Ideal

brandt, Titian. By the end of the century the salon moderns would be
threatened and eventually displaced by the rival claims of aestheticism
and modernism, namely, a presumably higher and more spiritual taste
for Italian primitives and masterpieces, or, at the other extreme, a taste
for impressionists and later even for twentieth-century painters.

Cowperwood, like Frick, Morgan, and Mrs. Gardner of Boston, also
built a splendid house in New York to serve as a museum. The style
chosen for this mansion was symbolic of Cowperwood and the tri-
umphant post-Civil War capitalists. His career in Philadelphia had be-
gun with a home in the style of modified Gothic; his Michigan Avenue
home had been solidly Norman-French; his New York residence could
only be an Italian palace of medieval or Renaissance origin. It was
meant to reflect his private tastes but also to "have the more enduring
qualities of a palace or even a museum, which might stand as a monu-
ment to his memory" (WP, 439). The house was to have not one gallery
but two: one for pictures, the other for sculpture and large works of
art. A smaller lounge on the second floor was to exhibit his jades, por-
celains, ivories, and other small objects. The modern condottiere of
free enterprise would not build a fortress on a hill but a museum on
Fifth Avenue.

Though a man of business, Cowperwood was a very different type
from Mr. Marshall. He was no philistine, no matter what a snob might
have thought, and it was more than means that made him buy his
works of art. Undoubtedly social considerations had played a role, as
had what he had seen in Europe. But Cowperwood was drawn to
beauty, feminine as well as artistic. Like Cardinal Mazarin he would, at
night, go into his gallery and wonder:

> The beauty of these strange things, the patient laborings of in-
> spired souls of various times and places, moved him, on occa-
> sion, to a gentle awe. Of all individuals he respected, indeed re-
> vered, the sincere artist. Existence was a mystery, but these souls

who set themselves to quiet tasks of beauty had caught something of which he was dimly conscious. Life had touched them with a vision, their hearts and souls were attuned to sweet harmonies of which the common world knew nothing." (*WP*, 382)

In Veblen's terms, Cowperwood is the very example of conspicuous consumption that the famous economist associated with the old feudal nobility. But it should be remarked that the conspicuous consumption so devastatingly exposed and analyzed by Veblen is quite different from what is called "noble spending," just as the life of the so-called robber barons differed from the *vie noble* of the ancien régime. The names of Renaissance princes are often enough coupled with American millionaires of the nineteenth century to warrant a digression marking the difference between them and the old nobility. Aline Saarinen, for example, wrote of J. P. Morgan's collections and donations in terms of noblesse oblige. But nobility never obliged to the foundation of museums, though many princely collections eventually became museums.

It is quite possible to find aspects of what we call the consumption society in the eighteenth century, both in France and in England, especially in the area of luxury goods. But even in late eighteenth-century France, on the eve of the Revolution, an important distinction was still drawn between *faste* and *luxe*, between magnificence, an attribute and obligation of the monarchs, princes, dukes, and the court nobility, and luxury, an attribute but no obligation of the rich. Both faste and luxe were expensive, both were visible; but their meaning and function within society differed. Sénac de Meilhan in his *Considérations sur les richesses et le luxe* of 1787 marks the difference in a telling manner by alluding to *le luxe de Fouquet* and *le faste de Louis XIV.* A monarch, a prince, a great minister, could be magnificent, whereas a financier could be luxurious. The nobility were under the obligation of *dépenses somptuaires*—lavish expenses and princely liberality—be-

American Impact, or Shopping for the Ideal

cause greatness itself, rank, high station, and the appearance of such were not distinct: appearance *was* reality. An unmagnificent king was unthinkable. The luxury spending of the financier class in the eighteenth century was an attempt to gain nobility through the creation of the appearance of nobility. This meant châteaux in the country, mistresses, an hôtel particulier and furnishings, including a gallery of pictures. But neither all the rich nor all the financiers were that ostentatious; nor was all such spending considered highly or admired. Nor were such spenders necessarily lovers of the arts.

The Rothschilds, Morgans, Vanderbilts, and others who accumulated art objects in the nineteenth century may have been in the tradition of the financier class of eighteenth century, but they were under no obligation to maintain the appearance of nobility, the grandeur associated with an ancient name, or the honour of being in the service of the king. The Duc de Choiseul as first minister of Louis XV had little choice but to appear magnificent and to overspend and find himself ruined upon his dismissal. Men in high places were expected to spend in the grand manner.

But while the millionaires of the nineteenth century might have spent more even than princes on works of art, they did so within a mental universe wholly unlike that of the late baroque world, for their economic mentality was still dominated by that of the bourgeoisie, a "saving for future ethos," to quote Norbert Elias.[3] To Veblen, conspicuous consumption might have looked like the potlatch, but millionaires were hardly ruined by their collecting. The bourgeois saves for a future he believes in; the grand gesture in spending is an attribute of the old baroque court nobility. Debts were no disgrace for that nobility. Debts and bankruptcy were, on the other hand, a disgrace for Balzac's César Birotteau.

Finally, there is another essential difference between the conspicu-

3. Norbert Elias, *La Société de cour* (Paris: Calmann-Lévy, 1974), 48.

American Impact, or Shopping for the Ideal

ous spending of the millionaire and the noble spending of the old court nobility: the aesthetic center had been displaced. The millionaire collected once the cult of art had been elaborated; the aesthetic part of his life was centered on acquisition, on objects of beauty. But the aesthetic of the old court nobility was centered on appearance, grandeur, magnificence. The aesthetic was in the service of nobility and not a sign of the possession of pecuniary wealth.

Cowperwood is a complex character. He is no barbarian, no mere rich man who has made his pile in a none too scrupulous manner and is trying to pass as a man of culture. For he is drawn to the ideal. This is what makes him a bourgeois, while his energy, daring, dynamism, and business acumen distinguish him from his European counterpart as a particularly American type. There were other American types who, like Mr. Marshall, did not consider art very important and yet supposed that perhaps it was one's moral duty to support the arts and endow museums. Thus Nathaniel Alden, Santayana's splendidly drawn Puritan, had a "weakness" for art—a word that speaks volumes—but it was not such a great weakness as to lead him to like art, only to support local artists by buying their pictures as a public duty. But Alden belonged to an older generation and to New England, and his attitude was that of the citizen of a new proud republic who thought it a duty to support the arts in a new society. Cowperwood belongs to a post–Civil War generation that would be disturbing precisely to the New England conscience. Boston believed in art, and, by the 1890s, as Van Wyck Brooks remarks, "Boston girls grew up with Botticelli manners." An ideal Renaissance, composed of Botticelli, Dante, and Petrarch, as well as Browning and Ruskin, had been, so to say, Bostonized.[4]

But how had it come about that Boston girls had Botticelli manners and that the Renaissance had been Bostonized? Ruskin provides one

4. Van Wyck Brooks, *New England Indian Summer, 1865–1915* (New York: Dutton, 1940), 435.

answer. He had a disciple at Harvard and many others were preaching his gospel of art. The Ruskinian influence helps explain American attitudes toward the arts and how these attitudes differ from those of the Europeans.

In Europe idealism was an aesthetic, artistic, and philosophical doctrine that defined itself against, or at least vis-à-vis, other aesthetic, artistic, and philosophical doctrines. Idealism in Europe suggests a religion of art to some; but it was not a moral or sentimental position. Indeed, in *Mademoiselle de Maupin* the aesthetic dominates any moral position, and the book can really be read as a manifesto of modern paganism. Idealism in painting referred to specific works: the *School of Athens* by Raphael, which begat the *Apotheosis of Homer* by Ingres, which begat Delaroche's *Hémicycle* in the Ecole des Beaux-Arts. A philosopher like Victor Cousin might link idealism to the true, the good, and the beautiful, and ultimately God and eternity; a painter knew it as the tradition of art derived from antiquity and the Renaissance, and, in the nineteenth century, at bay with a variety of modernisms—or materialism, as Quatremère would have said.

In the United States, however, the aesthetic variant of idealism that found its way to these shores was hardly ever separated from the moral, the didactic, or the sentimental. It came to be inseparable from the so-called genteel tradition of the later decades of the century. Thus one might argue that in the United States, idealism was *the* American position on the arts and not just one among other possible aesthetics. In Europe the artistic question came to be: what kind of art do you produce in a modern, secular, bourgeois world founded on industry, economic power, and money? The same question could have been asked in the United States and eventually was. But those who made up that genteel tradition—critics, poets, writers, even painters—hardly dared pose the question, partly out of private fears, partly because their position was founded on a conservatism that looked backward. The public constituting this genteel tradition also differed from their European counterparts, for the genteel tradition addressed itself to

American Impact, or Shopping for the Ideal

elevating and educating the upper and middle classes, that is, the monied classes. In Europe the conservative aesthetic was associated with state institutions and an artistic tradition, and little attempt was made to educate the nouveau riches of the empire or the third republic by writers, who preferred to ridicule rather than instruct. This does not mean the bourgeoisie did not have its apologists. One has only to think of Octave Feuillet or Georges Ohnet, who wrote genteel novels complete with pure and faithful wives, but there were also the scandalous Flaubert, Maupassant, and Zola. Indeed it would be easier to posit an antigenteel tradition in France rather than a genteel one. Taste was inseparable from class, and it was ever associated with some historical background.

But in the United States art was not defined by or in the same conditions. It was, interestingly enough, first defined in writings—from the lectern, the pulpit, and the editorial chair. Indeed, as a new people, the Americans of the early decades of the Republic had an advantage over older peoples, for they started out in history knowing what art was. In the early decades of the nineteenth century, essays on art undoubtedly outnumbered works of art in the Republic; definitions of art and beauty, inspired by Alison's *Essays on the Nature and Principles of Taste* (1811) or Hugh Blair's *Lectures on Rhetoric and Belles Lettres* (1783) had, in practical, protestant, and utilitarian America, a moral and utilitarian bias. For in the old world (corrupt) art had all too often been associated with courts, luxury, and effete nobility.

Later on Americans would also be lectured to on art by Ralph Waldo Emerson, the sage of Concord, whose essays on art and nature combine to make up a telling example of an American, New England version of a supposedly universal idealism: romantic, transcendental, moral, spiritual, neo-Platonic; and yet, strangely enough, if one takes account of Emerson's peculiar view of nature, this idealism is both natural and godlike. Emerson's view of art is as fine an updating of neo-Platonism as one may find anywhere. It is also significant that he

should have chosen the respectable form of an essay, whereas Gautier used the novel. Emerson's neo-Platonism remains respectable; Gautier's is slightly scandalous.

One may also turn to Nathaniel Hawthorne's masterpiece *The Marble Faun*, or *The Artist of the Beautiful*, for more insights into the formation of American attitudes toward and beliefs about art. The *Marble Faun* has the added attraction of giving the reader a fascinating view of the American artist in Rome, whose sojourn in Rome testifies to the strength over the American psyche of the neoclassical aesthetic long after it was being challenged in Paris.

What is striking about these views of art in Emerson and Hawthorne is that they are written as if the Enlightenment had never occurred. It is possible to link these American views to the idealism of Winckelmann and the aesthetics of Anton Raphael Mengs with its spiritualized beauty. But the polemical, combative, Davidian aspect of the first phase of neoclassical painting is absent from this view of art and beauty. The writings of Emerson and Hawthorne take us back to Renaissance Platonism, safely jumping over the baroque, not to mention the frivolous rococo. But they offer a Platonism elaborated by a Ficino without pricely patronage and within a milieu that is entirely middle class, a Ficino without the garden of the humanist but luxuriating in the warmth and color of a New England Indian summer and speaking not as a savant in a court of poets and princes but as a late Christian prophet.

Which brings us to the true prophet of art in the United States for the later nineteenth century, namely, Ruskin. For it was he and his American followers who really told Americans what art was; and he knew what it was because like most Englishmen and Americans he was a Protestant and loved God through God's work, nature!

The result of this transmigration of Ruskinian views of art and nature to the United States, combined with the New England influence, is a theory of art that rests on a spiritualized, naturalistic fallacy sanc-

American Impact, or Shopping for the Ideal

tioned by God. Behind the doctrines of the Ecole des Beaux-Arts and the writings and polemics of Quatremère de Quincy—even behind the statements and opinions of painters and critics, variously described as romantics, classicists, realists, or naturalists—lay centuries of questions about art, theories, and traditions, religious and secular patronage: questions and answers passed on through time by savants and institutions founded as early as the sixteenth or the seventeenth century. And in Europe there were countless examples of art works deviating from the canons of taste that were in the process of being discovered and about to be collected.

Behind the theories of art circulating in the United States, there was, above all, enthusiasm. And whereas in Europe aesthetic choices implied questions of class, politics, markets, and attitudes toward the established taste, in the United States aesthetic choices tended to reflect moral and religious beliefs and attitudes. The American businessman who came to be interested in art and decided to collect may have been tough-minded, ruthless, and even unscrupulous in his business dealings and the amassing of his fortune; but when it came to art, he—or his wife, or his daughter, perhaps even his son, who might have thoughts, God forbid, of not going into business—was an idealist. This idealism was not that formulated by a Quatremère de Quincy or Taine. It was closer to Victor Cousin; it might be said ultimately to derive from Winckelmann or Hegel, though such an idealistic businessman may never have heard those names. But as an American he had learned his art from the great followers of Ruskin: James Jackson Jarves, Charles Eliot Norton, Enrest Fenollosa, a Hegelian, and also from Emerson, Hawthorne, Henry James, and Henry Adams.

Why did Ruskin have such far-reaching influence?[5] His doctrine, as we have seen, fell on fertile ground that had been prepared by other

5. On Ruskin's importance in the United States, see Roger B. Stein, *Ruskin and Aesthetic Thought in America, 1840–1900* (Cambridge, Mass.: Harvard University Press, 1967).

American Impact, or Shopping for the Ideal

spiritualists. Yet, Ruskin's appeal lay in his religiosity and style. Ruskin was eloquent in a century in which eloquence of the pulpit was a highly regarded literary form. Max Nordau in his work *Degeneration* pointed out what appealed to the "anglo-saxon mind": he was turgid, fallacious, yet a master of style; and he was a bigot, also emotional, and a man of deep sentiment, with the temperament of an inquisitor. Indeed, Nordau called him the "Torquemada of aesthetics" (*D*, 77). Vernon Lee, an English writer living in Florence, put it in a less picturesque manner: "His philosophy is of far greater importance than any other system of aesthetics, because it is not the philosophy of the genius, evolution or meaning of any or all art, but the philosophy of the legitimacy or illegitimacy of all and every art."[6] An apt philosophy for a new nation.

It is precisely this moralistic and Christian inquisition into art that could appeal to American Puritans and transcendentalists who, as yet, had no art to speak of in their own country. Art itself became a moral lesson to be read. And in reading this lesson of art, the American followers of Ruskin were Jansenists in a world going over to the Jesuits.

James Jackson Jarves was not only the first American disciple of Ruskin, he was the first American to write about art on a theoretical level; the first great American collector of Italian primitives; and the first to write art history, art criticism, and aesthetics. His publication list included *Art Hints: Architecture, Painting, Sculpture* (1855), *Art Studies: The Old Masters of Italy: Painting* (1861); *The Art Idea* (1864); and *Art Thoughts* (1870). His story was told in a novel of Edith Wharton's called *False Dawn*, which implied that his message had come too soon to a country not yet prepared to accept art, at least as he understood it. He had considerable trouble trying to sell his collection and finally gave it to Yale University where it still is. But Jarves was not too early in bringing art thoughts and ideas to America; for after the Civil

6. Vernon Lee, *Belcaro, being Essays on Sundry Aesthetical Questions* (London: W. Satchell, 1881), 197–198.

American Impact, or Shopping for the Ideal

War the United States was ready to listen. His ideas he had learned from Ruskin whom he had met in Italy, and it was thus through Jarves that Ruskin's great influence began in the United States. From Jarves this influence passed to another disciple, who had also been to Italy, Charles Eliot Norton of Harvard.

The philosophy of art Jarves built up in the course of his life and that he expressed in his writings was a coherent doctrine concerned with the history of art and the importance of art in the future of the United States. Jarves's emphasis on the role of art in the United States is important because it distinguishes the uses of art in America from the uses of and attitudes toward art in Europe. In Europe history included a long past whose art was a heritage to be accepted, denied, or challenged, and even bought and sold. But in the United States history brought no such wealth of art; history was more the promise of a future, but what the future would be depended in part upon the correct reading of the past. Since the United States had no past to speak of, the lessons of the past had to be learned from Europe.

Jarves was no art historian in our professional, university sense of the word. He had no Ph.D. But he did think of art in historical rather than purely aesthetic terms. However, because he thought of history in moral and American terms, he connected art and its development with the rise and fall of the states and civilizations. For Jarves, as for Ruskin, the arts were thus signs of the moral stages of developing societies. But since in the United States history included the future, art could play a useful role in the construction of this future. Beauty could help men perform their moral duties; art might inspire morality and high ideals and thereby insure the nation's prosperity and adherence to the path set by God who had implanted the laws of art within the laws of nature.

In the early history of aesthetic thought in the United States then, art and religion were closely linked: not so much in fact or through institutions such as the church, as had been the case in Europe, but in

American Impact, or Shopping for the Ideal

the minds of those who thought and wrote about art. They had read Ruskin, not Kant. There was an additional reason for this union: "Men like Jarves, Ruskin, and even Norton, were seeking a religion that cut across questions of creed, a religion of the heart."[7] In Europe, if you think of art and religion you think immediately of the Roman church; but the curious thing about Jarves, Ruskin, and Eliot was that they dismissed the Roman Church from their thoughts and talked instead about the Middle Ages, conveniently forgetting that even the Middle Ages had been Roman Catholic. The paradox is easily understood once it is realized that they dismissed the baroque and the rococo as the corrupt forms of art of a post-Renaissance corrupted church. Such a view meant of course that historically, valid art is narrowed down to certain types of ancient and medieval art, mostly Italian: "The medieval art of Italy seemed to Jarves to be the purest expression of the religious ideal in art. He pardoned what he felt to be faulty execution in the works of Giotto, Sano di Pietro and Fra Angelico, and many others because these artists had faith" (R, 137). Things had somehow gone wrong in the Renaissance when sectarianism arose; and the Reformation, despite its laudable aim of purifying Roman corruption, led to fanaticism and the opposition of art and religion. The other villains in the drama were the Medicis; with them art started its decline because it ceased to be free. It had to serve princes.

Jarves, and others after him, saw Italian history from the perspective of the United States. Early republican Florence was perceived as a democratic city-state permeated by the wholesome spirit of labor and trade, similar to the early United States. But the Florence of the Medicis was that of bankers and princes and was marked by the luxuries of the rich rather than the simple tastes of craftsmen. Looking at the

7. Stein, *Ruskin and Aesthetic Thought*, 130. On aesthetics in fin de siècle America, see also Jackson Lears, *No Place of Grace: Antimodernism and the Transformation of American Culture* (New York: Pantheon, 1981).

American Impact, or Shopping for the Ideal

world about him did not induce Jarves to change his mind; it simply confirmed his views of Florentine history. If art had gone wrong in the sixteenth century, the modern world of the nineteenth century showed only too blatantly that art without faith was but technical ability and luxury, bereft of the spirituality of true art; it was without ideal.

Quatremère de Quincy had seen in the modern world the real danger to the art of the ideal and had spoken scathingly of those who believed in progress; Americans tended to think likewise. The modern world was a danger to the kind of free, moral, democratic art as had been obtained in the early Renaissance. And modern Paris—thriving, luxurious, attractive—was opposed to the virtuous Florence of the late medieval period when art was filled with the spirit of true religion.

Paris came to play in the American imagination much the same role as it had assumed among Europeans: it stood for modernity, but it was also the antithesis of virtuous America and also of democratic America. In Jarves's case Paris was that of Napoleon III. And like the Medicis, it pointed to the same lesson regarding the effects of despotism on art: "Despotism has made of Paris a brilliant bazaar, café, and theatre; in truth a well-baited trap for money and morals. Its standard of humanity is low, ambitions narrow, knowledge contracted to selfish aims, and chase of fleeting pleasure intense."[8] There was no denying, Jarves admitted, that it was a brilliant, well-planned, attractive city calculated to make a good and pleasing impression, just like its shop windows and the ladies' toilettes. But it was spiritually destitute. And this brio and the emperor's political success were due to the same cause: lack of morality in the country at large. Jarves had learned his Ruskin to perfection: art, morality, society, and politics were all united.

This view of Paris was general among Americans who were, after all, very earnest. Thus Henry Adams, serious about his education, knew it was frivolous to go to Paris: "France was not serious, and he was not

8. James Jackson Jarves, *Art Thoughts* (New York: Hurd and Houghton, 1870), 255.

American Impact, or Shopping for the Ideal

serious in going there. He did this in good faith, obeying the lessons his teachers had taught him; but the curious result followed that, being in no way responsible for the French, and sincerely disapproving of them, he felt quite at liberty to enjoy to the full everything of which he disapproved. Stated thus crudely, the idea sounds derisive; but, as a matter of fact, thousands of Americans passed much of their time on this understanding."[9] One is tempted to say that if Paris had not existed in the nineteenth century it would have been necessary to invent it to save Americans from Boston.

Be that as it may, it is clear that Paris in the American aesthetic played a role similar to that which it occupied in the minds of idealists, traditionalists, the minds of members of the Ecole des Beaux-Arts. It is also obvious that if in the French aesthetic Paris represented the temptations of the modern, in the American mind it represented the temptations of sin. The American was ambivalent: Paris was all wrong about art, yet it was attractive. And the attractions were feminine: luxuries, department stores, fine restaurants, the attractions of the senses, the toilettes of women, the demimonde—in short, the materialist aesthetic that was disapproved of by the Ruskinians as well as by the idealists, in whose view art had a mission. But in truth the attractions of Paris were also American attractions: for after the Civil War the United States, like Napoleon's Paris, was becoming a modern, dynamic, progressive, bustling, thriving, materialist country. New York's Fifth Avenue was meant to rival anything Paris or London could offer, so that the "art idea," introduced by Jarves into a United States at the crossroads of virtue and luxury, came to be a moral and aesthetic weapon against the rising tide of vulgarity.

Whereas Jarves had pioneered "art thoughts" in the United States, Charles Eliot Norton, another friend of Ruskin, fought the good fight

9. Henry Adams, *The Education of Henry Adams: An Autobiography* (Boston: Houghton Mifflin, 1918), 96.

American Impact, or Shopping for the Ideal

against the ever-mounting tide of post-Civil War American bad taste, or, as Norton used to say, "the horrible vulgarity of it all." Art education was not only a moral duty but an absolute and urgent necessity since the American Medici were capturing the public imagination and occupying Renaissance châteaux and *pallazi* on New York's Fifth Avenue. Santayana sketched a marvelous portrait of the new champion of art:

> Professor Norton, the friend of Carlyle, of Ruskin, and of Matthew Arnold, and, for that matter, the friend of everybody, a most urbane, learned, and exquisite spirit, was descended from the most typical of New England divines: yet he was loudly accused of being un-American. On the other hand, a Frenchman of ripe judgment, who knew him perfectly, once said to me, "Norton wouldn't like to hear it, but he is a terrible Yankee." Both judgments were well-grounded. Professor Norton's mind was deeply moralized, discriminating, and sad; and these qualities rightly seemed American to the French observer of New England, but they rightly seemed un-American to the politician from Washington.[10]

Professor Norton had reason to be sad. He no longer believed in God as had his Unitarian ancestors; and when he looked about him, Professor Norton saw Harvard students whom he had to try to educate into gentlemen.

If Jarves had brought the word to America, Norton would make it flesh by inculcating it in his students. This did not mean turning them into artists or art historians. Art and literature could help, however, to turn them into gentlemen. Here again, as in Europe, art was culture. As R. L. Duffus wrote of Norton: "We must think of him as a very great gen-

10. George Santayana, "Philosophical Opinion in America," in *The Genteel Tradition. Nine Essays*, ed. Douglas L. Wilson (Cambridge: Cambridge University Press, 1967), 101–102.

tleman, indeed, trying to make generation after generation of Harvard students into gentlemen, and through them, to make all Americans more gentlemanly. That is what art and culture meant for him."[11]

Duffus, reflecting on Norton from the perspective of the 1920s, thought it significant that Norton had chosen the Parthenon as the supreme human achievement. "When New England took up art it was natural for it to begin with something as perfect and cold as marble" (18). The inclusion of Greek art within his scope was about the only point on which Norton differed significantly from Ruskin. Otherwise his interpretation of art history differed little from that of his master or, for that matter, from that of Jarves. Culture was represented by Greece and Italy, especially Florence, between the fourteenth and sixteenth century. These were the two great moments of mankind. The eighteenth century had been more generous toward mankind and the past, for it had counted four great ages from the time of Pericles. And it had counted the sixteenth century of Leo X as a great age, as well as that of Louis XIV and Augustus, excluded by Norton.

Before taking his chair at Harvard, Norton had traveled widely in Italy and slowly formed his opinions on art and taste. On his last trip to Italy in 1869, low taste had, in his mind, come to be associated with Paris and New York, and he began to see the same "taste for what is fashionable, fresh and showy" spread even to his beloved Italy. That was another reason to be sad. And there were others. Norton's pessimism may have been a result of the rising influx of immigrants into the United States. To Godkin of the *Nation* this influx represented a threat to culture. Italy and the arts represented to men of this turn of mind a refuge, an enchanting ivory tower, sheltered from the modern—New York and its vulgar multimillionaires, Paris and its fashions, and industrial, brutal, dynamic America. To see Italy exposed to the same disease was sad indeed. And so after some hesitation Norton decided to

11. Robert Luther Duffus, *The American Renaissance* (New York: Knopf, 1928), 18.

return home for good. But it is obvious that teaching in bustling, expanding, energetic America could not mean what studying art had come to mean among the few Europeans engaged in that activity: the scholarly, almost neutral, professional study of the arts in history, in which their development was followed, the various schools delineated, and a survey of civilization made. Art also meant, for Norton and others who began to teach art history—art, for short—after the Civil War in eastern universities, as Vanderbilt put it, preaching "the gospel of art." Norton had three well-defined aims in mind when, in 1874, he began to lecture on art: to reveal the significance of the fine arts as an expression of the moral and intellectual conditions of the past; to illustrate the baseness of present America by way of contrast with the great moments of the past; and to refine the sensibilities of young men at Harvard.

Although he began lecturing in 1874, it was not until 1878 that he lectured on the Renaissance, and not until 1896 that he began using lantern slides to show the monuments he lectured on. Apparently Norton lectured as much on Dante as on Italian art. And since the great moments were Athens and the Gothic period in Florence and Venice, his task was facilitated. His aesthetic principles were simple: the aim of poets and artists was, through the imagination, to achieve the beautiful and the good. He was not at all in accord with trends at that time linking art and literature with beauty rather than with truth, and he deplored the views of a James or Flaubert, according to which the integrity of art existed irrespective of subject matter. Nor was he sympathetic to Zola, whose ignoble subject matter vitiated the sense of beauty and craftsmanship. Norton rejected the modern not only in its incarnation as fashion but also in its arts. He was no more tolerant of the art-for-art's sake tradition or the aesthetic movement; for that also separated art from morality and could potentially be perverse enough to lead to a fascination with the ugly, the strange, the foul, and the evil. Norton was an idealist who, had he been French, would probably have

American Impact, or Shopping for the Ideal

found a place in Taine's *Philosophes classiques du XIX⁰ Siècle* and been made fun of as a late seventeenth-century divine or Cambridge Platonist. In fact, his aesthetics were rather close to the idealism of Victor Cousin. Taine poked fun at this kind of sentimental idealism: "When one speaks of the ideal, it is with one's heart; and you think of that vague dream through which intimate sentiment is expressed; it is whispered, with a sort of contained exaltation; and when it is discoursed upon, it is in verse, or in a cantata; one touches it only with one's fingertips, or hands joined in prayer, as when one thinks of happiness, heaven, or love." [12]

But Norton, to put him back on his native soil, exemplified what Santayana called the "genteel tradition," a feeble, generalized aestheticism quite divorced from a living art. Indeed had Norton remained in Europe surrounded by his rare books he would probably have ended up as a character in a Henry James novel.

The allusion to aestheticism deliberately points to what strikes us as the negative side of the American national character as it took form, influenced by New England, about 1900. The United States may not have had an aesthetic movement presided over by an Oscar Wilde, or an art-for-art's-sake attitude struck by a Theophile Gautier; but one ought never forget Wilde's mot about Boston being refined beyond the point of civilization. There existed a diffused aestheticism that, had theologians been as tough-minded as Americans were in business, would have seen this aestheticism for what it was, a disguised, unconscious, heresy. Consider Mr. Hazard of Henry Adams's novel *Esther*:

> His theology belonged to the High Church school, and in the
> pulpit he made no compromise with the spirit of concession,
> but in all ordinary matters of indifference or of innocent plea-

12. Hyppolite Taine, *Philosophie de l'Art*, 2 vols. (Paris: Hachette, 1909), 2:223.

American Impact, or Shopping for the Ideal

sure he gave the rein to his instincts, and in regard to art he was so full of its relation with religion that he would admit of no divergence between the two. Art and religions might take great liberties with each other, and both be the better for it, as he thought.[13]

Such philosophical confusion makes it difficult not to fall into the heresy of aestheticism of art for art's sake, condemned by the followers of Ruskin. For if art and religion were one, then all the varieties of devotion to art were but so many cults; to exclude all but one was to assume the validity of a single doctrine, in this case art according to Ruskin. Max Nordau was not far off the mark when he called Ruskin a Torquemada. The theologians who, in the corrupt sixteenth century, formulated the church's doctrine on the use of images would have seen through the Reverend Hazard and the followers of Ruskin in a flash and recognized a classic case not of hysteria à la Nordau but of the symptoms that gave rise to the iconoclastic question in the Greek church, the confusion of the image with what it represented—in short, a modern version, quite unbeknownst to its practitioners, of image worship. Aestheticism in the United States existed in a vague, genteel, Protestant form.

Henry Adams himself, it has been shown, had an aesthete's character and view of the world. Like many other cultivated New England minds, he disliked the new America and, by extension, the Renaissance of the Medicis: "There is always an odor of spice and brown sugar about the Medicis. They patronized art as Mr. Rockefeller or Mr. Havemeyer does. They are not Dantesque."[14] He referred to this type of patronage of the arts as the "goldbug taste." Like Norton, he disliked

13. Henry Adams, *Esther* (New York: Holt, 1884), 104.

14. Ernst Scheyer, *The Circle of Henry Adams* (Detroit: Wayne State University Press, 1970), 69.

modern art, thinking it soulless and mercantile, the victim, as he aptly put it, of "the universal solvent of money valuations."

Such attitudes and pessimism explain the American proneness to aestheticism that may well be the most characteristic American trait with regard to the arts. But it is also a bourgeois trait, at its most intense and absurd. The American aesthete was but the obverse of the hard-working Mr. Marshall of Chicago who could not take art seriously. Just as in Henry Adams the Puritan was at war with the aesthete, so Americans were within themselves at odds about art, and the positions, like so many others in the United States, were always at extremes: one was either Henry James's Mr. Newman, "the great western barbarian, stepping forth in his innocence and might, gazing awhile at this effete Old World, and then swooping down on it"; or again, one might be Henry James's Mr. Gilbert Osmond, in whom the lack of distinction between religion and art that Mr. Hazard failed to draw manifests itself as a lack of distinction between art and evil.

There were, it is true, lesser intensities between the extremes; for example, the rather harmless Mr. Ned Rosier who collected bibelots, or Mr. Verver, the retired millionaire who collected bibelots, objets d'art, and even a genuine prince, escaped the utter selfishness of Osmond by thinking of his collection as a future gift to his home town. The American, seen through the eyes of Henry James and also Paul Bourget, was seen to play a central role in nineteenth-century art, if only because he collected, if only because he was usually so much richer than Europeans, and if only because he was such an accumulator. Art collecting was a sublime, pleasurable, novel form of capital formation. Indeed, considered as capital that did not create more capital or yield interest, it was the aesthetic because disinterested form of capital. It was capitalism as the sublime. And among the shadings between extremes occupied by Americans, there were those who put art even before capital, denying the power of money by that of art, as if the Virgin of Chartres, incarnate as a work of art, exercised enough power to

neutralize that of the dynamo. For such people, as James put it in one telling phrase, "life was a matter of connoisseurship" (*PL*, 262). Thus Gilbert Osmond's sole accomplishment, his fastidious taste, compensated for all his negative qualities: lack of talent, lack of genius, lack of prospects, and lack of wealth. There are traits of the dandy in Osmond but not of the European dandy à la Wilde, Baudelaire, or Gautier, all of whom were artists, creators, and fighting a war of style against the bourgeois. Osmond is the bourgeois aesthete, sterile and possessive, snobbishly fastidious. As Madame Merle said, he had to have the best, even in women, which he assimilated to his bibelots. Osmond refined his taste to the most exclusive snobbism. It was his way of asserting his difference in a democratic society. But it was not nobility that required a role or meant obligations. In Osmond, aestheticism, taste, fastidiousness, "implied a sovereign contempt for everyone but some three or four very exalted people whom he envied, and for everything in the world but half a dozen ideas of his own" (*PL*, 430). This was the Puritan's certainty of his election on the aesthetic plane. Everything was damned, everything was vulgar, everyone more or less lost; and he, Puritan that he was, must keep himself unspotted. His fastidiousness was a species of perverse saintliness, perhaps the only one open to the late Puritan type. Osmond's view of the world is indeed reminiscent of what students used to say about Norton's continuous harping on the "horrible vulgarity of it all." But for all his contempt of the world, Osmond did not withdraw from it; for he needed it to assert his superiority, live his false aristocratic life, and assume his pose, which was good enough to have seduced even as bright a girl as Isabel Archer. And the pose he assumed was a pose in the void.

It was an instance of a pervasive nihilism. Osmond himself put the finger on what was wrong with his position and that of most Americans living in Europe: "I sometimes think we've got into a rather bad way, living off here among things and people not our own, without responsibilities or attachments, with nothing to hold us together or keep

American Impact, or Shopping for the Ideal

us up; marrying foreigners, forming artificial tastes, playing tricks with our natural mission" (*PL*, 260). In contrast to this exile, the great western barbarian who swept down on Europe and then flew back home with his booty was better off, for at least he returned to breathe his own air. Those who stayed in Europe with their bibelots, no matter how splendid their villas or the gardens, lived in a hothouse culture. They looked at the culture and life of Europeans through tinted glass.

The American aesthete and exile had no historical or organic ties with the works he admired and sought after, a theme that not only preoccupied Henry James but was also central to Edith Wharton's *The Custom of the Country*, which, as we shall see, is concerned with one particular type of American abroad. This distance between Americans and Europeans was not lost on French novelists either. It was a frequent interest of Paul Bourget and was also alluded to by other novelists. Pierre de Coulevain's intriguing novel *Noblesse americaine* (1907) illuminates differences not only of national character but also of attitudes toward the arts and culture. In the story Annie Villars of a prominent old New York family marries the impoverished Marquis d'Anghuilon. There is the classic case of the rich American heiress marrying poor but authentic French nobility, though in this case it is also a love match. The newly wed couple spends a few weeks in Rome, where, in the contemplation of works of art, cultural differences and perhaps also class differences are brought to light:

> Every day the young woman went forth with her Baedeker. Arrived in some museum she went either to the left or right and stopped before the first wall of pictures, looked an instant into her guide, raised her eyes back to the painting, looked at it for a time more or less long, then recommenced with another picture and repeated the exercise for hours with a real pleasure and unequalled conscientiousness. She was not wrong in her admiration and sincerely enjoyed the sight of these masterpieces.

American Impact, or Shopping for the Ideal

> They charmed her eye without prompting in her any emotion.
> She saw and saw but she felt not.[15]

Annie was dutiful about enjoying art. She may even have been to Vassar and taken an art history course and undoubtedly was far more knowledgeable about art than her husband the marquis. He did not bother reading Baedeker at all. He looked at far fewer pictures than she did, but he felt, was touched, by what he looked at. It meant something else to him. One evening, as they left Saint Peter's basilica at dusk, they heard the angelus ringing and the effect of light and sound and the grandeur of the architecture was such as to stop the marquis in his tracks and to mutter How beautiful, as he was seized by the moment. "'Superb! immense!' Annie cried out, 'but I don't remember how many feet the piazza and colonnade measure; I must go see'" (233).

Annie was obviously not a Henry James character, though she did have sensibility and intelligence and was undoubtedly more sophisticated about art than Newman who had masterpieces copied to take home with him. The difference between Annie and the marquis is cultural. And it would take time for Annie to note the subtle differences between Americans and Europeans even though they might share the same art works—the Americans having purchased them; the Europeans having inherited them and sometimes lived with them so long they were taken for granted until some such experience as the marquis underwent made them take notice. Annie needed time to understand the difference. As she settled in her Parisian life and the summers at the ancestral chateau in the Bourbonnais, she noted the differences: "By comparing the old manor house with the finest dwellings of New York, she realized better than she ever had, the difference which exists between an aristocracy and a plutocracy" (282).

This difference existed also in Europe between the old nobility and

15. Pierre de Coulevain, *Noblesse américaine* (Paris: Ollendorf, 1907), 231–232.

American Impact, or Shopping for the Ideal

the varieties of new nobles: imperial nobility created by Napoleon, nouveaux riches, cosmopolitan society, and Henry James characters might have understood the difference without going to Europe simply by comparing Boston with New York or, worse, Chicago. Thus Boston, even for Europeans visiting the United States, became the cultural center of the United States. And in Boston, even clutter escaped—though just barely—being bad taste. One European visitor offered the following description of Mrs. Gardner's Boston interior of the 1890s:

> A sober elegance is the distinctive trait of this [Boston] society which wishes to show its refinement in all things. To be sure the splendors of luxury are not absent, but their éclat is muted, so to say tempered by good taste, which is not always the case. I could, for example, name a particularly opulent home which might all too easily have looked like some well-furnished bric-a-brac shop or some pretentious museum of decorative arts. But with the greatest tact succeeded precisely in avoiding this danger, so that nothing was *de trop*. From the altarpieces dislodged from Italian churches, bibelots from the eighteenth century, masterpieces of German and French painting, to the portrait of the lady of the house,—the most beautiful Sargent ever painted—, everything was in its place, even the flag of Napoleon's Grenadier Guards which, by the corner of a Renaissance chimney, tells the glories of French armies. No clutter, no profusion, no show; it all fitted into a savant harmony; it was simply the exquisite frame for a charming woman.[16]

But if Boston represented America's high culture, the price paid for it was a certain dryness and sometimes even exile, that is, maintaining the purity abroad.

16. Th. Bentzon, *Les Américaines chez elles* (Paris: Calmann-Lévy, 1893), 113.

Isabella Stewart Gardner, *by John Singer Sargent.*
Isabella Stewart Gardner Museum.

American Impact, or Shopping for the Ideal

Osmond and, to a lesser degree, Ned Rosier and Mr. Verver exemplify this peculiarly American high ideal of culture, taste, and artistic perfection almost to the point of death. It implies the museum mentality, the association of culture with a past, and the consequent rejection of the modern, thriving, vulgar, but living world, which is, after all, the condition of their disdainful aestheticism. But the fastidious aesthete who had to have nothing but the best was but one extreme of the American intervention in the art world.

The other extreme shall be called "the swooping barbarian." The aesthete picked and chose; he might exile himself, lose himself in the rarefied atmosphere of Europe's own cosmopolites, aesthetes, decadents, and nobles out to regild their arms by marriage to an American heiress. But not everyone was high church, capable of being saints in the world of high culture. The swooping barbarians—the wife and daughter of Mr. Marshall of Chicago, or the graduates of Vassar, Bryn Mawr, Smith, and even Wells College—all found a more direct way of acquiring culture. After the proper preparation of some course on art history or appreciation or simply reading Ruskin, they simply traveled to Europe, did the sights, and returned with culture to create museums, perhaps even teach courses in art. For even the barbarians— and the word was hard and rather unfair—believed in culture after Jarves, Ruskin, and Norton. It was preached at them in Harvard; it was lectured on at Yale and Princeton; even in Minnesota, thanks to Professor Gabriel Campbell of the Department of Mental and Moral Philosophy, art was taught. It was, indeed, a most noble and elevating subject, taught by a great many reverends: the Reverend John Bascom, the Reverend John Lansing Raymond, the Reverend James Mason Hoppin. They all prepared the great descent that the older generation of Henry James found somewhat vulgar. But the swoopers knew they were shopping for the ideal. As Paul Bourget noted on his tour of the United States in 1893: "You have to hear the Americans pronounce the word *art*, simply and with the article, to understand the profound zeal they

American Impact, or Shopping for the Ideal

feel to refine themselves, and also this word *refined*, ever on the lips of my fellow writers as I visit their club."[17]

The result of the American search for the ideal was, much as in Europe, the bibelotization of art. Because there was a great deal of money in the United States, there were a great many bibelots to be bought. For swooping down on Europe for the ideal meant shopping in the great bibelot bazaar. For Newman, an international flaneur, Europe—indeed the world—was "a great bazaar where one might stroll about and purchase handsome things; but he was no more conscious, individually, of social pressure than he admitted the existence of such a thing as an obligatory purchase."[18]

A further result of this international shopping for the ideal manifested itself in the bibelotization of the American home. The Gilded Age was the eclectic bibelot age. Paul Bourget saw in Newport what he considered the result of American shopping abroad: Elizabethan houses, French Renaissance châteaux, French eighteenth-century châteaux or town houses, Italian villas, and, within these, riches beyond belief, all of which he thought a result of the unconscious desire or need of the American to ennoble himself with a sense of the past, an honest need, Bourget thought, and one that saved these houses from what would otherwise have been brutal vulgarity. There was something pathetic, yet poetic about this need for something from the past in this materialistic world of the "check and the chic." And yet, there was perhaps just a trifle too much from the past.

In a novella called *Deux ménages*, Bourget is given a letter of introduction to a Mrs. Tennyson R. Harris of Fifth Avenue, who lived in a white marble construction in the manner of the Château de Blois. However, as she is in Newport for the season, the narrator takes himself there to be received by Mrs. Harris in a room that is meant to seem Parisian but does not quite succeed:

17. Paul Bourget, *Outre-mer*, 2 vols. (Paris: Lemerre and Meyer, 1894–1895), 1:49.
18. Henry James, *The American* (Boston: Houghton Mifflin, 1907), 66.

American Impact, or Shopping for the Ideal

Mrs. Harris received me in a species of boudoir with windows on the sea in which I immediately found an image of the salons I'd seen in Cannes, but it was a parody by excess of imitation, a caricature by way of *outrance*. Too many prints, too many pictures on the overly rich wall fabric, too many flowers and too big in too many precious vases, too many small English silver objects on tables, among too many photographs of princes and princesses, all with dedications. As for Mrs. Harris herself, she too seemed almost too beautiful, with her too red mouth, her too scrubbed teeth, her overly polished hands with their abuse of rings, and her dress was so much the fashion that she seemed a *femme-affiche*, a couturier's fashion model he'd had the genius to doll up for export.[19]

Mrs. Harris knows all the latest Paris gossip, has read all the latest books, so late indeed that Bourget hasn't even seen them in the Paris bookshops. Bourget got the impression of an America with a thin European veneer. And the dinner too, that evening, is also just too luxurious, what with Meissen dinnerware, a Sèvres service of imperial origin, and the portraits of Louis XVI and Marie Antoinette, duly inscribed *donné par le Roy*, hanging on the wall. And when Bourget accompanies Mr. Harris to Georgia in his private train he also notices a small library of 200 volumes, all first-rate and beautifully bound, and learns that in his off hours Mr. Harris works at his culture: "It is a big word which Americans always have on their lips and on their mind, and which they apply with equal seriousness to morals and gymnastics, as in *ethical and physical culture*" (V, 168). Poor Mr. Harris, Bourget also finds out, is the slave of Mrs. Harris's cultural snobbism and ambition. This truth is revealed to him in a curious performance they witness together in which a husband-wife team perform in a variety show. The wife declaims sublime poetry in free verse of her own creation

19. Paul Bourget, *Voyageuses* (Paris: Nelson ed., Calmann-Lévy, n.d.), 161.

and is politely applauded; the husband, a contortionist of uncanny ability, is wildly applauded and rakes in the money. The wife looks with disdain upon her husband's "art" and treats him as a nothing. Bourget is suddenly struck with the resemblance they bear to Mrs. Harris and Mr. Harris. In short what Bourget sees in this story and in his *Outre-mer*, his book about America, is a moral, democratic version of the relation that obtained between luxury and the grande cocotte of the Paris of Napoleon III and Louis Philippe. There are no cocottes in Newport—no adventurers either, he notes, only men who had earned their fortunes; but there are women who are voracious culture con-sumers, as expensive as the demimondaines only set on a pedestal. They are ladies, they are pure, and they are, for Paul Bourget, symbol-ized by the great John Singer Sargent portrait of Mrs. Jack Gardner, cleverly represented so as to appear almost saintly.

This need Americans have to surround themselves with objects that represent the dimensions of time, he thinks, is easily explained in a country in which everything dates from yesterday. But this need for duration can also have comic effects. In the villas of Newport, Bourget notices portraits of a Genoese grand siegneur, a Venetian admiral, an English lord of the eighteenth century, Louis XV by Van Loo, Louis XIV by Mignard, and a portrait of Napoleon with one of the flags of the grenadiers, whereupon someone remarks, "Yes, they have the portrait of the grand emperor, but where is the portrait of the grandfather?" (*OM*, 1:79). It is a telling witticism pointing less to the alienation of the owners, probably well-meaning swoopers, than to society in which art no longer functions as it did in its own past but has been reduced to the status of a bibelot, bought by someone who probably knew nothing of what it once had meant.

That some Americans did not understand the meaning of the bibelots or objets d'art they bought is a frequent theme in Henry James as well as Bourget and made devastatingly clear in Edith Wharton's cruel *The Custom of the Country*. For Undeen Spragg, from Ohio—later

American Impact, or Shopping for the Ideal

Mrs. Ralph Dagonet of a distinguished New York family; still later Comtesse de Chelles—Paris meant luxury, shopping, clothes, modernity. Italy, being art, meant boredom. And for Undeen, one of the Jamesian swoopers, art meant bibelots that could be exchanged for the life of luxury. Undeen marries de Chelles, who, being noble and burdened with a château in the country, can hardly afford to live in Paris. When Undeen wants to leave the country to live in Paris continually, de Chelles says they cannot afford it. Undeen then immediately thinks of selling the Boucher tapestries in the château that have been with the family since the eighteenth century, whereupon de Chelles says: "Ah, you don't understand." Indeed, for de Chelles and many representatives of his class, Boucher tapestries, family portraits, pictures, old furniture, all represent their past, their race, their traditions, their very being as nobles, not to mention the remains of a lost position. These were no mere bibelots. Given the right price, they were something an American could obtain. The clash between the swoopers and the swooped upon was inevitable and de Chelles unleashes his anger at Undeen:

> You come among us from a country we don't know, and can't imagine, a country you care for so little that before you've been a day in ours you've forgotten the very house you were born in—if it wasn't torn down before you knew it! You come among us speaking our language and not knowing what we mean, wanting the things we want, and not knowing why we want them; aping our weaknesses, exaggerating our follies, ignoring or ridiculing all we care about—you come from hotels as big as towns, and from towns as flimsy as paper, where the streets haven't had time to be named, and the buildings are demolished before they are dry, and the people are as proud of changing as we are of holding to what we have—and we're fools enough to imagine that because you copy our ways and pick up our slang you un-

derstand anything about the things that make life decent and honorable for us![20]

But the swoopers were irresistible. As Undeen leaves de Chelles for Moffat, an old attraction from her Ohio days who has become rich on Wall Street, so do the Boucher tapestries. The old world, both American, as represented in *The Age of Innocence*, and European, as represented by de Chelles and others met in the novels of James or Bourget, had no chance against Wall Street. And art, too, had no more chance against the modern world of luxury and swoopers than did its products past and present, assimilated to the world of things and the nouveaux luxe that Undeen loved so much. But as Undeen is finally satisfied because her new husband, Moffat, can provide all the *things* she craves, Moffat, true American that he is, develops a growing passion for pictures, furniture, tapestries, and a collection of unmatched masterpieces, as if somehow a killing on Wall Street did not suffice to give him a feeling of substance or achievement. And that Moffat, the swooper, vulgar, uneducated, calculating Wall Street speculator and barracuda, should also, after having made his pile, think of collecting works of art sets the seal on this strikingly American passion.

Henry James, returning to the United States toward the end of his life and meditating on the newly founded Metropolitan Museum of Art, did not miss the significance of this passion shown even by a Moffat. The aim, he concluded, was not so much aesthetic enjoyment but acquisition:

Acquisition—acquisition if need be on the highest terms—may, during the years to come, bask here as in a climate it has never before enjoyed. There was money in the air, ever so much money—that was, grossly expressed, the sense of the whole intimation.

20. Edith Wharton, *The Custom of the Country* (New York: Scribner's, 1913), 545.

American Impact, or Shopping for the Ideal

And the money was to be for all the more exquisite things—for *all* the most exquisite except creation, which has to be off the scene altogether; for art, selection, criticism, for knowledge, piety, taste.[21]

But ostensibly it was all to educate the sense of beauty to the soul and the mind; it was all for the spirit, the trade value of the objects being merely accidental and incidental. But James seems to be hinting, by his insistence on acquisition, that in bourgeois society even acquisition has been sublimated onto the aesthetic plane. "The Museum, in short," he continued, "was going to be great, and in the geniality of the life to come such sacrifices, though resembling those of the funeral-pile of Sardanapalus, dwindled to nothing."[22] The funeral pile was really that of the Old World; and it was a pile of bibelots.

One may read this magnificent intimation of the meaning of the Metropolitan Museum, and perhaps of the American type of museum, as the synthesis of two conflicting tendencies regarding art observed within Americans: the idealist strain tends toward aestheticism; and the swooping tendency was to accumulate, acquire, consume, pile up. The American museum of art was the result of a partnership among Osmond and Moffat and Undeen Spragg. The museum had become possible because the world of exiles and shoppers was part of a huge, international, though not always obvious, art market, the cosmopolis.

21. Henry James, *The American Scene* (New York: Harper's, 1907), 186.
22. Ibid.

Cosmopolis, or the
Snob's Progress

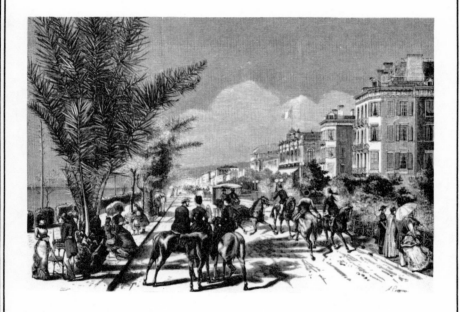

Promenade des Anglais. *Nice, France. 1881.*
Historical Pictures Service, Chicago.

Titles, no matter what anyone may say,
have more value than ever.
A title is as pretty as period furniture or old Gobelin tapestries,
and it decorates a woman far better
than her toilette or her diamonds.

The Duchesse de Blanzac in Pierre de Coulevain's
Noblesse américaine

Having exhausted the possibilities of the Paris *passages*, the flaneur as collector and aesthete—or even as American swooping down on old Europe—took on his final nineteenth-century form and turned cosmopolite; he boarded a train for Italy, home of the arts, refuge of aesthetes, market for antiquarians and experts, turn-of-the-century playground of the cosmopolitan crowd.

Walter Benjamin had interpreted the flaneur as assessing the marketplace of ideas and literature. We have seen Paris turn into a marketplace of articles de Paris, nouveautés, luxuries, *grandes cocottes*. The luxuries proved irresistible to Undeen Spragg who found Italy, and even the delightful hillsides of Siena that de Chelles loved, boring in contrast to the Paris of the rue de la Paix and the rue de Rivoli. But Italy in other company might have attracted Undeen as she had liked St. Moritz. For she had found there the cosmopolitan world that her husband de Chelles defined as "a kind of superior Bohemia, where one may be respectable without being bored." And Bowen, a character in the novel to whom this was addressed, answered: "You've put it in a nutshell: The ideal of the American woman is to be respectable without being bored; and from that point of view this world they've invented has more originality than I gave it credit for" (C, 274).

Undeen on her honeymoon with de Chelles was not ready for Italy. She had been too much taken with the modern to appreciate the true

refinements of Italy. Indeed, Italy, in contrast to that modern world deplored by the idealists, provided other "sensations," to use a fashionable term of about 1900. And one might call these sensations the countersensations to those provided by the magasins de nouveautés and the modern chic of Paris. The flaneur who had been attracted by the modernity of Paris learned in time to appreciate new sensations, and in Italy these were sure to be aesthetic and artistic. The sensationalism—the desire at the base of the modern city, the commercial and industrial civilization of the new world, and the Paris of the second empire—was transferred to the objet d'art. Thus the danger of being attracted to Parisian luxury products, slightly vulgar for seekers of the ideal, would be wholly dissipated in Italy. The fastidious aesthetes as well as the swoopers were pleased by Italy since it proved to be one vast marketplace if you but knew the right people and found the right advice. By 1890, the flaneur had turned into a snob and joined cosmopolis. Cosmopolis knew no frontiers but had its cities, its beaches, seasons, casinos, and its icons that were all a must.

The cosmopolis of Paul Bourget or Henry James was the art world of the high bourgeois epoch; it represented a dimension and space in which art, money, aesthetics, tourism, and connoisseurship blended into a form of snobbism ever in search of what Henry James called in a short story, "the real thing." In the search for this real thing, Paris had been but a first step, as the Louvre had been but an introduction to the far vaster art reserves of Italy, and as the articles "de Paris" had been but an introductory lesson in desire and acquisition preceding the last lesson, the acquisition and appreciation of that sublime bibelot, the objet d'art. The first Mrs. Verver, introduced in *The Golden Bowl* only as a memory, had been taught the joys of acquisition by Mr. Verver and had also, under his guidance, graduated from the rue de la Paix onto a higher plane; Mrs. Gardner of Boston had taken the same ascending road to the sublime, as she graduated from dresses by Worth, which

Cosmopolis, or the Snob's Progress

stunned Boston, to famous jewels, which dazzled, to a palace filled with the very best objets d'art, which showed Boston just who she was.

In this bourgeois search for the material grail, Paris was a school for distinction and snobbism, providing instruction in the various stations to be reached, the indispensable lines to know, the best shops to frequent. In this new version of a rake's progress, the snob's progress, Paris as well as London offered the flaneur in his last incarnation the image of a life-style in which the bourgeois thought he at last approached the poetic, aesthetic, dashing (and now defunct) nobility of the old regime. Ah, but was it really noble? Was it really the *real thing*?

The preconditions of the snob's progress were two: letters of introduction and letters of credit. The latter was most important. Money, which Henry James found to be in the air about the Metropolitan Museum of Art, circulated around the grand hotels, the famous beaches, the casinos and villas of the cosmopolitan set. Generally, money meant unearned income, based on vast holdings of real estate, bonds, or stocks; or, if recently acquired, money usually meant income from a huge stock market coup or cleverly arranged bankruptcy followed by even more cleverly arranged suppression of scandal, though there were bound to be whispers about such and such. In this world of cosmopolis represented by the novelists of the fin de siècle, only the Americans were singled out as having made their fortunes the hard way. They might be in Europe on a tour, but they kept up with affairs at home, directing them from afar and ready to be called back at any time to save a situation. There were intimations of disasters, of immense deals and immense wealth. The American man of business abroad appeared not as a robber baron but, rather, as a new type of feudal lord. In contrast, the Europeans seemed to be connected with banking, which allowed one a certain leisure. But, generally speaking, it was best to avoid talk of background and the origins of someone's fortune:

whatever was not connected with income from noble land was bound to be somewhat vulgar, just as the Medicis had appeared somewhat vulgar to Henry Adams. In any case, work (meaning a few hours at the office or the stock market) played no role in cosmopolis, was not talked about, was not even assumed, though money was. The ideal was to have an income more than sufficient to be free from having to step into an office at regular times, or at least for a time short enough to leave the evenings open for a social life. And if, like Dickie Marsh (a Paul Bourget character described as a Napoleon of business from Marionville, Ohio), you had to keep an eye on your vast holdings and their management, then you might travel on your yacht, along with three secretaries who kept continually in touch with affairs at home so that any important decision might be made on the spot. But if you had enough wealth to live in the accustomed luxury and felt no inclination to oversee your investments too closely, then you had twenty-four hours a day on your hands and the question arose as to what to do with them.

The form that leisure took among the inhabitants of cosmopolis explains why some Americans preferred to stay in Europe rather than return home, quite aside from their search for culture and refinement. For as Ned Rosier said succinctly: "There's nothing for a gentleman in America." It was a country where everybody worked. Mr. Marshall could not understand why his son, upon his return from Europe, wished to live the life of a gentleman and, rather than work, do something vaguely connected with art. Even that very refined gentleman Charles Eliot Norton worked; he taught art at Harvard. There was no place in the United States for someone whose occupation was doing nothing. For a man there seemed no alternative to work. Bourget, in Newport, had been struck by the lack of adventurers and fortune hunters. Cannes, Nice, Baden-Baden, Cabourg, Biarritz, all had had their adventurers—men who were gallant to women and lived by gambling and marrying rich heiresses, who went about with the rich and fre-

Cosmopolis, or the Snob's Progress

quented the best circles, but in any case, did not work. Women in the United States, the women of the rich, that is, were the true leisure class as Europe understood the term. They had their clubs, teas, social ambitions, charities, churches; accordingly leisure had come to be thought of as something for women, and husbands the guarantors of such leisure and what went with it, namely, culture and refinement.

But in Europe, a gentleman by definition did not work and found there were a great many agreeable ways of doing nothing, such as spending accumulated capital. Interest in art or culture provided but one possible answer to the question of how to spend one's time and money in the rites, activities, and displacements of cosmopolitan society. This high life, which was not necessarily aesthetic though it had its style, produced several social types of which the Jamesian aesthete is the exception; one does not imagine Ned Rosier or Gilbert Osmond at the races. Aside from the general category of snobs, a term widely used to designate most of "society" before 1914, there were the *viveurs* and the *fêtards*, high livers and prototypes of what would later be called playboys, themselves derived from previous types of an earlier age such as dandies and lions of the romantic period.

Raymond Casal, one of Paul Bourget's characters, is a good example of the better type of viveurs. Better in that he was no vulgar fêtard or *noceur* and had style, dash, and a shrewd knowledge of the world that kept him from being taken in by it. Intelligent, worldly, a good sportsman, an excellent shot—highly important in a society that still settled affairs of honor by duels—and a known seducer, he was no aesthete; neither was he particularly interested in the arts or in letters, horses and women being more his affair. Casal outlined the life of a viveur one night in a moment of boredom in which he had two hours to fill but nothing to fill them with:

> In the morning there is sleep, one's toilette, and horse riding.
> After lunch there are always a few minor affairs to settle; then,

Cosmopolis, or the Snob's Progress

from two to six, there is love. If there is no love, there is always tennis or shooting and fencing. From five to seven, poker. From eight to ten, dinner. From midnight to morning, gambling or *la fête* [which might be interpreted as touring the demimonde]. From ten to midnight there is the theatre, true, but how many plays are worth seeing twice? One really ought to find a way of filling those two hours. Perhaps form a club just for that purpose.[1]

This life required not only a good constitution but also a good deal of money. Bourget estimated that the viveur required an income of about 150,000 francs a year to live in style. With that, Paris was his. He might belong to one or two chosen clubs that the young bourgeois sought vainly to enter. Such was the *viveur de grande espèce* who married at forty to recoup his fortune and continue his life by spending his wife's dowry. As for the society he belonged to and in which he moved, it had a hierarchy, constitution, unwritten rules and customs, and even a geography. It was a cosmopolis:

> Half European, half French which filled the greater part of the *hôtels* situated around the Parc Monceau and the Arc de Triomphe, as well as a small number of old *hôtels* on the Left Bank. This society has well-established revenues, a strict etiquette, galleries of authentic pictures, carefully kept carriages, loges at the opera, sensational receptions, in brief, an opulent high life decor. This modern society resembles the age to which it belongs and whose luxury-aristocracy it represents. Like the times it is mobile and improvised, all of contradictions, and deprived of tradition. A great fortune, provided it was acquired without too much scandal, will force open the door, as will talent, provided it

1. Paul Bourget, *Un Coeur de femme* (Paris: Lemerre, 1890), 82–93.

Cosmopolis, or the Snob's Progress

does not show its native egotism. But ruin, on the other hand, puts a lock on this door which is hardly ever unlocked.[2]

The geography alluded to in this passage, the Right Bank and the few *hôtels* of the Left Bank, points to a merging of the bourgeoisie, the *côté de chez Swann* in Proust, with the old nobility of the Faubourg Saint-Germain, the *côté de Guermantes*; but this merging also included the new money aristocracy of well-to-do Jewish families involved in banking and finance. It was not an open society but exclusive, despite the fact that it was based on something classless in theory, namely, money. As Claude Larcher, one of Bourget's many writer-characters, explains to René Vincy, a budding writer just invited to his first reception in society:

> You will enter society, my dear, and you will be received often; but you will never be part of it, no more than I am, no more than any other artist, no matter how much genius he may have, because, quite simply, you were not born in it, and because your family is not of it. You will be received and parties will be given in your honor. But try to marry into it and you will find out. . . . As for those women you dream of as being delicate, fine, and aristocratic! if you only knew them! They are vanities dressed up by Worth and Laferrière. . . . There are not ten among them capable of true emotion.[3]

The artificial nature of this society, uprooted, traditionless in the view of conservatives like Bourget or exiles like James, was reflected not only in its exclusiveness, its way of trying to appear as an aristocracy, but also in its very architecture. Though "galleries of authentic pic-

2. Paul Bourget, *L'Irréparable* (Paris: Plon-Nourrit, 1901), 7.
3. Paul Bourget, *Mensonges* (Paris: Lemerre, 1898), 45.

Cosmopolis, or the Snob's Progress

tures" were mentioned by Bourget as signs of this world, the use of the epithet is significant as it implies not only a search for the real thing but also a world of the inauthentic, in close proximity, that must at all costs be avoided. The alliance between art and this millionaire society was likely to be based on luxury rather than that of true taste and discernment cherished by the connoisseur, amateur, or scholar.

Bourget explained in *Pastels* that democracy in the nineteenth century had had both a political and an economic effect, the latter in the realm of commodities and the world of luxury. The democratization of society and the economy had put in the reach of all what he aptly called:

> *un à peu près de luxe*, an almost but not quite luxury. By extension the same causes had produced an almost but not quite true elegance and high life which sufficed, for the undiscerning, to create the illusion of the real thing. The *à peu près* or near enough had its symbol and principal means of action in the great novelty stores, the department stores, whence women issued forth as if dressed by Worth, as if furnished with period furniture, and as if truly enriched by the curios purchased. But the toilette, the furniture, the bibelots were, alas, only almost that,—and this almost but not quite that sufficed to maintain the distance necessary to fool the undiscerning.[4]

The nearly enough sufficed to satisfy the many who could not afford the real thing. The real thing could only be bought and acquired by those who had real fortunes, that is, very great ones. Thus the viveur or higher liver with his 150,000 francs a year could live the real thing: but below him, at a lesser level of fortune, lived his à peu près, his imitation, almost but not quite the real thing, who lacked a "*je ne sais quoi*

4. Paul Bourget, *Pastels* (Paris: Lemerre, 1899), 5.

Cosmopolis, or the Snob's Progress

of nobility or position, fortune or personal tact. It could be a bourgeois ashamed of being one, a stranger trying to be a Parisian, etc. . . , and he in turn would have his 'nearly almost the real thing,' the son of a tradesman who in his turn would have his approximation, the rich student from the Provinces who wished to be initiated into the high life only to be entered into a life of corruption." (5).

This life of the *fête parisienne* and its cosmopolitan counterpart, its setting in ancient or modern *hôtels*, châteaux, villas, or grand hotels, amid its bibelots, authentic or nearly so, was in the last analysis that of Thorstein Veblen's famous conspicuous consumption. The ritual of the viveur coincided with the conspicuous spender: "fashionable restaurants and fashionable theatres, the race course in the spring and autumn, the terraces of Monte Carlo in winter, the beach at Trouville or the Casino at Aix-les-Bains in the summer, the salons of dressmakers, linen drapers in vogue, and petticoats elaborated by these artists."[5] There were of course other places to know and be at the right time with the right people. Cosmopolis had its places of high pilgrimages: Bayreuth to hear Wagner (you couldn't really hear him anywhere else, my dear); Orange, Nîmes, Béziers for Gallo-Roman antiquities; Baden-Baden for the waters and the casino; Dieppe, Cabourg, Deauville, Biarritz, Cannes, Nice for the right beaches and promenades and, again, the casinos; St. Moritz to escape the summer heat; Scotland to shoot grouse; London for its social season, grand luxuries, and social cachet; and then, of course, there was Italy for aesthetic experiences. Italy, for cosmopolitan society, mobile, exiled, restless, was the closest thing to home.

Italy was a very special, privileged place in late bourgeois culture. It not only had an immensely rich artistic heritage to be pilfered and rummaged in by millionaire Americans. It was also the source of

5. Paul Bourget, *Dualité* (Paris: Plon-Nourrit, 1901), 184.

Cosmopolis, or the Snob's Progress

infinite, ever-renewed, aesthetic experiences and discoveries, sensations and enthusiasms. Italy was the center of cosmopolitanism, the hub about which the cosmopolite world revolved. Bourget set his novel *Cosmopolis* in Rome not in Paris, which was reserved for other aspects of the late bourgeois world; and another of his studies of cosmopolite mores, *Une Idylle tragique* was set in Nice and Cannes. But Rome he used as a setting for the type of international society of millionaires, mostly Americans, Jewish bankers and financiers, impoverished nobles, collectors, aesthetes, fashionable writers, ruined or eccentric Italian princes, even slightly mad scholars and anarchists, which made up cosmopolis. Dorsenne, Bourget's protagonist, a successful, fashionable, cosmopolitan, and therefore rather nihilistic writer, pessimistic, believing in nothing, committing himself to nothing, is in Rome writing a book about Italy. Who was not writing a book about Italy around 1900? Bourget himself had written one entitled *Italian Sensations*, a title that bespeaks the basis of aesthetics and aestheticism about 1896, what with all the talk and writing about tactile values and empathy around that time. It was a title, however, also directed against the rising "scientific school" of art criticism that insisted upon the right attributions of the works one might see in small, out-of-the-way Italian churches, a criticism so obsessed with attribution as to forget the amateur observer's capacity for pleasure. Bourget proclaimed the flaneur's right to enjoy Italy and its works of art even at the risk of wrong attributions.

Within Italy there were places of particular election and association. Florence was a dream of lightness, art, mysticism à la Botticelli and Fra Angelico, a city whose sublimated love of the body could be seen in the forms of fine adolescent youths; but, above all, it was the city of art and the Renaissance, no longer disapproved of by Jarves or Adams. The "quinzaine de Florence" was a must in the early spring when the light and air were pure and fresh. To live there was somehow to live in the company of Lucca della Robbia, Sandro Botticelli, Fillippo Lippi,

Cosmopolis, or the Snob's Progress

and the great Donatello. And there was so much to learn in those mornings in Florence as one wandered about the city with Mr. Ruskin's little red book, entitled, precisely *Mornings in Florence*. But the city also satisfied and stimulated the diseased, languishing, fragile, and slightly perverted souls summarized and defined by the lily and the iris. The atmosphere of Florence was definitely Paterian; Jarves and the other Puritans who had approved of early and late medieval Florence but frowned on the Renaissance were gone; it was all right to love the Mona Lisa, to ponder Leonardo, and to talk of Michelangelo. And in the hills above the city of Alberti and Brunelleschi, those evocative names conferring distinction on those who knew them, the rich and cultivated, the cognoscenti and the aesthetes, the rich Americans and the English *milordi* lived in villas set in delightful gardens, studied and described by Mrs. Wharton and illustrated by the late post-pre-Raphaelite Maxwell Parrish. Here were the privileged of cosmopolis, who knew the real thing and were aware of their art sensations. But for the cognoscenti and those sincere Americans ever on the search for culture—or for a bargain—even this place of privilege was not enough. Those in the know went beyond Florence into the hills, to Siena or Pisa, and to the Umbrian hills where hidden treasures might be glimpsed in little hillside churches, where perhaps truer sensations might be felt than at the Uffizi, already so crowded, already threatening one's art sensations and obfuscating the tactile values.

And of course there was Venice, also a special place of pilgrimage for the lover of beauty and the seeker of special sensations. It was, perhaps, a more complex aesthetic experience than Florence, which, as everyone knew, was the Renaissance, a bit intellectual, even if spiritual. Venice offered something else. If in the eighteenth century one had come to Venice for the carnival, in the fin de siècle bourgeois culture one went to Venice for romantic associations, remembrances of great loves past, Musset and George Sand who had loved and wept there and written books about it later. Wagner had died there; and Nietzsche,

Cosmopolis, or the Snob's Progress

too, had stayed in Venice. Venice seemed to attract those aesthetes fascinated with death and decay, an association best captured by Thomas Mann's *Death in Venice*, in which the city represents both the south, light, and warmth but also its corruption and misery, its *far niente*, and its end to the categorical imperative. And for the less effete bourgeois, there was the ritual of life at the grand hotel, the hour for tea, the beach, the visits to churches and museums, the princely life in some rented pallazo on the Grand Canal.

Indeed, if Florence induced a dream of spirituality or spiritualized sensations, Venice was the experience of the beauty of matter, color, delight in the senses, delight in the pleasures of sight. It was also a perfect refuge from progress, that terrible progress that turned the world ugly with its factories and produced an ugly mood among the working classes. In Venice the lower classes were so much happier; they sang as they maneuvered the gondolas for the rich tourists. It was almost a privilege to be poor in such a place of beauty. Venice with its watery world, its shimmer and gliding gondolas, was an image of the vague, the fluid, the infinite, the eternally languid that the fin de siècle loved so much. Venice was a watery Carrière, the dissolution of form in Turner and Monet, a grand opera in Tiepolo, a masquerade, the ultimate illusion of beauty in which the false aristocracy of cosmopolis mirrored itself. But there was a touch of death about the place, and a melancholy and romance summed up in Giorgione. Here the tactile values of a school of art inspired by mind and form yield to optic values. The divine Sandro yields to the tender reverie of Giorgione. Here, on the Rialto and among the still, brilliant waters of the lagoons, rather than in misty Holland, one could find the true reflection of Baudelaire's *luxe, calme, et volupté*.

One could also speak of Rome, Naples, Pisa, and Orvieto, and so many other cities, all with their sense of place, their particular sensations, their treasures—but there are enough guide books for that. From another point of view Italy was not so much sensations as a mar-

ketplace for both swoopers and aesthetes. It was the ultimate bazaar where culture lay within reach and could sometimes be had for a song. Here Americans might safely turn into dilettanti. Here at last that American desire to satiate the eye, which Paul Bourget thought developed among Americans to a higher degree than among Europeans, could be fulfilled. But the delight in works of art, the seeking out of aesthetic and artistic sensations, was but the sublime surface of something that had different motivations. The ultimate experience was perhaps not so much the contemplation of beauty but its possession, and the ultimate aesthetic activity and sensation, acquisition. On his visit to the United States, Bourget did not fail to notice this alliance of the aesthetic with speculation, quoting an overheard remark apropos of the then current financial crisis: "The Italians are rather low down just now, and there are things to be had *sub rosa*. But in this moment nobody can profit by it" (*OM*, 1:74).

Italy was a beautiful market. But it was a market that required guides or investment counselors, for the real thing was not immediately apparent or to be found by or offered to all. The bourgeois as collector wanted the real thing, the best, the sure thing, the safe thing, the authentic, and thus it is that in bourgeois society even disinterested scholarship and the mania for attribution could prove indispensable and turn into something delightfully unexpected such as a profit or a corner on the market.

The general bibelotization of art in the nineteenth century, with its search for the real thing, its nearly so, and its approximation was bound to come up against the problem of authenticity. Since the object of art had been uprooted from its ancient sites and functions, stripped of its religious and social and political associations, it had become, regardless of the definitions of philosophers, an object with an exchange or trade value. Thus the moment of the expert had arrived. And the flaneur as American tourist seeking culture, refinement, and the real thing, made his way to I Tatti.

I Tatti, or
Sublimating Sales

Bernard Berenson inside I Tatti.
Photograph by Robert M. Mottar, Scope Association, Inc.
Courtesy of Fogg Art Museum, Harvard University.

The snob is the bourgeois gentilhomme of aesthetics.

Pierre Veber, *Chez les snobs*

I Tatti is a villa located outside of Florence that once belonged to the late Bernard Berenson: art expert, connoisseur, and art historian. B.B., as he was familiarly known, donated I Tatti to Harvard University. In this book we are interested in him less as an expert than as a character out of Henry James or Paul Bourget.

One of the peculiar characteristics of cosmopolis was that one could never be quite sure who was or was not an art dealer. It was such a genteel profession that it seemed no profession at all, and the line between trade and a disinterested love of art was entirely blurred. In the aesthetic realm there existed a demimonde, one in which the work of art was discreetly up for sale among friends and connoisseurs without ever being up for sale in public. Cosmopolis produced a set of amateurs who loved the arts, knew them sometimes to the point of expertise, and collected them, but who might, in need and given the proper, discreet circumstances, part with a piece or two. Dealing in art in this way was a gentleman's way of making money without embracing a visible profession, which might make for a loss in prestige and status.

One of Paul Bourget's characters is an excellent example of a type familiar enough in cosmopolis. Bernard de la Nauve appears in a tale called *La Pia* set in the hills of Tuscany between Florence, Siena, and Pisa. Bernard de la Nauve supplemented a severely diminished income by selling works of art that he collected but was not unwilling to part with. He was part of the fête parisienne, a leisured viveur as Bourget called him, but gifted, and he was also a part of cosmopolis. Despite his diminished means, he lived as if he had 50,000 francs a year. An elegant bachelor, he rode his own horse in the morning, dined and supped in fashionable restaurants, was to be seen in his orchestra chair at all the premieres, and loved and played as expensively as

I Tatti, or Sublimating Sales

when he'd ruined himself in the usual way in Paris. He belonged to an ancient though untitled family that had for some time been dissipating its fortune. Bernard also belonged to a class of semiadventurers who lived a life of leisure made possible by a variety of methods: coups on the bourse; gossip writing for some newspaper, foreign or domestic; or means more or less admissible in good society. But Bernard de la Nauve had his own expedients. He was, in the post-Goncourt sense of the word, an artist; he had taste, he sang, he painted, wrote, was an excellent raconteur, and had a passion for old furniture and paintings, rare faience and old tapestries. And so when he had to supplement an income that in the course of his life was gradually diminished by 90 percent, he began to give up some of his collected objects not to merchants but to friends. This activity soon became a way of making a living that allowed him to live on the level of the elegants in the circles he frequented: "The bibelots thus sold were one day replaced by others, which in turn were sold and replaced. In short the dilettante turned into a *brocanteur* in black tie and tails who may, in all the houses in which he dines, recognize here a desk-set, there a terra cotta, elsewhere a frame, or piece of furniture which came from his small entresol of the rue Matignon" (V, 45–46). His clientele was obviously chosen; art in cosmopolis was not for everyone. (There were the department stores for everyone.) Art in cosmopolis supposed a monied elite, and la Nauve sold his bibelots, all authentic, exclusively to millionaires setting up a residence in Paris, the rich of the stock exchange, Russian or Polish grands seigneurs, the kings of petrol or salt pork, or some Argentine or Honduran magnate. He also sold to Dickie Marsh, the Napoleon of business who appears in *Une Idylle tragique*. Bourget's narrator tells la Nauve he considered Americans the feudal and magnificent lords of the modern world; but la Nauve answers that they were enormous children playing with the toys of old Europe.

B.B. was an American version of la Nauve. His lineage was not as ancient and distinguished, to be sure, and there was no dissipated for-

I Tatti, or Sublimating Sales

tune behind him; but he was the American taking the bibelots of old Europe very seriously, indeed, making of culture a discreet commodity, of the objet d'art a sure thing, all on a discreet, genteel, exclusive level. At I Tatti about the luncheon table the ambiguities of bourgeois culture were carefully veiled and never allowed to show.

Berenson was not from an ancient family fallen on hard times because of a generation of viveurs; he came of immigrant stock, from people who had come to the United States to "make it" in the new country. The missing aristocratic background was made up for by Boston's aesthetic culture and Harvard, which prepared the young Bernard Berenson for his future achievements and his transsubstantiation into the divine B.B., sage of I Tatti. And Harvard meant, in Berenson's youth, Charles Eliot Norton and his particularly Bostonian, transcendentalist, and Unitarian view of art and Italy. But it also meant for Berenson the discovery of Walter Pater, of whom Norton disapproved but with whose aestheticism Berenson fell in love, envisaging a Paterian, epicurean way of life that was dedicated to art. Boston and Harvard, corrected or softened by Pater, thus gave Berenson that peculiarly idealist view of art that derived from Ruskin by way of Jarves, was filtered by reverends, expounded by Norton, and somewhat sensualized by Pater, who, as George Moore once remarked, always had something of a vicar about him. Indeed, Pater's aestheticism was implied in Norton's philosophy of art even though the Puritan in him could not admit this. To Norton's New England mind there had to be more to art than the famous hard, gemlike flame of aesthetic appreciation.

Berenson, when he left Boston for Europe in 1887, had first thought of being a writer. He had been seduced by Pater's prose, and Mrs. Gardner had helped Berenson financially on the understanding he would cultivate himself further in Europe and turn into a writer, perhaps like Francis Marion Crawford who also had been patronized by Mrs. Gardner. But Berenson in Europe became more and more fascinated by pictures, though his dream of being a writer was somewhat

I Tatti, or Sublimating Sales

realized in his library and love of conversation. But the eye became Berenson's dominant sense and was turned not toward a white page to be written on but, rather, toward pictures to be scrutinized, analyzed, photographed, classified, and compared, so that seeing turned into knowing. The literary life envisaged as self-cultivation, the dream of his Paterian utopia, took second place to the activity of purchasing books and building up a library, reading, conversing, and in the very setting of these activities, the villa I Tatti. Only later in life did Berenson turn into an essayist, producing not only essays on art but also journals and an essay on aesthetics. The Harvard aesthete had turned into a cosmopolite expert posing as a great humanist.

Berenson can be considered a representative of late bourgeois culture in its Boston variety. Logan Pearsall Smith, his brother-in-law, points to the role of culture in this society in his memoirs: "I became vaguely aware of Culture, not indeed as a thing of value in itself, but as bestowing a kind of distinction upon its possessors, a distinction superior in some mysterious way to that of the big-game killer which had hitherto been my ambition and my dream."[1] Logan's initiation into culture had been instigated by his sister Mary, later Mary Costelloe, later still Mary Berenson. Likewise, Berenson had been converted to the culture that later became a ritual at I Tatti. And culture as these two understood it was a mixture of Boston and Pater and, beyond these, Matthew Arnold and his "best that has been known and said in the world." Although Arnold's famous definition is that of a moralist and writer, Berenson needed only to add the best that has been painted for the definition also to be his. Certainly culture conferred distinction upon him as it was meant to do upon the money magnates of the time. In a letter to Mary, Berenson defined culture in purely Paterian terms as "the real selfish passion for training oneself *to have enjoyment of the exquisite and beautiful thing lead on to the enjoyment of*

1. Logan Pearsall Smith, *Unforgotten Years* (Boston: Little, Brown, 1939), 82.

one even more beautiful."[2] This emphasis on enjoyment is important. Culture as understood here no longer has anything to do with the values assigned it by Madame de Staël and her generation with its sense of history. Indeed, this Paterian-Berensonian concept of culture is not French at all, as Edith Wharton well understood: "Culture in France is an eminently social quality, while in Anglo-Saxon countries it might also be called anti-social. In France, where politics so sharply divides the different classes and coteries, artistic and literary interests unite them; and wherever two or three educated French people are gathered together, a *salon* immediately comes into being."[3]

New England culture was less social but much more spiritual; Santayana poked fun at the New England view of culture in his description of the Simkins's home: "The house was religiously quiet; not one speck of dust; flowers everywhere discreetly placed; charming old-fashioned manners; one glass of sherry; one stroll in the garden; a little music in the picture gallery, where there was a drawing by Mantegna" (*LP*, 407–408). And Miss Eugenia Simkins was perfection herself: "Beautiful, gentle and wise. There was nothing superior that she didn't love —Bach, Mozart, Beethoven, Giotto, and Botticelli, Blake, and Turner. There was nothing inferior at which she didn't shudder" (*LP*, 408). By Berenson's time the process of assimilating culture to social and class distinction was a fact. It distinguished the bourgeois from the lower classes and from the mere possessor of wealth. In a society tending increasingly toward democracy, class distinction came to be based on aesthetic considerations rather than on ancient lineage; on moral qualities, degrees, or diplomas rather than on money. As Berenson wrote:

> Culture submits character to aesthetics, and not aesthetics to character. I am not sure even that there have been many aiming

2. See Sylvia Sprigge, *Berenson: A Biography* (Boston: Houghton Mifflin, 1960), 107.
3. Edith Wharton, *A Backward Glance* (New York: Scribner's, 1964), 261–262.

I Tatti, or Sublimating Sales

so solely at culture who have aesthetically appreciated character, as I have. So culture is perhaps possible in a condition of things in which class distinctions are very great. Then a few of the highest class can devote themselves solely to culture without harm, and perhaps to the great advantage of the community. But in the modern state that is scarcely possible, and in the state to come culture will not be possible at all.[4]

Berenson's involvement with art was thus more than that of the art expert. It was inseparable from culture as it was thought of in the period of about 1880–1914. And the relation of Berenson as critic and expert to the art market, as well as his pose as a man of culture, exemplify the role of art in bourgeois culture at its apogee. Culture at this time was far different from what it had been: different from that of the eighteenth century; from that of a Montesquieu and the nobility of the robe with its sense of history, just as it was different from the historical imagination of a Chateaubriand, also a great poseur; or from that of Macauley or Madame de Staël. Presumably it was true hellenism. Pater in this respect is rather revealing. He makes some interesting false remarks about Voltaire that help to define the Paterian view of true culture: "Voltaire belongs to that flimsier, more artificial, classical tradition, which Winckelmann was one day to supplant, by the clear ring, the eternal outline, of the genuine antique."[5]

Voltaire may have been many things, but he was not flimsy and did not belong to the classical tradition but, rather, to a modernity particular to his age. But then Pater's and Berenson's views of culture were even beyond the idealism of Jarves, Ruskin, Arnold, or Norton. Berenson's views belonged to the culture of cosmopolis, which is why he

4. Bernard Berenson, *The Bernard Berenson Treasury,* ed. Hanna Kiel (New York: Simon and Schuster, 1962), 38.

5. Walter Pater, *The Renaissance* (London: Macmillan, 1935), 169.

I Tatti, or Sublimating Sales

could easily figure as a character in Paul Bourget; in this culture art, bibelots, sensations, play a far greater role than knowledge and intellect. Outwardly, B.B.'s culture was that of his books, his conversation, his perspective, and his setting. As for his famous talk, always alluded to and commented on, even noted down by Count Morra, if we are to judge from his journals, letters, biographers, and the various famous people who left notes of their visits to I Tatti, it was not the conversation of a genius but of an aesthete, a man of wide reading, and on a level with the sort of reading provided by such books as *Anatole France in Slippers* or the *Garden of Epicurus*, selections from Maeterlink, or B.B.'s brother-in-law's famous book entitled *Trivia*. It was cosmopolitan chitchat, the talk of a man who had read much, seen a lot of art, knew the right people, had been to the right places, and was also a good observer of the milieu in which he circulated.

The result of this talk and of his being talked about was a kind of fin de siècle humanitas at last discovered by the public after the Second World War, a humanitas that would not be boring to his friends, his little circle of admirers ever at his feet, as the master at the luncheon table dropped his mots and uttered words of wisdom. One thinks, on a far higher and more organized level, of the very popular lectures of Professor Caro at the Collège de France and the lectures of Bergson always attended by women of fashion. And more recently the easy manner of Lord Clark talking to millions about "civilization." The culture of social gossip, it included some risqué stories and opinions about books, life, manners, women, love, art, and history. Always behind it all was the idea that art was the basis of civilization and not the other way around. For Berenson, even religion was ultimately a fine art, spiritual nourishment, life enhancing.

And art in this view of the world was aesthetic art, or high art, mostly European, mostly Italian, mostly quattrocento and cinquecento, although Japanese art was also admitted into this aesthetic realm because of its perfection of line and form. It was an aesthete's view of art

I Tatti, or Sublimating Sales

and its history, very Bostonian in its Italian and Japanese orientation, Anglo-American in its emphasis on the Renaissance, and Germanic in assuming a pure, disinterested aesthetic experience and its pretension to scientific expertise. Berenson's view of civilization was that of a Pater; his hellenism was Victorian and had nothing in common with that of Nietzsche who saw the barbarians beneath the polish of Greek art. The polar opposite of this hellenism was not barbarism but nineteenth-century philistinism. Hellenism, with its association with beauty as well as paganism, was the bourgeois's latest way of not appearing bourgeois. For Berenson hellenism ignored Greek science and philosophy. In the words of Meryle Secrest, the latest of Berenson's biographers, "To him the summit of human achievement was the Greek concept of the human form, and his criteria were those of the Golden Age: clarity, proportion, order, and harmony. That art might exert its power through its ability to evoke terror, primitive awe, fear or disgust, was outside his philosophy. For Berenson, the beginning and end of art was delight."[6]

Berenson's views were far less advanced than those of a Quatremère de Quincy or a James Jackson Jarves and the generation of the neo-classicists who were convinced that art might serve as an instrument for the education of mankind. Berenson's "philosophy" of art combined eighteenth-century epicurean aesthetics with Pater's view of the Renaissance as itself an aesthetic moment. But then cosmopolis, which included in part Berenson's clientele and guest list, could hardly be expected to espouse a philosophy of art not based on pleasure: acquisition and possession were pleasure, and in the last analysis the entire aesthetic rested on desire, no matter how veiled or sublimated to something presumably spiritual.

Berenson judged art, as his critic Georges Waldemar remarks, ac-

6. Meryle Secrest, *Being Bernard Berenson* (New York: Holt, Rinehart and Winston, 1979), 187.

cording to some archetypal model he judged to be universally valid, much like his former professor of art at Harvard, Charles Eliot Norton. The archetype was Greece and the Renaissance. And his view of the Renaissance was little more advanced than that of Pater, whose little book on the Renaissance ends with a chapter on Winckelmann. Berenson even failed to understand, as Waldemar points out, that the Renaissance did not mark progress in art, along the lines thought of and argued by Vasari and later classicists, but was in fact only a new convention of representation and, hence, a new attitude of man toward the world. Waldemar goes so far as to conclude that Berenson was in the last analysis only an academic, in which case one might make him a successor of Quatremère de Quincy, though he was a far less rigorous thinker. But then there is reason to accept Waldemar's judgment. The academic is, after all, reassuring to the bourgeois since he represents the established sure thing. And Berenson did not or did not wish to understand modern art—cubism, futurism, surrealism—in this again resembling his Harvard mentor. He admitted Cézanne to his personal pantheon of artists for his supposed classicism but failed to see what Cézanne meant to his fellow artists. Instead of perceiving in Cézanne a certain anxiety about painting in the modern world, he saw the Mediterranean landscape.

But then painters, the artist as creator, did not figure in Berenson's meditations on art and art history; they were at best craftsmen. Abstract, nonrepresentational art could not be art for reasons Berenson explained according to his theory of tactile values and because he was convinced cubists and futurists were incapable of mastering spatial representation, which he obviously linked with the Renaissance. Berenson the aesthete was no great theorist. And he was repulsed by a modernity foreign to someone nurtured, as he was, on the genteel tradition of spiritualized, aestheticized, and Bostonized Florence.

Aside from his expertise and connoisseurship of Italian Renaissance art, Berenson's contribution to art history as a discipline was thus pri-

I Tatti, or Sublimating Sales

marily that of an aesthete. Form and content were one; the end of art was delight; subject matter was secondary, a mere pretext for the artist's expression of formal values and their execution. The image was neither a key to the meaning of the work nor a thread to follow in a world of ideas and the imagination that existed beyond the frame of the picture and belonged to the world in which the artist had lived. It was not B.B. who invented the science of iconography. It was left to the later Panofsky to "read" pictures, as one might an emblem book, just as it was left to Max Dvorak to think of art history as *Geistesgeschichte*, an aspect of the history of the human spirit, which it already was for the Enlightenment, Hegel, Quatremère, and Madame de Staël. As a thinker about art and its relation to social forces, Berenson did not even rise to the level of Jarves or Norton, and he never produced a cultural history such as Burckhardt's. But perhaps their work smacked too much of professionalism and was thus repugnant to the aesthete for whom art was pure enjoyment. In Berenson's views, art seemed to have nothing to do with myth, magic, religion, power, politics, or ostentation. Aesthetic art was for aesthetic enjoyment. The counterpart of scientific criticism was scientific aesthetics, as the counterparts of the market value of art were tactile values and life-enhancement. Berenson's views of culture and art, as well as his aesthetics, were what they were because they eminently suited cosmopolitan society, its market, its hedonistic view of art, and art's position as supreme bibelot. Expertise was assessing the bibelot; aesthetic enjoyment was enjoying the bibelot. But it was not enough to assert such views of art and culture: the validity of these views had to be demonstrated scientifically. The aesthete had to justify himself to the Puritan; hence, the curious nature of fin de siècle aesthetics.

As Henry James had noted, Berenson's was an age of advertisement. Put into advertising form, Berenson's aesthetic theory, modeled on the famous *Guinness is good for you*, lets itself be reduced to *art is good*

I Tatti, or Sublimating Sales

for you. The market was far more limited than that for Guiness, but it made up in quality and mark-up what it lost in volume.

When Berenson asked himself why one felt pleasure before a work of art he came up with the idea of "tactile values." He formulated this theory in his book *Florentine Painters of the Renaissance* and elaborated on it in his later book, far more theoretical than his others, *Aesthetics and History*: "Tactile values occur in representations of solid objects when communicated, not as mere representations (no matter how veracious), but in a way that stirs the imagination to feel their bulk, heft their weight, realize their potential resistance, space their distance from us, and encourage us, always imaginatively, to come into close touch with, to grasp, to embrace, or to walk around."[7]

Although these tactile values are connected with the materiality of things represented, as opposed to the much touted spirituality of art, these tactile values are precisely those qualities of the work of art that make it "life enhancing": "Tactile values are life enhancing and do not excite mere admiration, but give gratification and joy. They therefore furnish a basis upon which, as critics, we may erect our standards of judgment" (*AH*, 60).

The emphasis on gratification and joy, this promise of a special experience as opposed to mere admiration, is worth underlining since all the nouveautés, articles de Paris, laces, bibelots, and dresses in chic shops and department stores were also instruments of gratification, so gratifying as to prompt purchasing. The work of art with its tactile values was a powerful bibelot indeed. And what made it a bibelot was that the tactile values had nothing to do with the subject matter. Had it been otherwise the Puritans who purchased all those Italian madonnas would have had to take account of the subject matter, which was associated with the detested Roman church. But tactile values, not subject matter, made primitive stone carvings, as well as Florentine

7. Bernard Berenson, *Aesthetics and History* (New York: Pantheon, 1948), 63.

I Tatti, or Sublimating Sales

madonnas, or Venetian landscapes, into works of art, just as in modern times these same values made some paintings by Degas into works of art: "What is it but tactile values combined with movement that makes us pass over and almost forget in so many of Degas' paintings the vulgarity of his washer-women, his far from appetizing ballet girls, and his shapeless females tubbing and sponging?" (*AH*, 66). Artists may turn such vulgar creatures into something life enhancing because the artist gives them form, which Berenson defines as "radiance from within," while the tactile values turn into something mysterious called "ideated sensations" that exist in the imagination and are "produced by the capacity of the object to make us realize their entity and live its life" (*AH*, 67). It sounds dangerously as if B.B. expected the millionaire buyers to feel the life of the washerwomen painted by Degas. But it could hardly mean that and so must point to something else.

The ideated sensations are unconscious, prompted by the artist who draws the perceiver's attention "to the muscular changes, the tensions and relaxations that accompany every action no matter how slight."

We react physiologically, though unconsciously, to the picture and thereby experience joy and life-enhancement. Exercise is good for you, and looking at a Ucello you can exercise without fatigue, unconsciously, and feel the thrill of battle, without losing an arm or a leg. It is this experience of life-enhancement that became the test of true art, for "representations that communicate feelings of dejection or nausea would be the less artistic, the more skillfully and successfully they were done." At this point the work of art and its effect—ideated sensation produced by the tactile values—is reminiscent of Pavlovian experiments: works of art are defined as stimulants in a search for delight and happiness, with the good and the bad in art defined as a physiological response. Or shall we compare them to consumer items to be purchased according to one's likes or dislikes or appetites?

But no, the danger of such a vulgar interpretation of tactile values

I Tatti, or Sublimating Sales

and their effects is avoided by defining the joy prompted by the work of art as being pure of desire. Life-enhancing, ideated sensations "must remain intransitive, inspiring no definable desire, stimulating no appetite, rousing no lust for sensual enjoment. We must not glide or slip, or still less leap from ideated to real sensations, from art to actuality" (*AH*, 70). And thereby is the Puritan saved from damnation, and all those Italian virgins in the frames remain safe, and buying art is no sin, but an intimation of a higher, purer, truer, and more perfect life. Tactility being imagined, sensations being ideated, remain safe, disinterested, as the old idealism is saved despite all the talk of joy, tactility, and sensations. The church of art is saved from the bazaar.

In Henry James's *The American* the Reverend Babcock finally parts with Newman because although they both love pictures, Newman enjoys them and Europe too much like an "unregenerate epicure." Before separating, Babcock sermonizes Newman: "Art and life seem to me intensely serious things, and in our travels in Europe we should especially remember the immense seriousness of Art. You seem to hold that if a thing amuses you for a moment, that is all you need ask of it; and your relish for mere amusement is also much higher than mine. You put, moreover, a kind of reckless confidence into your pleasure which at times, I confess, has seemed to me—shall I say it?—almost cynical" (*A*, 72). In Berenson's aesthetic the almost cynical is made safe by spiritualizing the sensations, defining the amusement as disinterested life-enhancement. At the same time the reintroduction into the aesthetic argument of the notion of disinterestedness, borrowed from Kant and a safe Pietistic background (as distinct from the same notion to be found in the abbé Du Bos, which is that of the man of the world judging a work of art without the jealousy and "interest" of artists and professionals), also removes the supreme bibelot, the work of art, from the dangerous place of desire, the market.

The work of art thereby once more finds its specific place in the realm of the ideal, so dear to fin de siècle aesthetes and the wives of

I Tatti, or Sublimating Sales

millionaires who knew that money wasn't everything. "For ideated sensations," Berenson continued, "that constitute the work of art belong to a realm apart, a realm beyond actuality, a realm of contemplation, of 'emotion remembered in tranquility,' a realm where nothing can happen except to the soul of the spectator, and nothing that is not tempering and refining" (*AH*, 70). But ideated sensations and tactile values will give you much more than a glimpse of the ideal; they lead to that rare moment, the secularized religious experience that frees you of desire and the world, the aesthetic experience:

> In visual art the aesthetic moment is that fleeting instant, so brief as to be timeless, when the spectator is at one with the work he is looking at, or with the actuality of any kind that the spectator himself sees in terms of art. He ceases to be his ordinary self, and the picture of building, statue, landscape, or aesthetic quality is no longer outside himself. The two become one entity; time and space are abolished and the spectator is possessed by one awareness. When he recovers workaday consciousness it is as if he had been initiated into illuminating, exalting, formative mysteries. In short, the aesthetic moment is a moment of mystic vision. (*AH*, 84–85).

You, too, can know through art the ecstasy of Saint Theresa. But of course what the visionary sees or unites with in the contemplation of a work of art is not God but something less theological, something much more vague, "the inner life of things," to use a phrase of T. E. Hulme's. The artist, for Berenson as well as for his contemporary Bergson, was less of an inventor than a seer. "Artistic personalities are equivalent to distinct modes of seeing, and are something in the nature of a sport," writes Berenson in one of the few places of *Aesthetics and History* in which he considers the artist (*AH*, 222). This sport can

be in the nature of genius: what the artist sees, he places before the public, and he is followed in turn by other artists who adopt his vision and propagate the vision of the genius by their skill: "Something new, something never seen before was placed before the eye of a public astonished and fascinated by Leonardo. His vision of things was popularized by scores of pupils" (*AH*, 223). And, most marvelous of all, Leonardo created unconsciously, because artists are not really thinkers but craftsmen: "The real artist, if at the moment of creation he thinks at all, thinks of little but his craft, the action and arrangement chiefly, and of the skill and mastery he has acquired previously—I mean how to draw, how to paint, what proportions, what types to give his figures" (*AH*, 103). It is a remarkable attitude for a man who is sometimes taken for the last humanist, a great Renaissance connoisseur, and representative of hellenism. For in this view art is deintellectualized and the idealism of Berenson and the fin de siècle avers itself to be very different from that of the academic tradition, for, to use Reynold's terms, painting was a mental activity and no mere mechanical skill. The idealism of the fin de siècle was not to understand art as something about beauty, the ineffable, the mystic vision that art supposedly prompted. The aesthetic experience is something the mind cannot grasp. This view was widely held at the time and it is worthwhile exploring why. This mystical approach may be attributed to Bergson, as it was by his arch enemy Julien Benda who engaged in a long polemic with him and the times; in addition, it was also attributed to Berenson by his disciple T. E. Hulme.

According to Hulme, Bergson's theory of art was the same as Schopenhauer's, but it was better stated: in Schopenhauer, "Art is pure contemplation of the Idea in a moment of emancipation from the Will. . . . In Bergson it is actual contact with reality in a man who is emancipated from the ways of perception engendered by action, but the ac-

I Tatti, or Sublimating Sales

tion is written with a small 'a', not a large one."[8] If this is art then it is less activity than contemplation. Art is confused with the aesthetic, the aesthetic moment with mysticism, and creation is a kind of vision. The work, as object, as superbibelot, has somehow disappeared. It is as if intelligence were excluded from creativity, as if Leonardo had never filled all those notebooks of his with speculations about the nature of his art, as if innumerable poets had not reflected upon their art and written poetics, as if painters had never written academic discourses, as if works did not exist save in that ideal realm of contemplation; finally, it is as if history had been eliminated. The reason for this radical spiritualization of art and its experience lies in Bergson's strict separation of intellect (the mechanical) and life (the intuitive). But then for Bergson, according to Hulme, the artist is not an inventor in the classic Renaissance or even baroque sense but someone who dives into the flux of life and comes out of it with a shape or form he attempts to fix forever as a work of art: "He cannot be said to have created it, but to have discovered it, because when he has definitely expressed it we recognize it as true" (152).

Thus art reveals reality, as it did for the neo-Platonic mannerists, though their respective realities may differ. The artist, in contact with reality—not the world of Platonic forms or ideas but the flux of life— makes others see what he has seen and as such remains, though not an inventor, an exceptional being: "It is only by accident, and in one sense only, that nature produces someone whose perception is not riveted to practical purposes; hence the diversity of the arts. One applies himself to form, not as it is practically useful in relation to him, but as it is in itself, as it reveals the inner life of things" (152). This is at once a romantic and bourgeois view of the artist; he is born that way, he is privileged, he is the romantic genius; but he is impractical, he is

8. T. E. Hulme, *Speculations. Essays on Humanism and the Philosophy of Art*, 2d ed. (London: Routledge and Kegan Paul, 1965), 149.

not made for this world, he is like Baudelaire's albatross, splendid in flight, awkward on the ground. Art is therefore not a métier (no craft for any bourgeois son to learn but a diversion, an amusement); it is gift. Monet was only an eye, but what an eye!

But the special nature of the artist confers uniqueness on his work and, therefore, rarity, value distinct from that of the manufactured, reproducible object. The definition of the artist as someone diving into the flux of life and finding something to express as art, this separation of contemplation from action and the discrediting of the old idea of invention also serves to confuse the artistic and the aesthetic and, therefore, the artist and the aesthete: both are seen as contemplatives, differing from each other only in that the artist has a skill not possessed by the other, otherwise complementary. The application of the term *artist* to connoisseurs like la Nauve or the Goncourts is indicative of this confusion between artist and aesthete, also found in the person of Whistler or the aesthetic movement. If the romantic artist proclaimed his superiority over and separation from the bourgeois by stressing his creative genius, the fin de siècle bourgeois, posing as an aristocrat, puts the artist in his place by reducing artistic production to skill while raising the aesthetic to a form of contemplation that he shares equally with the artist. If the artist is left to dive into the flux of life to bring back a formed vision, the bourgeois as aesthete or collector in turn recognizes the artist who depends for his livelihood on this recognition. The artist becomes a dependent of the bourgeois in a way he never was to the nobility of court and town who left questions of taste to architects, directors of the academy, court painters, and creators of various luxuries.

But the bourgeois as aesthete, the reader of aesthetic criticism, proclaims himself the equal of the artist in matters of taste because he claims to be disinterested: "From time to time," writes Hulme, "by a happy accident, men are born who either in one of their senses, or in their conscious life as a whole, are less dominated by the *necessities of*

I Tatti, or Sublimating Sales

action. . . . They do not perceive simply for the purposes of action: they perceive just for the sake of perceiving" (154). But, as Whistler puts it, "the voice of the aesthete was heard in the land, and catastrophe is upon us." For by this distinction of action and contemplation, the artistic remains pure, untainted by practical considerations or by the market, separate from the practical world and from business. Painters do not really paint for money but for art's sake. Writers do not really write for money either but for literature's sake. Dr. Johnson and innumerable others who earned their living, meager or opulent, by their pen, may be safely dismissed as hacks or journalists; for the essence of art lies elsewhere, beyond worldly success, in the artist's vision and the aesthete's recognition of that vision. And if the artist could communicate his vision it was because his mind was conceived along the same lines as that of the aesthete in search of life-enhancement. Intelligence, work, and knowledge were safely left out of this picture of the artist since these were associated with the practical, everyday, workaday world of action, business, purpose. On the whole this aesthetic was that of rentiers living off unearned income and having nothing to do but contemplate.

The implications of this aesthetic theory are amusing when considered with regard to Berenson's own activities. His intelligence—active, practical—is used in his criticism and expertise, the authentication and certification of works of art. It was the side of his life that allowed him to make a living even though he had no inherited fortune like so many others in cosmopolis. But his intelligence and the income he derived from it, which allowed him to live in style at I Tatti and in various grand hotels on his travels as the season demanded, were presumably less important or real than the contemplation of pictures and the landscape for the sake of contemplation. Obviously this aesthetic, resting on the confusion of the artistic and the aesthetic, positing a pure purposeless perception, is possible only within the context of a rentier

I Tatti, or Sublimating Sales

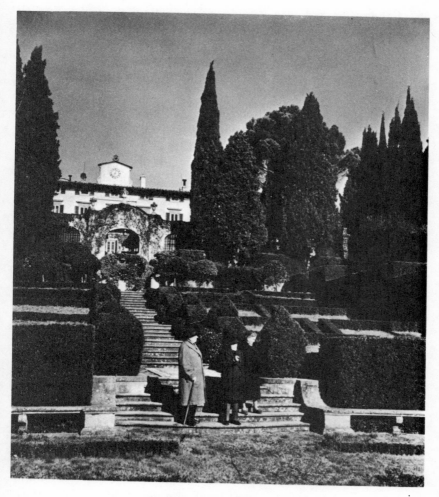

Bernard Berenson and friends at I Tatti.
Photograph by Robert M. Mottar, Scope Association, Inc.
Courtesy of Fogg Art Museum, Harvard University.

class on a prolonged *villeggiatura*. The aesthetic of the exiles, English as well as American living in or about Florence or some other Italian city, was the aesthetic of cosmopolis.

But in Berenson's case the aesthetics of cosmopolis was that of someone who had to keep the ideal, the Ruskin-Jarves-Norton-Pater line, pure and strictly separate from the practical side of expertise, art in the service of dealers, art objects to be bought or sold. A curious shift has occurred: sin, once connected by the Puritan with pleasure taken in the work of art, as opposed to the Reverend Babcock's high seriousness, has been shifted to the commerce of art. The bourgeois is ashamed of his commercial background; for he longs to be an aristocrat with no taint of trade upon him or behind him. In the fin de siècle period, this fear of trade made for an aesthetic aristocracy that concealed its millions behind an aesthetic facade. The market was thus kept strictly separate from "art"; the last humanist was in no way an art dealer. The old dualism of matter and spirit was mobilized in a new form to veil the reality of bourgeois society and existence that, for all its aesthetic trappings, its aesthetic moments, and its women talking of Michelangelo or writing books about Donatello, was, as Paul Bourget's writers and artists clearly saw, based only on and cared only for money.

But there are further amusing implications to this aesthetic of pure perception and life-enhancement. It is, really, a tourist aesthetic, supposing the sleeping car and the grand hotel. It is as if all those works of art gathered in museums—the Uffizi, the Louvre, the Brera—or perceived on tour in Italy, or Egypt, and even in far Japan or India, had ceased to be the products of history (the "signs of the history of mankind" to use Quatremère's telling phrase) and were, instead, merely stimuli for traveling millionaires, cultured milliners, or bored cosmopolites. This tourist aesthetic, concerned with the enjoyment of works of art, is but a vulgarized form of Pater's rarified aestheticism. Whereas Ruskin linked Christian morality to art, Pater constructed a morality

I Tatti, or Sublimating Sales

based on art that promoted life lived as art, stressing not the spirit of art but its sensuous qualities. Evangelical purism was supplanted by aesthetic fastidiousness and the result was aesthetic criticism, as distinct from historical or intellectual criticism. Pater aestheticized history, making of the past a vast romantic affair that resulted in a craving for the picturesque. The art work was thus transformed from a historical monument or sign into a vehicle of enjoyment for either the aesthete's refined pleasure or for the crowd of tourists. The grand tourist of the eighteenth century was not the direct ancestor of Cook's tour or Baedeker's guide. The grand tourist of the fin de siècle and the late bourgeois world went to Italy for sensations and acquisition more than for education or accomplishment. The work of art, that supreme bibelot of the sleeping-car set, was ultimately but a very select and rare consumer item, an article de nouveauté from a romantic past rather than a modern department store. History had been eliminated by an aesthetic based on the latest science, psychology.

Berenson's unstated assumptions and the implications of his aesthetic doctrines were made more explicit by his rival and neighbor Violet Paget, alias Vernon Lee. This is not to say she commented on Berenson as she had Ruskin but that her aesthetic, more systematically expressed, was more clearly stated than Berenson's. It is only from the perspective of the postbourgeois and the postcultural world in which we live that the inanity of that aesthetic becomes apparent. Vernon Lee had a far better mind than Berenson, and her *Art and Life* (1896) and her essay on *The Beautiful* (1913) show her thinking to advantage and represent the traditional type of aesthetic treatise as *Aesthetics and History* does not.[9] B.B.'s thinking on aesthetics, which dated from his Florentine painters, was so close to Vernon Lee's own that she grew

9. Vernon Lee, *Art and Life* (East Aurora, N.Y.: Roycroft Print Shop, 1896); *The Beautiful, an Introduction to Psychological Aesthetics* (Cambridge: Cambridge University Press, 1913).

suspicious of involuntary plagiarism and caused a certain cooling of their relations for many years.

Both *Art and Life* and *The Beautiful* were essays in the psychology of art. Her reasoning rested not on metaphysical definitions of the beautiful and of art, as did the classical aesthetics, but on what happens within us in the presence of beauty. It was the same question that had prompted Berenson to come up with his idea of tactile values. Both Vernon Lee's essays were empirical rather than dogmatic or rationalistic. And both B.B. and Vernon Lee were convinced that such attempts to understand the psychology of art were scientific.

The Beautiful started with an empirical, verifiable statement rather than an abstract definition of beauty: "Beautiful implies on our part an attitude of satisfaction and preference" (*PA*, 2). Much the same was formulated in the earlier *Art and Life*: "The contemplation of beauty refreshes and invigorates our spirit" (*AL*, 14). A concession is made to Kant by emphasizing that the beautiful is neither the good nor the true, though beauty is admittedly a power for good. But though beauty is not the good, Lee argues, it is good for you: it invigorates the spirit or soul; it is life enhancing; it satisfies. Her language is dangerously close to that of advertisement. The reason the beautiful is invigorating is that both it and the good have a common source in the vital, primordial energies necessary to man's survival in the universe, so that beauty and its satisfactions may be linked to the theory of evolution. Beauty is one of the higher products of evolution. Thus beauty and the higher objects of life—the altruistic function, for example, or the higher harmonies of universal life, and the nobler growth of the individual—coincide: "Under the vitalizing touch of the beautiful, our consciousness seems filled with the affirmation of what life is, what is worth being, what among our many thoughts and acts and feelings are real and organic and important, what among the many possible moods is the real, eternal yourself" (*AL*, 21–22). The beautiful has thus been natu-

I Tatti, or Sublimating Sales

ralized, the work of art assimilated to some function in the general evolution of mankind, and the distinction between art, nature, and the senses blurred.

Julien Benda, the author of the famous *Treason of the Intellectuals*, had in a devastating critique of the aesthetics of the pre-1914 period, as summed up in Bergson, pointed to a distinction that the partisans of Bergson had overlooked or passed over, a distinction between two opposed sensibilities that corresponded to different aesthetics. There was a sensibility for form, solidity, and clarity of outline that involved the senses of touch and sight. The other was the musical sensibility, based on the ear, smell, taste, tending toward the fluid, the contourless form, and more troubling to the soul than the plastic sensibility. The first type of sensibility he considered masculine, the second feminine; the first tended toward centrality, the second he saw as the sensibility of a decentralized consciousness.[10] The plastic he saw as classical and aristocratic; the musical he saw as romantic and democratic.

These tendencies of sensibility are to be found in Berenson as well as in Vernon Lee. The tactile values of the former and the vitalism of the latter correspond respectively to the classical and the romantic, the masculine and feminine. And both in effect based their aesthetics on the nervous system, the physiological basis of the sensibility. Thus we can all vibrate to music and empathize with tactile values, capacities that represent the unstated democratic aspects of the psychology of art. For if art is indeed a question of physiological responses, then, since all men are biological, all men can respond to beauty.

But neither B.B. nor Vernon Lee could or would go that far. Though their aesthetics were based on psychology and sensibility, they were intended to be exclusive and reserved and attributed to an elite. In

10. Julien Benda, *Belphégor. Essai sur l'esthétique de la présente société française* (Paris: Emile Paul, 1918), 40–41.

spite of science, evolution, nervous systems, empathy, "satisfying" reactions to the beautiful, in spite of a language close to advertisements, the aesthetic of life-enhancement was saved from democratic implications by the imposition of limits that made it an upper-class aesthetic after all. The limit was imposed; it had nothing to do with any logic, science, or internal necessity. Arguing like the theologians of old, Vernon Lee wrote that the physiological basis of aesthetics can lead only so far, just as in religion theological argument for belief in God can only go part of the way; the last step belongs to faith. The seventeenth-century critics who pondered the beauties of style and wondered why some writings pleased more than others were more honest with their je ne sais quoi to designate something pleasing beyond the rules of art than the fin de siècle aesthetes and aestheticians were with their tactile values and life-enhancing qualities or ideated sensations. In the aesthetic of Vernon Lee the leap from reason and science to faith was not a theological statement of belief but an askesis: "into all aesthetic training there must needs enter an ethical, almost an ascetic element" (*AL*, 23).

The physiological foundation of aesthetic pleasure, the insertion of the beautiful into the process of evolution, is not about to sap the foundation of the religion of art. The aesthete is turned into a lay saint; the Puritan may have his art *and* his religion. Physiology and biology lead in the end to the aesthetic moment that B.B. called mystical; a moment, however, only prepared for by aesthetic training. Aesthetic exercises replace spiritual exercises. For beauty bestows pleasure only to the degree the recipient or novice is capable of "attention, intelligence, and reverent sympathy." The Reverend Babcock excommunicates Christopher Newman.

For the religion of art, as Roger Fry would find out when he tried to apply Berenson's theory of tactile values to the understanding and experience of modern art, was a high church. Having been taken to task for his attempt to democratize the enjoyment of art in his theoretical

I Tatti, or Sublimating Sales

work *Significant Form*, which implied an aesthetic based on the senses, he was later to write:

> I now see that my crime had been to strike at vested emotional interests. These people felt instinctively that their special culture was one of their social assets. That to be able to speak glibly of T'ang and Ming, or Amico de Sandro [one of B.B.'s creations] and Baldovinetti, gave them a social standing and distinctive cachet. This showed me that we had all along been labouring under a mutual misunderstanding, i.e., that we had admired the Italian Primitives for quite different reasons. It was felt that one could only appreciate Amico di Sandro when one had acquired a certain considerable mass of erudition and given a great deal of time and attention, but to admire Matisse required only a certain sensibility. One could feel fairly sure that one's maid could not rival one in the former case, but might by a haphazard gift of Providence surpass one in the second.[11]

It is now obvious that an aesthetic built on physiology had to be democratic and that the form of its argument, the disposition of terms, was similar to that used to attract buyers in a department store. Class distinctions in this aesthetic could only be maintained by recourse to the aesthetic of the old regime and the distinction between higher and lower arts, that is, aesthetic art and the merely pleasurable. Art remained serious, as the Reverend Babcock would have it, through this distinction, as did the rule that not all were capable of the higher pleasures of art since this required the exercise of the will, attention, and training, all of which was not given to everyone.

11. Frances Spalding, *Roger Fry, Art and Life* (Berkeley: University of California Press, 1980), 68.

I Tatti, or Sublimating Sales

The distinction between the higher and the merely pleasurable arts implied distinct classes of people. It is tempting to make taste, in this scheme, correspond with an upper class and mere pleasure with the lower classes; but, in fact, it did not work out that way. In Vernon Lee's terms the distinction was not so much one of class or income as one between a true aesthetic elite and the philistines. One might be of the elite and yet not be rich in the ordinary sense of the word. "Our real aesthetic life," she writes, "is in ourselves, often isolated from the beautiful words, objects, or sounds" (AL, 53–55). And this aesthetic life presumably has nothing to do with the possession of beautiful objects. The true aesthete is thus isolated from the merely rich by separating the aesthetic realm from the notion of property, from the possession of bibelots. Aesthetic experience is defined as good, unselfish, altruistic. For the center of the experience, that mystic moment of union, is not in the object, which can be possessed, but in the emotion: "All strong aesthetic feeling will always prefer ownership of the mental image to ownership of the tangible object; any desire for material appropriation or exclusive enjoyment will merely be so much weakening and adulteration of the aesthetic sentiment. In every person who truly cares for beauty, there is a necessary tendency to replace the legal illusory act of owning by the real spiritual act of appreciation" (AL, 53–55).

The bourgeois concept of private property is thus separate from the aesthetic domain. The rich with their bibelots need not feel they have deprived anyone of aesthetic enjoyment, which is not guaranteed by ownership. And they do a positive good by endowing museums, building collections, and supporting the acquisition of objets d'art. At the same time this separation of the object possessed from the aesthetic experience, which is internal and emotional, makes possible the creation of an infinite number of art history courses built on slides that "represent" the object not present in the classroom, courses that may prepare the student for the aesthetic experience. A vague, ideal realm of aesthetic experience is posed as open to all with the proper pre-

I Tatti, or Sublimating Sales

paratory askesis. The aesthetic realm is the old paradise, though there was, in the novel conditions of the late bourgeois world, no one to write that it was more difficult for a rich man to enter this paradise than for a camel to go through the eye of a needle. But the separation of true aesthetic appreciation from ownership of the object that prompts it consoles nonowners. They are not aesthetically deprived. They may look at but not touch the works of art. They need not envy the owner of a Botticelli to truly appreciate his work as, in the crowded Uffizi, before the *Birth of Venus*, "the tactile imagination is roused to a keen activity, by itself almost as life-heightening as music. But the power of music is even surpassed where, as in the goddess's mane-like tresses of hair fluttering to the wind, not in disorderly rout but in masses yielding only after resistance, the moment is directly life-communicating. The entire picture [B.B. continued] presents us with the quintessence of all that is pleasurable to our imagination of touch and movement. How we revel in the force and freshness of the wind, in the life of the wave." [12]

The separation between true aesthetic appreciation and legal ownership of the work may have satisfied impecunious aesthetes, professorial aestheticians making do with a middling salary, but it must have seemed blatantly false to any true collector. And any art dealer not posing as a humanist among transmigrated Boston gentility discoursing to admiring graduate students and future museum curators must also have known this doctrine to be either false or simply irrelevant in the real, as opposed to ideal, world. In auction houses as in private transactions it was desire not aesthetic theories that ruled the souls of bidders.

The connoisseur and the aesthete, and perhaps even the last hu-

12. See Ernest Samuels, *Bernard Berenson. The Making of a Connoisseur* (Cambridge, Mass.: Belknap Press of Harvard University, 1979), 231.

manist with his exquisite hands and his astounding eye, may have felt superior to the American millionaire who bought a Bernardo Luini without batting an eye because it was supposed to make him appear cultured (if you have to ask the price, you can't afford it, noted J. P. Morgan); and the aesthete might look on such as mere philistinism and mutter to himself that, after all, the newly rich are always vulgar. But these were the consolations of those who had to ask the price. In the long run, the presence of the picture bought, the objet d'art acquired, and the bibelots seen in the salon and the drawing room lent their owners part of their aura; indeed, the aura of the work was transferred to its owner. And in time, with gifts to museums, parties and dinners in black tie and tails given for curators and directors and even scholars, the possessors ceased to be merely "proud possessors" and became spiritual, cultured, genteel, and ever so generous. The transformation of the merely nouveaux riches into the cultural elite follows logically, though not explicitly, from the doctrine of life-enhancement. How could the rich remain vulgar once they had glimpsed, thanks to the effect of tactile values and ideated sensations, the realm of the ideal? How could you still be vulgar after a mystical experience? They, too, learned to savor, appreciate, enjoy that higher realm which awaited them after a long day at the office, the firm, Wall Street, and the cares of business. The art works possessed were, aesthetic theory notwithstanding, the concrete form of the ideal: a collection, a château, a villa, a house on Fifth Avenue. Askesis was for the less wealthy. With enough wealth you could always buy enough indulgences to be exempted from askesis. In the end the aesthetics of cosmopolis was Januslike: exclusive for the poor, open to the rich. And the rich knew it. That is why in questions of authenticity they relied on experts and not on the aesthetic experience.

B.B. was not a philosopher; neither was he an art historian, and for all his talk of culture, his humanist pose, he was first and last a con-

noisseur of Italian art, an expert, a kind of insurance agent in a very tricky trade. Cosmopolis was not only an international playground but also an international art market in which the shrewd investor ceased being quite so sure of himself. He and his wife knew they wanted "the real thing." And in this vast marketplace of cosmopolis, I Tatti was rather like that shop of Alexandre Arnoux on the rue Montmartre; it looked more like a salon than a shop.

If B.B. as aesthete was the product of the times, so was he as expert. He was the right man at the right time, even in the right place. The art expert became an important figure of the international scene only in the late nineteenth and twentieth century. He even made his appearance in fiction at this time. In former times collectors had relied for advice and knowledge on merchants, amateurs, or connoisseur-friends, and even artists; but all this had changed by the time B.B. came on the scene. Art history had become a specialized discipline, requiring increasingly specialized knowledge. The number of great, original works of art that might enter the market had been considerably reduced by the creation of national collections; but dealers, agents for these, and, consequently, the competition, had also increased.

However, as Max J. Friedlander also pointed out, elements foreign to the art market and scene had entered it, namely, aristocrats, society women, sons of rich families, and people generally unconcerned with the reputation of a firm because they were free-lance dealers. (The example of Bernard de la Nauve provides a case in point.) Prices thus increased, as did the tension among the works available, the dealers, and the risks involved. Finally, the market was, as Friedlander puts it, Americanized, which means the Americans tended to rely more on experts than others did. When experts are used they run the risk of displeasing clients; however, on the other hand, they can rightfully maintain that they are not responsible for the prices. But the rage for experts at this time, Friedlander further points out, was also connected to the rage for a work with the artist's name attached to it. This

I Tatti, or Sublimating Sales

increased the expert's responsibility in the trade. If you told a prospective buyer that such and such a work was late fifteenth-century German or Italian, people tended to be disappointed. If you said it was by the master of such and such an altarpiece at such and such a place, that was better. But best of all was to pin the artist's name on the work. And so expertise became a thriving, profitable industry.

Paul Bourget poked fun at this mania for expertise and scientific method in the identification and authentication of unsigned works of art, and Meryle Secrest, author of a recent biography of Berenson, thinks the story was directed at B.B. In *The Lady Who Lost Her Painter*, an up-and-coming young art historian and expert discovers a great Italian work of the fifteenth century that he attributes to an important name. But the work is a forgery, painted by a young painter in need years before the expert discovered it. The painter reveals to the expert that he painted it, but the expert refuses to accept this because he is convinced his methodology is foolproof, scientific, infallible. Bourget described the expert's method:

> To criticize a canvas, instead of enjoying it, as you or I might do in our intimate being, is to anatomize it, dissect it line by line, grain by grain. Then there begins, to verify its origin and history, a patient bureaucratic labor, a life of bookworms, weeks spent in rummaging through old papers, establishing a dossier; expertises on handwriting, letter by letter, point by point, infinite comparisons with photographs. What more! And all this to arrive finally at some uncertain date and a contestable name. That is criticism.[13]

Berenson spent perhaps less time in archives than in churches, indefatigably studying details as well as wholes, and he also used photo-

13. Paul Bourget, *La Dame qui a perdu son peintre* (Paris: Plon-Nourrit, 1910), 36–37.

graphs a great deal. There is no doubt as to his expertise and the validity of most of his attributions. But the significance of this desire for authentication, for attribution, however important it may be for art history, also has another dimension: for what was being certified was "the real thing." And this certification affected the price. The bibelot had left the realm of the ideal to enter the market and it possessed not its aesthetic aura so much as its quotation. In B.B.'s case too, given his growing fame, the authentication and attribution, signed, also represented a blessing and a certificate of real value. The two threads so closely intertwined in bourgeois aesthetics and society, the ideal and the market, are inextricable. The blessing was cachet, a certified value, a blue chip in cosmopolis. But B.B. could not admit this and insisted that neither criticism nor expertise led to true appreciation of art: "In general," he told his friend Count Morra, "art criticism is completely useless work—commercial and heterogeneous. The critic ought to do only one thing: tell us which works are beautiful. . . . A work of art is like a woman; 'Il faut coucher avec.'" [14]

One wonders whether B.B. realized that his allusion to works of art as women made of him a metaphorical pimp. Be that as it may, this downgrading of criticism was part of his elaborate facade; he needed his expertise to maintain the facade. And the last humanist who professed to disdain criticism made his entry into cosmopolis with a grand devaluation of Venetian paintings from private collections shown at the New Gallery in London in 1895. The labels on the pictures of this memorable show exhibited the attributions of the owners as they had come down by tradition or been given by the dealers. Berenson looked and wrought havoc: of 33 so-called Titians he accepted 1, and of the 120 pictures shown, he accepted only 15 as correctly attributed. Now a Titian demoted to "workshop of" or "follower of" is not only no longer

14. Count Umberto Morra, *Conversations with Berenson* (Boston: Houghton Mifflin, 1965), 254–255.

I Tatti, or Sublimating Sales

a Titian, it is also a financial loss. The supreme bibelot was a market item even on the level of high art, and aesthetic enjoyment and life-enhancement suddenly diminished if its price fell. And the bourgeois who might talk of the ideal to the women in his salon knew it. And that is why he relied on the art broker, the expert.

Looked at without sentiment and preconceptions, the objet d'art was thus also a force for sublimating money into a different form of wealth. Berenson not only played an important role in this sublimation of money, he also lent the supreme bibelot an aura that placed it in a realm beyond all vulgar thoughts of money and the marketplace. In this he was of course helped by the ideologies of Jarves, Norton, Pater, and the genteel tradition. And in this role, on the level of theory he was an exemplary figure of late bourgeois culture. But his effectiveness lay beyond theory: it lay in the very setting and ritual of life at I Tatti, the villa outside Florence, the city of Renaissance culture. Florence had been important to Jarves and Norton, and Berenson interpreted its culture as that of a yearning for the aesthetic, for refinement, for the life of culture; but which bourgeois historians had also seen as the beginning of modern history. The regularity of life at I Tatti—the work in the morning on his books, followed by lunch with many guests with B.B. playing the role of "the autocrat at the luncheon table," followed by more conversation and a walk or a ride in the country to enjoy the landscape—all this contributed to cast an aura upon the possessors of works of art by association with a genteel life. And in the summer there were trips to St. Moritz, or expeditions to little churches lost in the hills, or to some great museum to study paintings. All this bespeaks the cosmopolitan setting of the art market and a style of life that was a style of selling.

With B.B., the villa, ruling-class architecture since the Palladian era, becomes the *villeggiatura* of the transatlantic and sleeping-car set. And the very location of I Tatti signaled the high regard in which the art of

the Renaissance was still held: it localized the source of true aesthetic value and experience, it explained the sensuality of tactile values as reconciled with the spirituality of aestheticism, as Giotto and Dante, Botticelli and Ficino, may define the sensuous and tactile joined to the mystical. But I Tatti defined a fin de siècle view of the Renaissance, closer in spirit to Pater and Burckhardt; and if the Medicis are remembered it is not as bankers and astute politicians, using art in a propagandistic way, but as aesthetes, patrons, presumably disinterested, of the arts. Life in the Renaissance had been "artistic," picturesque as in the poems of Browning. But Florence was safe too for the taste of the times; it was prebaroque; it was not a city associated with the art of a corrupted, sensuous, theatrical Roman Catholicism, so that even the location of I Tatti near Florence exemplifies the Jarves-Norton view of art history.

On a less sublime level, however, disregarding the gentlemanly pose, the chitchat at the table, the image of the last humanist, Berenson eventually turned into a Medici in reverse. For whereas they transmuted gold into the works and riches of art, he transformed the riches of art into an income, though one exquisitely veiled by the fin de siècle humanitas in the form of love of art, a fine library, some choice pictures, and conversation in which money was never mentioned. The culture of I Tatti was that of the rich at a particular historical moment, that in which culture still played the role of distinction, and it was sold with the art work. I Tatti, the grand hotels and the rich beaches, were but the setting of a discreet art business. As the high courtesans of the second empire had had their setting in the luxury of the theater and opera, the Bois or the Champs Elysées, the villa outside Florence was the setting of the great expert, a kind of grande cocotte of the art world.

Commerce, aesthetics, and astheticism, expertise and trade were all inextricably confused in the figure of B.B. who had worshipped at the feet of Walter Pater; posed as an aesthete devoted to art and beauty,

self-styled Hellene; follower of Morelli, the founder of scientific con-
noisseurship; sage of I Tatti and center of an international confrater-
nity of those who had known B.B. and been to I Tatti. But his achieve-
ment—celebrated in books, photographs, memoirs—rested on a
fragile skeleton in the closet, the skeleton of all bourgeois aesthetics:
the trade value of art, money made in selling rather than in creating or
commissioning works of art. The intrinsically priceless objet d'art en-
tered an international art market; the disinterested love of beauty was
turned into a profit; the art expert turned into an intermediary be-
tween conflicting desires. And the name of the game was cachet. The
work attributed and certified was a work blessed; the bourgeois love of
the real thing, now a sure thing, was satisfied, his fears of "being taken"
stilled. It was, in the post-Reformation world, a new form of indul-
gence buying. The limits between villa and marketplace, or investment
office, blurred; the tone of talk and trade was exquisitely polite; the spir-
itual values covered the pecuniary values with an aesthetic veil. The
flaneur sipped his tea or sherry, listened to the master, and sat down
to write his broker. Life was enhanced by art; it might be troubled by
the rise and fall of the market, but the picture was at last the *real thing*.
The view from the terrace was splendid. The collection in the villa of
the best, a lesson in discretion, discrimination, taste.

But the pictures at I Tatti reminded one famous visitor of something
else. When Max Beerbohm was shown to his room he was handed a
card on which were noted the artists and works hanging in the room
and was moved to exclaim, "Oh, a Menu!"

From Aura to Inflation

Some twenty years ago, in a very distinguished midwestern museum of art, a director, a few curators, and a dapper, scholarly, cosmopolitan New York art dealer were conversing over lunch in the shade of newly planted trees of a recently finished inner courtyard. As is often the case when conversation is of art among curators, art historians, and dealers, talk turned not to ineffable beauty but to the quoted prices of masterpieces. The dealer pronounced that the true value of art could not be priced, that masterpieces had no price; there was no talk of an art market. Later I had occasion to visit his and other galleries in New York and Paris. Seated in Louis XVI armchairs, leaning comfortably back (more so than in any Bauhaus creation), as domestics brought in one tempting painting after another to dazzle and charm my soul and mind, I gazed upon these lovely objects of desire and beauty. It was discreet, genteel, polite, and suave; it was so far beyond the marketplace, it could have hardly been called selling in galleries of such four-star grande classe. It was as if the Harvard Business School and its multiple replicas or imitations had never existed. And it seems now, in retrospect, to have been a denial of Walter Benjamin's thesis about the loss of aura, as if indeed, B.B. had definitely preserved it. But as a Molière doctor once said, "*nous avons changé tout cela.*"

These galleries in the grand manner still survive, but the term *art market* is today definitely current, and the nineteenth-century disparity or tension between high art and the bibelot has taken on new and intriguing forms. Today culture is an industry; the purchases of masterpieces by major museums becomes a media event; and museum exhibitions are raised to international blockbuster status as art and its ideated sensations are marketed like any other product. As for

Postscript: From Aura to Inflation

bibelots, they are still very much with us, marketed not only in a variety of department stores or gift shops but also, thanks to glossy photography, unsolicited mail order catalogues sent out by firms that sometimes call themselves collections. But despite this mass marketing, the aura of art survives: thousands still line up for hours for a Cézanne, Picasso, or King Tut exhibition. For all those in the lines, art and the art work is still something special, unique, a once-in-a lifetime event, and that aesthetic experience, despite the discomfort of lines and tired feet, is a must. Indeed, may one not say that after all the work of the experts of the period of B.B., exhibitions are more of a must than ever before, because one may now be sure that the works are, at last, identified and absolutely authentic? That they are, at last, as Henry James might say, "the real thing"?

Consider then the storm in the teacup of the art world when a few years ago an eminent collector of modern art (modern art has finally been accepted as nearly equal in status, in some circles at least, to cinquecento madonnas), a former governor of an imperial state, allowed the reproduction of ninety-six selected pieces from his collection—in a limited edition, of course. At about the same time a famous former director of an equally famous museum endorsed, in writing, an expensive reproduction of an Andrew Wyeth painting. A famous art critic, the very model of an art establishment figure, rose to the defense of art and wrote of "hype," "shamelessness," and "selling of haute schloch."

The eminent critic's literary shock seemed to betray a curious lack of historical understanding of what the German social literary critic Theodore Adorno referred to as the "aporetic" nature of art. Indeed, why be surprised or indignant at the marketing of reproductions when art works, old or new, great, good, bad, indifferent—or even kitsch—are also marketed even by art critics? Why write of "haute schloch" in an age that includes antiart in museums of fine art? The bourgeois connoisseur, as we have seen, has always loved, desired, and accumulated art, not to mention match boxes, bottle caps, stamps, glass

Postscript: From Aura to Inflation

bottles, locks, keys, dolls, toys, etcetera, etcetera, etcetera. And since modern, efficient, sophisticated marketing techniques may be used to sell even a president to a people, there is no reason not to sell art, as well as reproductions and bibelots, in the same way. The not-too-well-off bourgeois who has taken an art course in the wrong college and has been motivated by all those glossy slides, the less rich petit bourgeois, the blue-collar worker aspiring to class, the half-educated college student, the Ivy League, Harris tweed proletariat may, thanks to reproductions, live in an art environment made up at least in part by endorsed reproductions. After all, ours is an age of plastic flowers.

But what would the marketing of these endorsed and prestige, or shall we say "elite," reproductions do to the status of the original work of art? Would they pose a new threat to the aura of the authentic art work? Would the long work of art education be lost among the public rushing to buy endorsed reproductions? Would people cease to understand the distinction between the unique and the series? Were graduates from the business school threatening graduates in art history? Walter Benjamin had only explored the loss of aura within a specific historical context, that of his childhood, in which original works were posed on easels in the salon, curtains drawn tightly, green plants watered by maids, and places set with at least three different glasses. But Benjamin's Marxist eschatology had blinded him to the marvels of post-business school capitalism. He had not foreseen that aura, far from being lost, would be regained—and marketed. The shocked critic of Fun City had failed to understand the true significance of the endorsed collection of reproductions. The marketing of art and selected endorsed reproductions can of course be denounced on the plane of idealism, as Quatremère de Quincy did the art world of his day; or it can be dismissed, gleefully, as an inevitable aspect of corrupt bourgeois culture. But both positions are founded on the failure to see that the aesthetic experience has shifted from the contemplation of the work of art to its acquisition. Modern techniques of reproduction

Postscript: From Aura to Inflation

make possible this democratic aesthetic experience of acquisition to a greater and greater public of art-educated individuals.

In this shift of interest from work to acquisition, the museums are far from guiltless. Quite apart from their own sales desks, or indeed sales departments, and catalogues of cards, reproductions and bibelots, not to mention the cookbooks sold by some, the mentality of museum ruling circles has for years been dominated by the acquisitive spirit and the will to outbid one another. International sales call forth international competition and publicity. At their conclusion, one director, somewhere, will at last be able to exclaim triumphantly: "Ha, we got it, and the other guy didn't!" The killing on the market becomes a killing in the auction house. And the crowds line up to gape at a famous philosopher gazing at a bust of a famous poet. It was evident a long time ago that beauty, the disinterested love of art, the imperative of conservation, and the disinterested scholarship of art, or the education of public taste (assuming this can be done in museums or universities), had taken second place to the grand moments of a director's life: triumph in the auction room. The aura of art, thanks to the media, has rubbed off on directors and museums.

What the ex-governor-collector and ex-director did by endorsing reproductions was to let the cat out of the bag, which upset the art critic. The old idealist aesthetic of beauty, the old role of art as a sign of social distinction and culture, has been laid to rest. Art remains the sign only of wealth and the aura about it is the aura of gold. Art no longer distinguishes the grand seigneur, the prince, the gentleman or virtuoso, the cultured individual, the eccentric collector or ever-avid accumulator, or even the genuine lover who hung, slightly untidy, about auction houses and rummaged in old antique shops. The art work is a sign of wealth and with reproductions it can even produce what it never did before without a sale, dividends.

To understand this novel development we must give up all thought of idealism, aura, and the wickedness of endorsed reproductions. This

Postscript: From Aura to Inflation

latest adventure of the work of art in the period of its reproducibility is best understood within the general phenomenon of contemporary inflation with the help of the baroque economics of mercantilism and the gold standard. For the multimillionaire who proposes to issue a limited series of reproductions of works from his collection is acting like a baroque prince or monarch issuing currency. As the prince had his effigy on the coins minted, the multimillionaire issues signs of his taste. The collection of originals in this marvelous system acts as bullion in a financial system based on the gold standard. The reproductions are to the original collection what paper money is to gold bullion. The value of the reproductions remains constant for as long as the edition remains limited. The currency is sound when backed by bullion and when the degree of gold or silver in the coins is unaltered. The reproductions are the investment of persons of limited wealth and they are backed by the originals of a collector who is a judicious man of taste, wealth, prestige, and power, as solid as the House of Morgan was to its investors. Indeed, the reproductions may be far more stable and sound than currency that may be increased or decreased by the director of a reserve bank under some political or market pressure. As for the ex-director endorsing the reproduced Wyeth, he may readily be likened to a sound and respected investment counselor. After all, when E. F. Hutton talks, people listen. The model of this behavior is purely economic, albeit neither Keynesian nor Reaganian; nevertheless, it illustrates the dynamics of capitalism: a system that succeeded in turning antiart into art was bound to replace art eventually as the object of aesthetic experience and activity. Indeed one may conceivably argue that the art market within the capitalist system of today represents the survival of the baroque imagination avid for brilliance, glory, transcendence, and illusion. And what greater illusion is there than that of being able to get nothing for something?

The new system of the arts cum reproducible sign of wealth is not only democratic since it can spread art to all but also aristocratic since

Postscript: From Aura to Inflation

it maintains class distinctions in a subtle, invisible manner even within institutions whose democratic characteristics are touted by a democratic rhetoric. Money, as the nineteenth-century bourgeois soon saw, does not make a safe base for class distinctions; there were, after all, periodic arrivals of nouveaux riches on the scene. Hence the necessity of culture and the aura of art as class distinction. But today, modern marketing and the credit card, along with publicity and the media, threaten culture and aura. A new form of class distinction has arisen, cleverly hidden not only from the masses but, best of all, from the educated middle class: the foundation of class distinction on the possession of original works of art. Class distinction is no longer based merely on the quantity of money (after all you can steal the money and be rich without becoming respectable very soon), but on those who own originals as opposed to those who own only reproductions. But since reproductions are images of originals owned by the rich, the less rich are thereby allowed to share in the wealth, share in the same values, as our economic metaphor turns into an aesthetic trickle-down theory of taste. And all is for the best in the best of all possible economic and aesthetic systems.

Henry Adams once pessimistically observed that the great problem of the twentieth century would be for the American brain to catch up to the American brawn. He had cause to be pessimistic though not exactly for the reasons he may have had in mind. For the brain did catch up; but it was that of the business school graduate quite infected by what Adams so wonderfully described as the universal solvent of money valuations. As for Adams's one-time colleague, Charles Eliot Norton, he might have found a better understanding of the plight of art in his time, though hardly any consolation, had he read Thorstein Veblen as well as Dante.

S · E · L · E · C · T · E · D
B · I · B · L · I · O · G · R · A · P · H · Y

Adams, Henry. *The Education of Henry Adams: An Autobiography*. Boston: Houghton Mifflin, 1918.

———. *Esther*. New York: Holt, 1884.

———. *Letters of Henry Adams*. Boston: Houghton Mifflin, 1930.

———. *Mont Saint-Michel and Chartres*. Boston: Houghton Mifflin, 1905.

Alsop, Joseph. *The Rare Art Traditions: The History of Art Collecting and Its Linked Phenomena Wherever These Have Appeared*. Princeton and New York: Princeton University Press, and Harper and Row, 1982.

Amory, Cleveland. *The Proper Bostonians*. New York: Dutton, 1947.

Andrews, Wayne. *Architecture, Ambition and Americans*. New York: Harper's, 1947.

Balzac, Honoré de. *Traité de la vie élégante*. Paris: Librairie nouvelle, 1853.

Beer, Thomas. *The Mauve Decade*. New York: Knopf, 1926.

Benda, Julien. *Belphégor. Essai sur l'esthétique de la présente société française*. Paris: Emile Paul, 1918.

———. *Les Sentiments de critias*. Paris: Emile Paul, 1917.

———. *Sur le succès du Bergsonisme*. Paris: Mercure de France, 1914.

Benjamin, Walter. *Charles Baudelaire. Ein Lyriker im Zeitalter des Hochkapitalismus*. Frankfurt am Main: Suhrkamp, 1969.

———. *Reflections, Essays, Aphorisms, Autobiographical Writings*. Translated by Edmund Jephcott. New York: Harcourt, Brace, Jovanovitch, 1978.

Berenson, Bernard. *Aesthetics and History*. New York: Pantheon, 1948.

———. *One Year's Reading for Fun, 1942*. New York: Knopf, 1960.

Selected Bibliography

———. *The Passionate Sightseer; from the Diaries, 1947 to 1956*. New York: Simon and Schuster and Abrams, 1960.

———. *Rumor and Reflections*. New York: Simon and Schuster, 1952.

Boulenger, Jacques. *Sous Louis Philippe: Les Dandys*. Paris: Ollendorf, 1907.

Bourget, Paul. *Essais de psychologie contemporaine*. Paris: Lemerre, 1887.

———. *Nouveaux essais de psychologie contemporaine*. Paris: Lemerre, 1888.

———. *Outre-mer*. 2 vols. Paris: Lemerre and Meyer, 1894–1895.

Brooks, Van Wyck. *New England Indian Summer, 1865–1915*. New York: Dutton, 1940.

Canby, Henry Seidel. *The Age of Confidence: Life in the Nineties*. New York: Farrar and Rinehart, 1934.

Carassus, Emilien. *Le Snobisme et les lettres françaises de Paul Bourget à Marcel Proust*. Paris: Armond Colin, 1966.

Chapman, John Jay. *Learning and Other Essays*. New York: Moffat, Yard, 1915.

———. *Memories and Milestones*. New York: Moffatt, Yard, 1910.

Chisolm, Lawrence W. *Fenellosa: The Far East in American Culture*. New Haven: Yale University Press, 1963.

Claretie, Jules. *L'Américaine. Roman contemporain*. Paris: Denta, 1892.

Coulevain, Pierre de. *Eve victorieuse*. Paris: Calmann-Lévy, 1901.

———. *Noblesse américaine*. Paris: Ollendorf, 1907.

———. *Sur la Branche*. Paris: Clamann-Lévy, 1903.

Cram, Ralph Adams. *The Decadent: Being the Gospel of Inaction*. Cambridge, Mass.: Privately printed, 1893.

Daudet, Alphonse. *Le Nabab*. Paris: Charpentier, 1884.

Dietrichsen, Jan D. *The Image of Money in the American Novel of the Gilded Age*. Oslo, n.d.

Doisneau, Robert, and Bernard Delvaille. *Passages et galeries du 19ᵉ siècle*. Paris: A.C.E., 1981.

Selected Bibliography

Dumas, *fils*, Alexandre. *La Dame aux camélias*. Paris: Nelson ed.,
Calmann-Lévy, n.d.

Fischel, Oskar, and Max von Boehn. *Modes and Manners of the Nine-
teenth Century as Represented in the Pictures and Engravings of
the Time*. Translated by Grace Rhys. 4 vols. London and New
York: Dent and Dutton, 1927.

Fournel, Victor. *Ce qu'on voit dans les rues de Paris*. Paris: Delahays,
1858.

Fuller, Henry Blake. *With the Procession*. New York: Harper's, 1895.

Goblot, Edmond. *La Barrière et le niveau*. Paris: Alcan, 1925.

Guinon, Arthur. *Décadence*. Paris: Librairie theatrale, 1901.

Gunn, Peter. *Vernon Lee: Violet Paget*. London: Oxford University
Press, 1964.

Hawthorne, Nathaniel. *The Marble Faun*. Boston: Houghton Mifflin,
1891.

Hitchcock, Henry Russell. *The Architecture of H. H. Richardson and
His Times*. Hamdon, Conn.: Archon, 1961.

Hughes, Rupert. *The Real New York*. New York: Smart Set, 1904.

Jones, Howard Mumford. *The Age of Energy: Varieties of American
Experience, 1865–1915*. New York: Viking, 1970.

König, René. *Sociologie de la mode*. Paris: Payot, 1969.

Lano, Pierre de. *L'Amour à Paris sous le Second Empire*. Paris: Empis,
1896.

Lee, Vernon. *Art and Life*. East Aurora, N.Y.: Roycroft Print Shop, 1896.

———. *Belcaro, being Essays on Sundry Aesthetical Questions*. Lon-
don: W. Satchell, 1881.

———. *The Beautiful, an Introduction to Psychological Aesthetics*.
Cambridge: Cambridge University Press, 1913.

Lewis, R. W. B. *Edith Wharton. A Biography*. New York: Harper and
Row, 1975.

Lucien-Graux, Docteur. *Les Factures de la Dame aux Camélias*. Paris:
Privately printed, 1934.

Selected Bibliography

Lynes, Russel. *The Taste-Makers*. New York: Harper's, 1947.

Mariano, Nicky. *Forty Years with Berenson*. Introduction by Sir Kenneth Clark. London: Hamish Hamilton, 1966.

Martin Fugier, Anne. *La Bourgeoise: Femme au temps de Paul Bourget*. Paris: Grasset, 1983.

Maurer, Emil. *Der Spätburger*. Bern: Francke, 1963.

McAllister, Ward. *Society as I Have Known It*. New York: Cassel, 1890.

Miller, Michael B. *The Bon Marché: Bourgeois Culture and the Department Store*. Princeton: Princeton University Press, 1981.

Morgan, H. Wayne. *New Muses: Art in American Culture, 1865–1920*. Norman: University of Oklahoma Press, 1978.

Mumford, Lewis. *The Brown Decades: A Study of the Arts in America, 1865–1895*. New York: Harcourt Brace, 1931.

Morra, Count Umberto. *Conversations with Berenson*. Boston: Houghton Mifflin, 1965.

Nash, Roderick, ed. *The Call of the Wild (1900–1916)*. New York: George Braziller, 1970.

Nordau, Max. *Degeneration*. New York: Appleton, 1897.

Pater, Walter. *Marius the Epicurean: His Sensations and Ideas*. New York: Modern Library, n.d.

———. *The Renaissance*. London: Macmillan, 1935.

Pasdermadjan, H. *The Department Store, Its Origins, Evolution and Economics*. London: Newman, 1954.

Samuels, Ernest. *Bernard Berenson. The Making of a Connoisseur*. Cambridge, Mass.: Belknap Press of Harvard University, 1979.

Saarinen, Aline. *The Proud Possessors: The Lives, Times, and Tastes of Some Adventurous American Collectors*. New York: Random House, 1958.

Schuyler, Montgomery. *American Architecture and Other Writings*. 2 vols. Edited by William H. Jordy and Ralph Coe. Cambridge, Mass.: Belknap Press of Harvard University, 1961.

Secrest, Meryle. *Being Bernard Berenson*. New York: Holt, Rinehart and Winston, 1979.

Selected Bibliography

Smith, Bonnie G. *Ladies of the Leisure Class. The Bourgeoises of Northern France in the Nineteenth Century.* Princeton, New Jersey: Princeton University Press, 1981.

Smith, Logan Pearsall. *Unforgotten Years.* Boston: Little, Brown, 1939.

Staël, Germaine de. *Corinne, ou l'Italie.* Paris: Charpentier, 1841.

Steegmuller, Francis. *The Two Lives of James Jackson Jarves.* New Haven: Yale University Press, 1951.

Symonds, John Addington. *In the Key of Blue and other Prose Essays.* New York: Macmillan, 1893.

Taine, Hyppolite. *Notes sur Paris: Vie et opinions de M. Frédéric Thomas Graindorge.* Paris: Hachette, 1901.

———. *Philosophie de l'Art.* 2 vols. Paris: Hachette, 1909.

———. *Voyage en Italie.* 2 vols. Paris: Hachette, 1898.

Tharp, Louise Hall. *Mrs. Jack.* Boston: Little, Brown, 1965.

Tomkins, Calvin. *Merchants and Masterpieces. The Story of the Metropolitan Museum of Art.* New York: Dutton, 1970.

Tomsich, John. *A Genteel Endeavor: American Culture and Politics in the Gilded Age.* Stanford: Stanford University Press, 1971.

Veblen, Thorstein. *Theory of the Leisure Class.* Introduction by John Kenneth Galbraith. Boston: Houghton Mifflin, 1973.

Wendt, Lloyd, and Herman Kogan. *Give the Lady What She Wants: The Story of Marshall Field and Company.* New York: Rand McNally, 1952.

Wharton, Edith. *A Backward Glance.* New York: Scribner's, 1934.

Wharton, Edith, and Ogden Codman, Jr. *The Decoration of Houses.* New York: Scribner's, 1901.

Winner, Viola Hopkins. *Henry James and the Visual Arts.* Charlottesville: University of Virginia Press, 1970.

Zeldin, Theodore. *France 1848–1945.* 2 vols. Oxford: Clarendon Press, 1977.

Zola, Emile. *L'Argent.* Paris: Charpentier, 1927.

———. *Au Bonheur des dames.* Paris: Charpentier, 1883.

———. *Nana.* Paris: Fasquelle, 1926.

I · N · D · E · X

Index

Index

Index

Index

Index

Index

Index